EXTREME PERSPECTIVE!
FOR ARTISTS

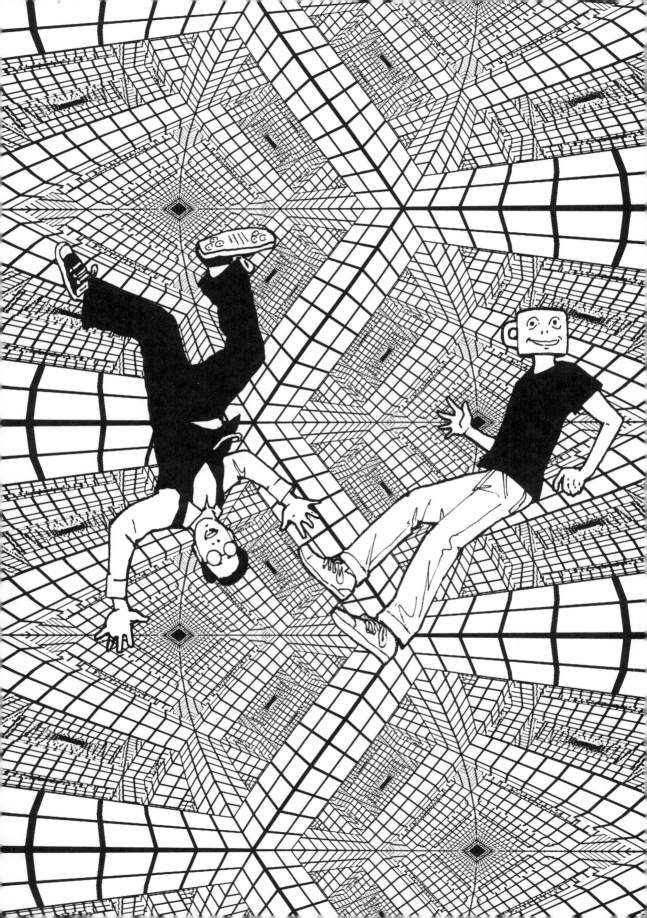

EXTREME PERSPECTIVE! FOR ARTISTS

LEARN THE SECRETS OF CURVILINEAR, CYLINDRICAL, FISHEYE, ISOMETRIC, AND OTHER AMAZING DRAWING SYSTEMS THAT WILL MAKE YOUR DRAWINGS POP OFF THE PAGE

DAVID CHELSEA

WATSON - GUPTILL PUBLICATIONS / NEW YORK

TO MY FAMILY

WATSON-GUPTILL is a registered trademark and the
WG and Horse designs are trademarks of Random House, Inc.

Library of Congress Control Number: 2010932240

ISBN 978-0-8230-2665-4

Printed and bound in Malaysia for Imago

Design by Jess Morphew

10 9 8 7 6 5 4 3 2 1

First Edition

CONTENTS

ACKNOWLEDGMENTS

My thanks to the unfailingly patient and perceptive editors Candace Raney and Caitlin Harpin, who managed to wade through the sometimes dense and confusing material in this book without once losing their way, and art director Jess Morphew, who made it all look as good as possible. Gary Falgin, founder of the Gage Academy of Art and my first perspective teacher nearly thirty years ago, once more provided an invaluable second pair of eyes, as he had on my first perspective book. I could not have completed this project on time without the able assistance of Evan Bartholomew, Dan Cottle, Jacob Mercy and Jefferson Powers. I would like to especially single out Jefferson, a skilled cartoonist in his own right, for showing me the hidden possibilities in Adobe Illustrator. This application had been sitting on my hard drive for years without my having found a use for it, but it turns out to be ideally suited for perspective diagrams. The spiral staircase sequence in the Extra Vanishing Point chapter is entirely Jefferson's work, and following that example I was able to do the rest of the diagrams in Illustrator. Tom Lechner's help was invaluable in creating cylindrical versions of the perspective grids on the attached disc, which in turn were the basis for the fisheye grids. Above all I thank my family—my lovely wife Eve, son Ben and daughter Rebecca, for their support and company during the period I was working on this book. Ben, a crawling baby when my first perspective book came out thirteen years ago, has by now acquired enough computer skills to provide his dad valuable CGI assistance. The 3D model of the perspective gazebo is entirely Ben's work, but he has created much more elaborate work on his own, including several all-CGI video games. As perspective was the cutting edge of art in the Renaissance, computer art is the cutting edge of today, and the next generation is already swimming in seas I have barely stuck my toe in.

PREFACE

Welcome to *Extreme Perspective! for Artists*, a follow-up to *Perspective! for Comic Book Artists*, which appeared in 1997. Let me say at the beginning that I love comics and think it is the ideal medium for explaining a complex subject like perspective, but it does have its drawbacks. Comics are not an especially compact way to get across information; a point that another book can make in a paragraph may take me several pages. For that reason I knew on the first book that space would not allow me to cover everything I might have liked to, and a fair title for the follow-up could be *Stuff Left Out Of The First Book*. I always knew that there would not be room for aspects that are routinely covered in other books but which can be considered peripheral, like reflections, shadows, staircases and inclined planes, which happily you can find within these pages. I had intended to include chapters on curvilinear perspective and paraline drawing, but had to drop them as my deadline loomed. Just as well, because those chapters became the nucleus of the new book. I hope those readers who have been waiting for my take on these aspects and others will enjoy exploring perspective further with me. First, we'll take the stairs.

CHAPTER 1
Extra Vanishing Points

In the first book, I said to Mugg, "You live in a box." I meant that we all live in boxy rooms and rectilinear streets, which we can capture in simple one- , two- , or three-point perspective. However, almost nobody lives in a pure box. How, for example, would you depict a slanted roof, an octagonal table, or even a spiral staircase? For these complicated structures, we need to place extra vanishing points on the horizon. Don't worry, it's not as complicated as it sounds.

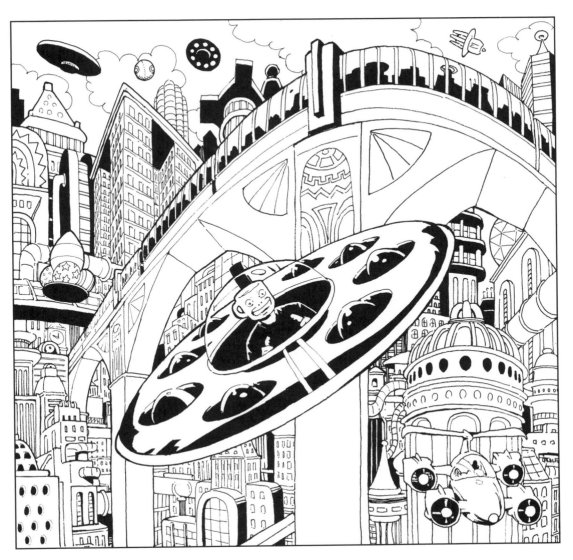

CHAIRLESS CAFE

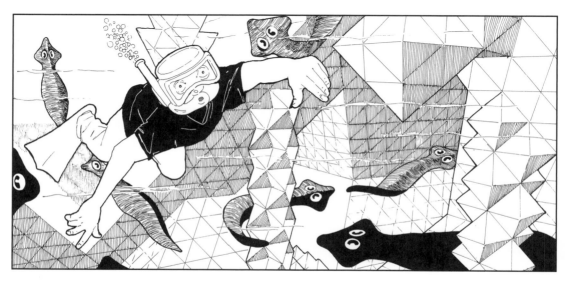

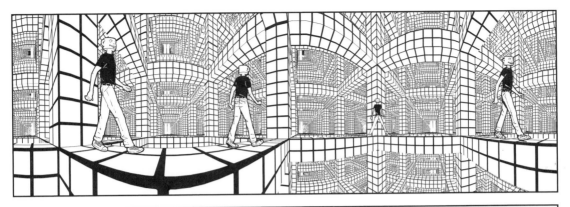

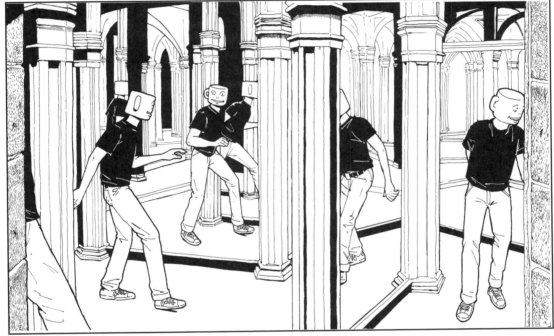

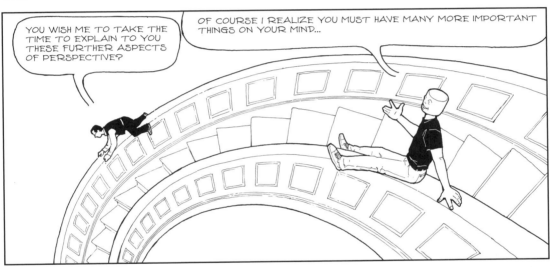

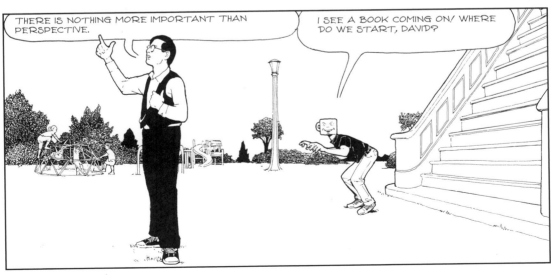

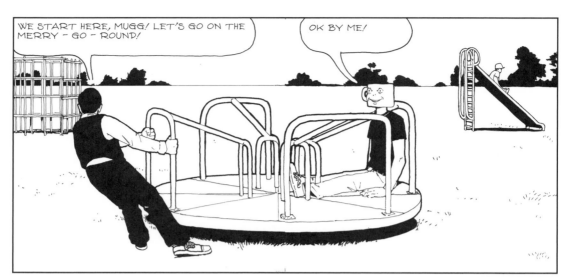

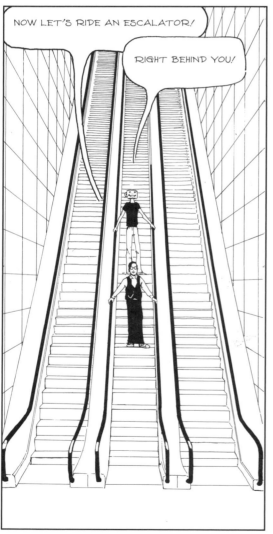

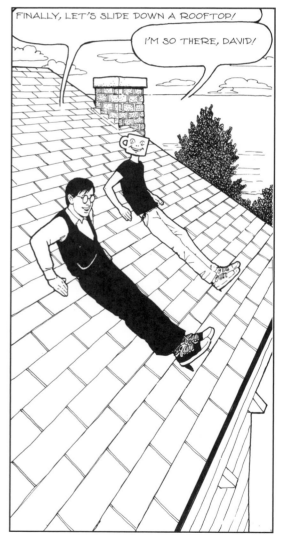

NOW, WHAT DO YOU SUPPOSE ALL THESE THINGS HAVE IN COMMON, MUGG?

THEY'RE ALL EXTRA COMPLICATED TO DRAW?

YES, BUT WHY DO YOU SUPPOSE THAT IS?

WELL, BECAUSE... BECAUSE...

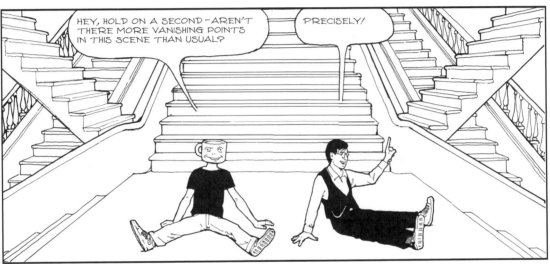

HEY, HOLD ON A SECOND – AREN'T THERE MORE VANISHING POINTS IN THIS SCENE THAN USUAL?

PRECISELY!

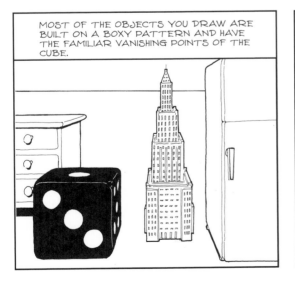

MOST OF THE OBJECTS YOU DRAW ARE BUILT ON A BOXY PATTERN AND HAVE THE FAMILIAR VANISHING POINTS OF THE CUBE.

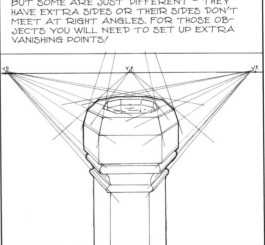

BUT SOME ARE JUST DIFFERENT – THEY HAVE EXTRA SIDES OR THEIR SIDES DON'T MEET AT RIGHT ANGLES. FOR THOSE OBJECTS YOU WILL NEED TO SET UP EXTRA VANISHING POINTS!

AN OBJECT LIKE THIS HAS ITS EXTRA
VANISHNG POINTS ON THE HORIZON.

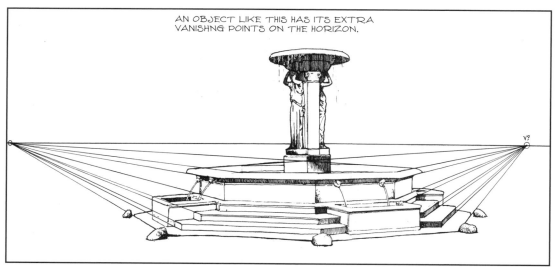

WHILE AN OBJECT LIKE THIS WILL HAVE ITS
EXTRA VANISHING POINTS ON A TRANSVERSE
HORIZON, AT RIGHT ANGLES TO THE FAMIL-
IAR ONE.

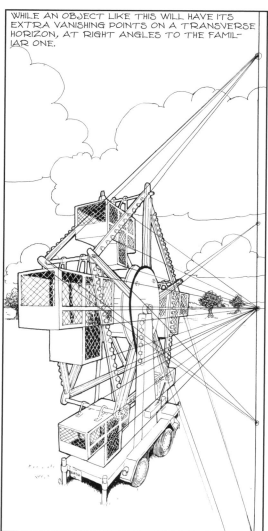

AND A TILTED OBJECT LIKE THIS ONE WILL
HAVE ITS VANISHING POINTS ON A TILTED HO-
RIZON WHICH MEETS THE REGULAR HORIZON
AT AN ANGLE.

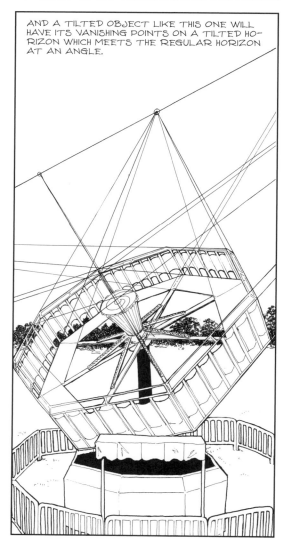

EXTREME PERSPECTIVE! FOR ARTISTS

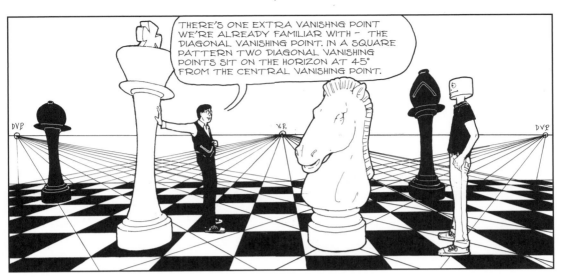

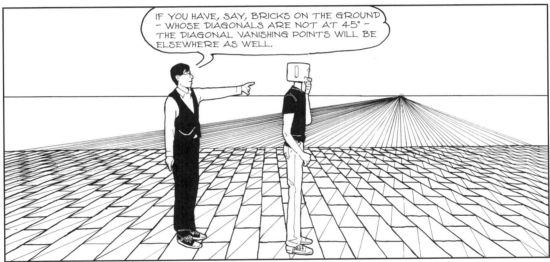

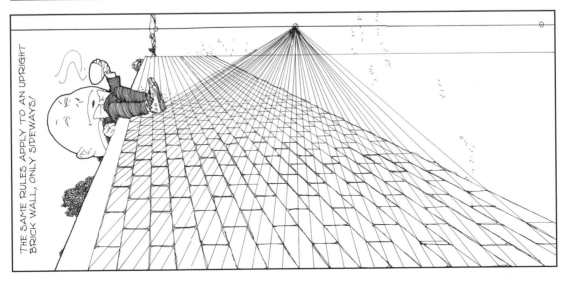

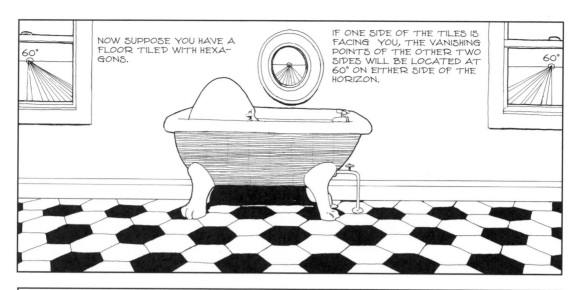

NOW SUPPOSE YOU HAVE A FLOOR TILED WITH HEXAGONS.

IF ONE SIDE OF THE TILES IS FACING YOU, THE VANISHING POINTS OF THE OTHER TWO SIDES WILL BE LOCATED AT 60° ON EITHER SIDE OF THE HORIZON.

60°

60°

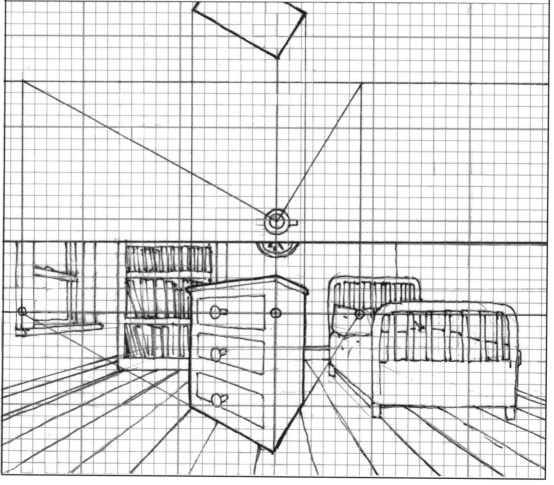

YOU CAN SET THOSE VANISHING POINTS ANYWHERE YOU LIKE, BUT IF YOU NEED TO DO IT WITH MATHEMATICAL EXACTITUDE — SAY YOU HAVE A SQUARE OBJECT TURNED AT AN ANGLE WITHIN A ROOM IN ONE – POINT PERSPECTIVE — YOU CAN DRAW A FLOOR PLAN WITH LINES AT THOSE ANGLES RADIATING FROM THE POINT YOUR OBSERVER IS STANDING AT AND INTERSECTING YOUR PICTURE PLANE.

IF YOU HAVE A TIPPING BOX LID, ITS VANISHING POINT WILL BE ON A TRANSVERSE HORIZON, HIGHER OR LOWER AS IT TIPS. OBVIOUS ENOUGH, BUT WHAT MAY NOT BE OBVIOUS IS THAT THE DIAGONAL VANISHING POINTS FOLLOW CIRCULAR TRACKS AS IT TIPS WHICH ARE DRAWN AS HYPERBOLAS IF YOU'RE FACING THE AXIS OF ROTATION (I.E., THE HINGE) FRONTALLY —

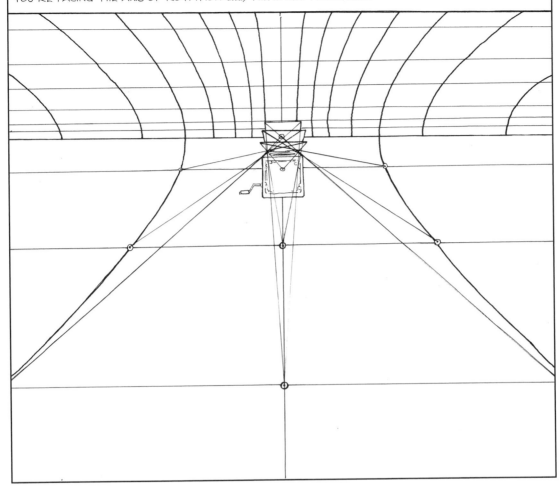

PERFECT CIRCLES IN A SIDE VIEW —

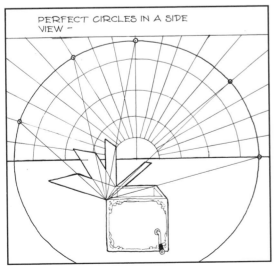

AND EITHER AN ELLIPSE OR A PARABOLA OR A HYPERBOLA IF YOU'RE SOMEWHERE IN BETWEEN. I KNOW, IT'S COMPLICATED. WE'LL DEAL WITH HOW TO DRAW HYPERBO- LAS AND PARABOLAS IN THE CHAPTER ON SHADOWS.

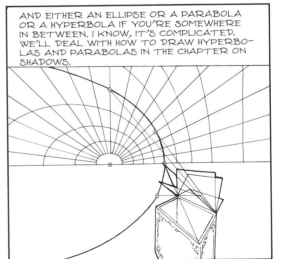

YOU DEFINITELY NEED EXTRA VANISHING POINTS TO DRAW A STAIRCASE. USUALLY IT'S NOT THAT COMPLICATED - THE STAIRS ARE INCLINED AT A CERTAIN ANGLE, AND THE VANISHING POINT IS LOCATED AT A CORRESPONDING POINT ABOVE THE HORIZON.

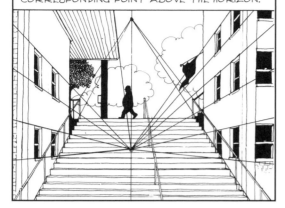

WHEN YOU'RE LOOKING DOWN A FLIGHT OF STAIRS, THE VANISHING POINT FOR THEM WILL BE BELOW THE HORIZON.

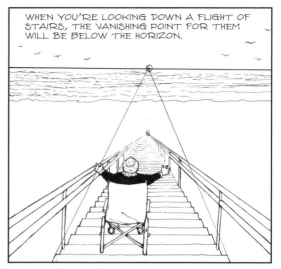

THE SAME PRINCIPLE IS TRUE ON A HILLY STREET. THE EXTRA VANISHING POINT IS LOCATED DIRECTLY ABOVE THE REGULAR ONE. NOTICE THAT THE BUILDINGS DON'T TILT - THEIR VERTICALS ARE STRAIGHT AND THEIR RECEDING LINES GO TO THE CENTRAL VANISHING POINT.

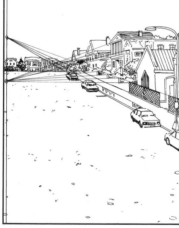

LOOKING DOWN, THE LINES OF THE HILL GO TO A POINT BELOW THE HORIZON.

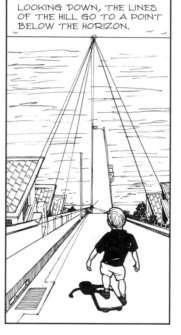

SO, WITH THAT UNDER YOUR BELT, I THINK YOU'RE READY FOR SOMETHING REALLY CHALLENGING -

NOT - THE SPIRAL STAIRCASE!!

START BY DRAWING A HORIZON ON A SHEET OF GRAPH PAPER....

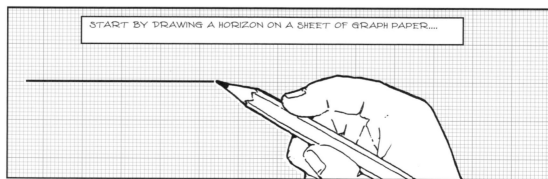

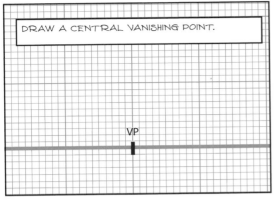

DRAW A CENTRAL VANISHING POINT.

VP

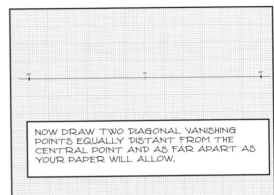

NOW DRAW TWO DIAGONAL VANISHING POINTS EQUALLY DISTANT FROM THE CENTRAL POINT AND AS FAR APART AS YOUR PAPER WILL ALLOW.

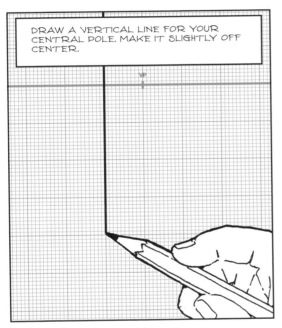

DRAW A VERTICAL LINE FOR YOUR CENTRAL POLE. MAKE IT SLIGHTLY OFF CENTER.

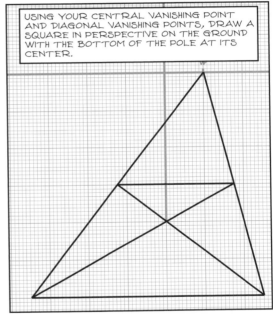

USING YOUR CENTRAL VANISHING POINT AND DIAGONAL VANISHING POINTS, DRAW A SQUARE IN PERSPECTIVE ON THE GROUND WITH THE BOTTOM OF THE POLE AT ITS CENTER.

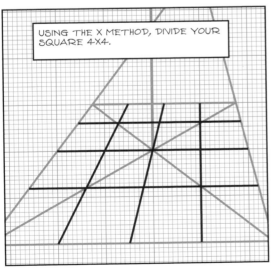

USING THE X METHOD, DIVIDE YOUR SQUARE 4X4.

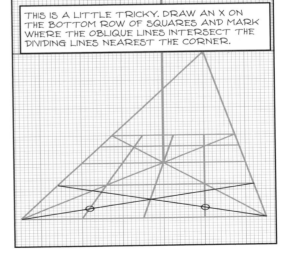

THIS IS A LITTLE TRICKY. DRAW AN X ON THE BOTTOM ROW OF SQUARES AND MARK WHERE THE OBLIQUE LINES INTERSECT THE DIVIDING LINES NEAREST THE CORNER.

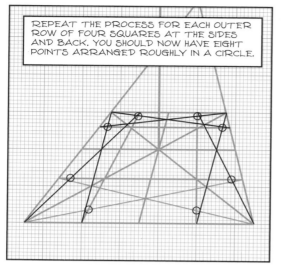

REPEAT THE PROCESS FOR EACH OUTER ROW OF FOUR SQUARES AT THE SIDES AND BACK. YOU SHOULD NOW HAVE EIGHT POINTS ARRANGED ROUGHLY IN A CIRCLE.

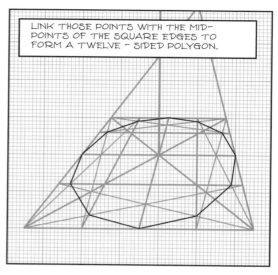

LINK THOSE POINTS WITH THE MID-POINTS OF THE SQUARE EDGES TO FORM A TWELVE-SIDED POLYGON.

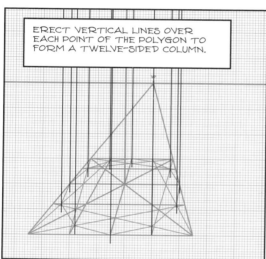

ERECT VERTICAL LINES OVER EACH POINT OF THE POLYGON TO FORM A TWELVE-SIDED COLUMN.

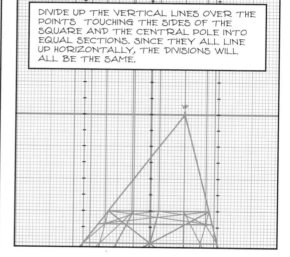

DIVIDE UP THE VERTICAL LINES OVER THE POINTS TOUCHING THE SIDES OF THE SQUARE AND THE CENTRAL POLE INTO EQUAL SECTIONS. SINCE THEY ALL LINE UP HORIZONTALLY, THE DIVISIONS WILL ALL BE THE SAME.

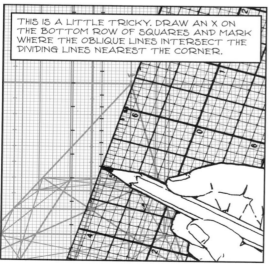

THIS IS A LITTLE TRICKY. DRAW AN X ON THE BOTTOM ROW OF SQUARES AND MARK WHERE THE OBLIQUE LINES INTERSECT THE DIVIDING LINES NEAREST THE CORNER.

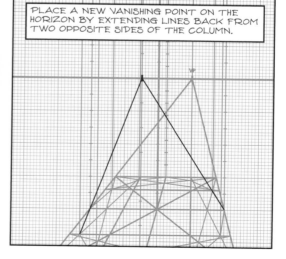

PLACE A NEW VANISHING POINT ON THE HORIZON BY EXTENDING LINES BACK FROM TWO OPPOSITE SIDES OF THE COLUMN.

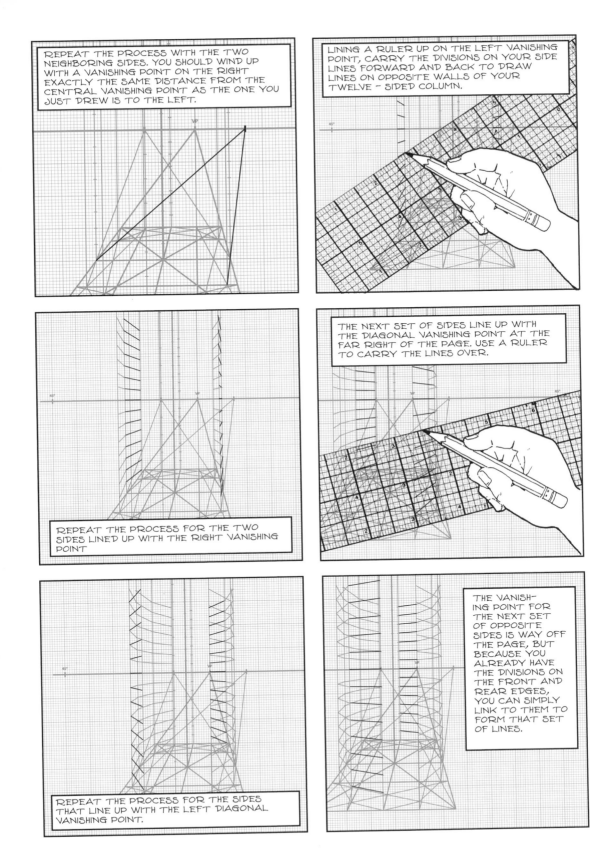

REPEAT THE PROCESS WITH THE TWO NEIGHBORING SIDES. YOU SHOULD WIND UP WITH A VANISHING POINT ON THE RIGHT EXACTLY THE SAME DISTANCE FROM THE CENTRAL VANISHING POINT AS THE ONE YOU JUST DREW IS TO THE LEFT.

LINING A RULER UP ON THE LEFT VANISHING POINT, CARRY THE DIVISIONS ON YOUR SIDE LINES FORWARD AND BACK TO DRAW LINES ON OPPOSITE WALLS OF YOUR TWELVE-SIDED COLUMN.

REPEAT THE PROCESS FOR THE TWO SIDES LINED UP WITH THE RIGHT VANISHING POINT

THE NEXT SET OF SIDES LINE UP WITH THE DIAGONAL VANISHING POINT AT THE FAR RIGHT OF THE PAGE. USE A RULER TO CARRY THE LINES OVER.

REPEAT THE PROCESS FOR THE SIDES THAT LINE UP WITH THE LEFT DIAGONAL VANISHING POINT.

THE VANISHING POINT FOR THE NEXT SET OF OPPOSITE SIDES IS WAY OFF THE PAGE, BUT BECAUSE YOU ALREADY HAVE THE DIVISIONS ON THE FRONT AND REAR EDGES, YOU CAN SIMPLY LINK TO THEM TO FORM THAT SET OF LINES.

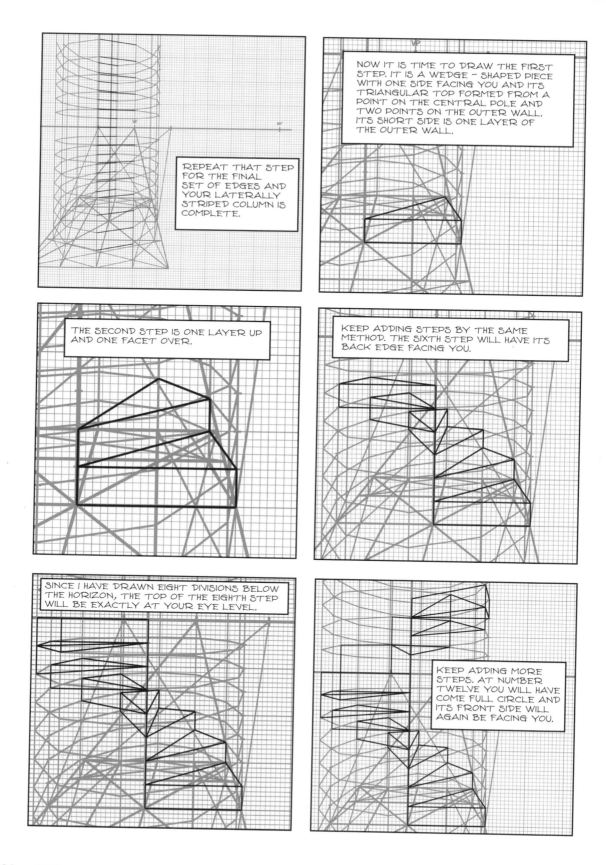

REPEAT THAT STEP FOR THE FINAL SET OF EDGES AND YOUR LATERALLY STRIPED COLUMN IS COMPLETE.

NOW IT IS TIME TO DRAW THE FIRST STEP. IT IS A WEDGE - SHAPED PIECE WITH ONE SIDE FACING YOU AND ITS TRIANGULAR TOP FORMED FROM A POINT ON THE CENTRAL POLE AND TWO POINTS ON THE OUTER WALL. ITS SHORT SIDE IS ONE LAYER OF THE OUTER WALL.

THE SECOND STEP IS ONE LAYER UP AND ONE FACET OVER.

KEEP ADDING STEPS BY THE SAME METHOD. THE SIXTH STEP WILL HAVE ITS BACK EDGE FACING YOU.

SINCE I HAVE DRAWN EIGHT DIVISIONS BELOW THE HORIZON, THE TOP OF THE EIGHTH STEP WILL BE EXACTLY AT YOUR EYE LEVEL.

KEEP ADDING MORE STEPS. AT NUMBER TWELVE YOU WILL HAVE COME FULL CIRCLE AND ITS FRONT SIDE WILL AGAIN BE FACING YOU.

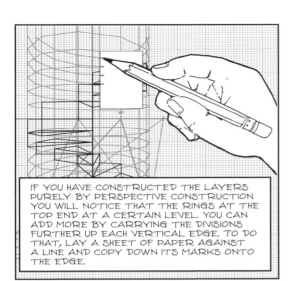

IF YOU HAVE CONSTRUCTED THE LAYERS PURELY BY PERSPECTIVE CONSTRUCTION YOU WILL NOTICE THAT THE RINGS AT THE TOP END AT A CERTAIN LEVEL. YOU CAN ADD MORE BY CARRYING THE DIVISIONS FURTHER UP EACH VERTICAL EDGE. TO DO THAT, LAY A SHEET OF PAPER AGAINST A LINE AND COPY DOWN ITS MARKS ONTO THE EDGE.

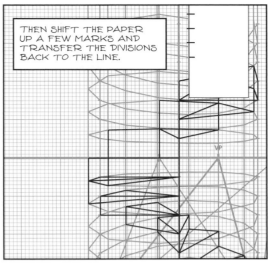

THEN SHIFT THE PAPER UP A FEW MARKS AND TRANSFER THE DIVISIONS BACK TO THE LINE.

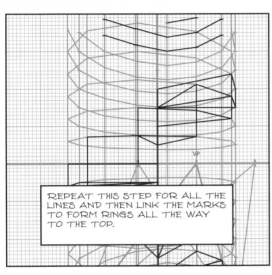

REPEAT THIS STEP FOR ALL THE LINES AND THEN LINK THE MARKS TO FORM RINGS ALL THE WAY TO THE TOP.

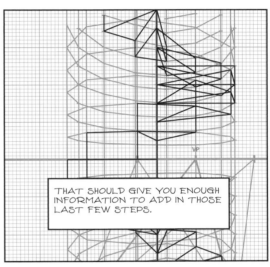

THAT SHOULD GIVE YOU ENOUGH INFORMATION TO ADD IN THOSE LAST FEW STEPS.

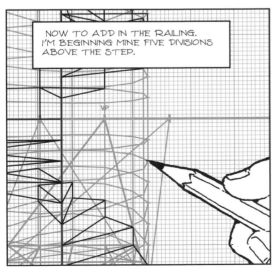

NOW TO ADD IN THE RAILING. I'M BEGINNING MINE FIVE DIVISIONS ABOVE THE STEP.

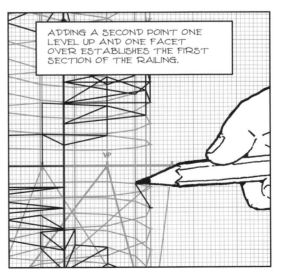

ADDING A SECOND POINT ONE LEVEL UP AND ONE FACET OVER ESTABLISHES THE FIRST SECTION OF THE RAILING.

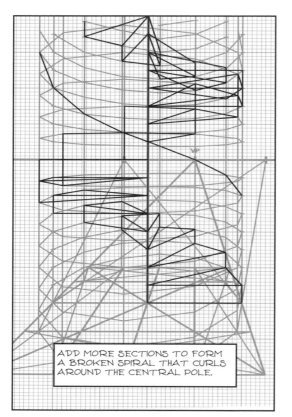

ADD MORE SECTIONS TO FORM
A BROKEN SPIRAL THAT CURLS
AROUND THE CENTRAL POLE.

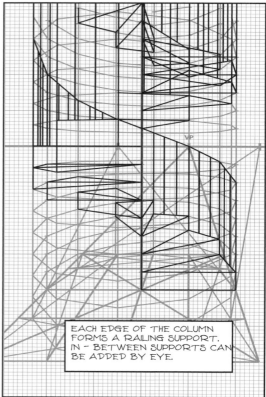

EACH EDGE OF THE COLUMN
FORMS A RAILING SUPPORT.
IN - BETWEEN SUPPORTS CAN
BE ADDED BY EYE.

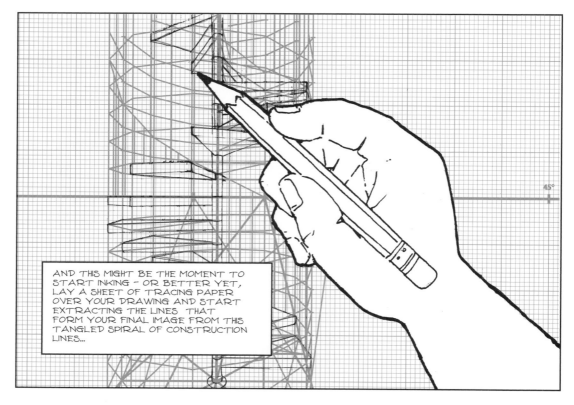

AND THIS MIGHT BE THE MOMENT TO
START INKING - OR BETTER YET,
LAY A SHEET OF TRACING PAPER
OVER YOUR DRAWING AND START
EXTRACTING THE LINES THAT
FORM YOUR FINAL IMAGE FROM THIS
TANGLED SPIRAL OF CONSTRUCTION
LINES...

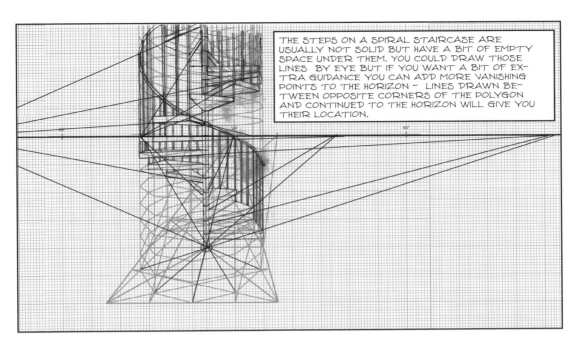

THE STEPS ON A SPIRAL STAIRCASE ARE USUALLY NOT SOLID BUT HAVE A BIT OF EMPTY SPACE UNDER THEM. YOU COULD DRAW THOSE LINES BY EYE BUT IF YOU WANT A BIT OF EXTRA GUIDANCE YOU CAN ADD MORE VANISHING POINTS TO THE HORIZON — LINES DRAWN BETWEEN OPPOSITE CORNERS OF THE POLYGON AND CONTINUED TO THE HORIZON WILL GIVE YOU THEIR LOCATION.

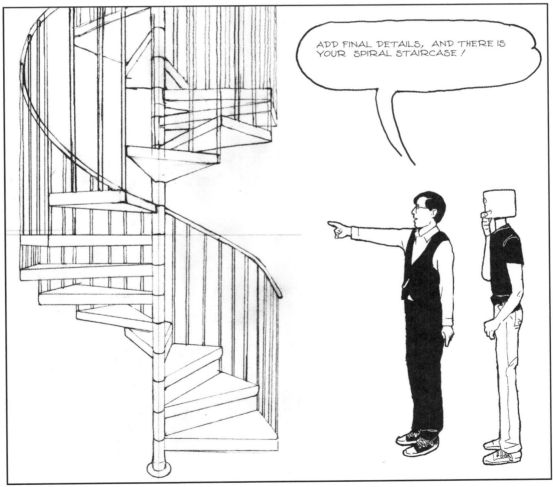

ADD FINAL DETAILS, AND THERE IS YOUR SPIRAL STAIRCASE!

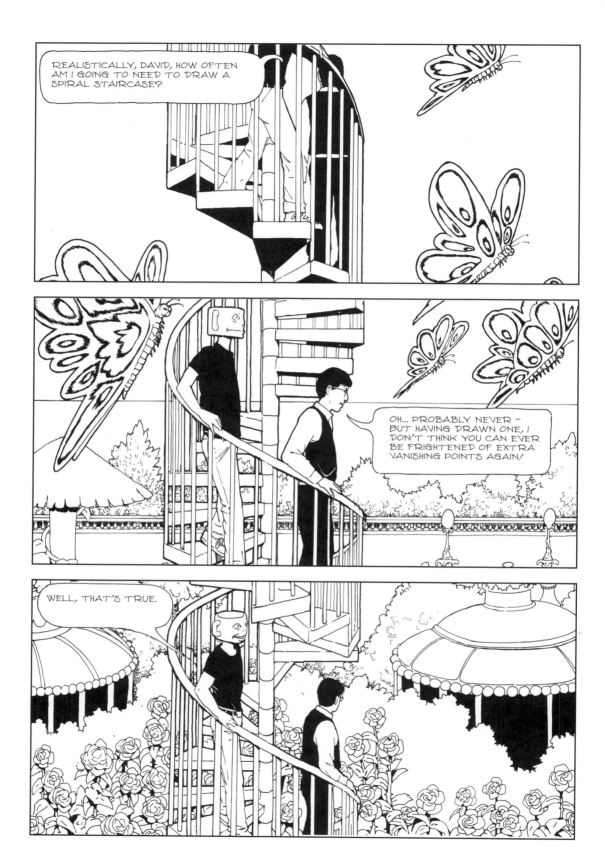

CHAPTER 2
Anamorphosis: Perspective that Pops

Anamorphosis, a visual novelty in which a weirdly distorted image can be read only from a single point in space, takes us back to perspective's roots. Renaissance artist Brunelleschi's original perspective demonstration involved a painting of the Baptistry in Florence, viewed through a peephole in front of the real Baptistery. Viewers said they could not tell where the painting left off and the real scene began. In time, perspective lost that sense of magic and became merely one tool among many that artists use to make their pictures look realistic. Anamorphosis restores the strict geometry of station point and picture plane, stretching perspective as far as it can go by following the rules to their logical extreme.

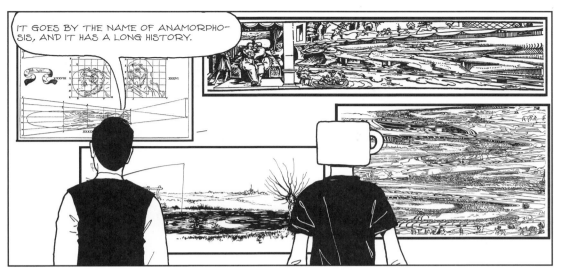

IT GOES BY THE NAME OF ANAMORPHO-SIS, AND IT HAS A LONG HISTORY.

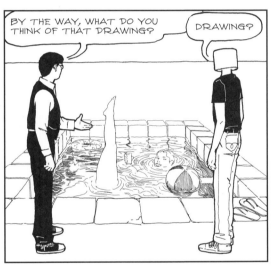

BY THE WAY, WHAT DO YOU THINK OF THAT DRAWING?

DRAWING?

VERY SKILLFUL. HOW IS IT DONE?

YOU ARE ASKING TO ME TO DIVULGE SECRETS THAT HAVE BEEN CLOSELY GUARDED FOR CENTURIES.

SO, ARE YOU GOING TO DO IT?

OKAY!

ANAMORPHOSIS: PERSPECTIVE THAT POPS **31**

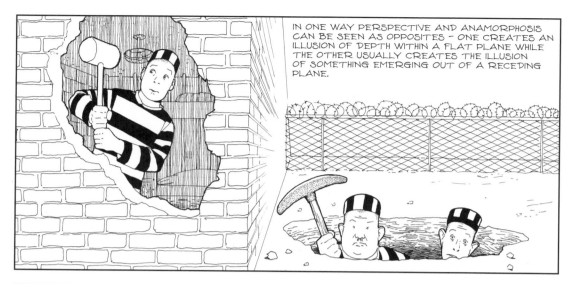

IN ONE WAY PERSPECTIVE AND ANAMORPHOSIS CAN BE SEEN AS OPPOSITES – ONE CREATES AN ILLUSION OF DEPTH WITHIN A FLAT PLANE WHILE THE OTHER USUALLY CREATES THE ILLUSION OF SOMETHING EMERGING OUT OF A RECEDING PLANE.

BUT IN FACT THE TWO METHODS ARE ONE. IN CLASSIC PERSPECTIVE THEORY, WHEN AN OBSERVER STANDS EXACTLY AT THE STATION POINT THE DISTORTIONS AT THE EDGES OF THE PICTURE DON'T MATTER BECAUSE THEY ARE EXACTLY CANCELLED OUT BY FORESHORTENING.

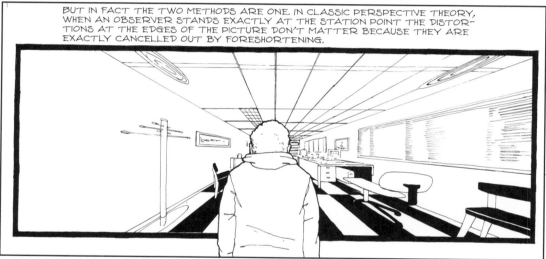

WHAT HAPPENS IN ANAMORPHOSIS IS THAT YOU CUT OUT THE UNDISTORTED MIDDLE OF THE PICTURE AND LEAVE ONLY THE HIGHLY DISTORTED EDGE!

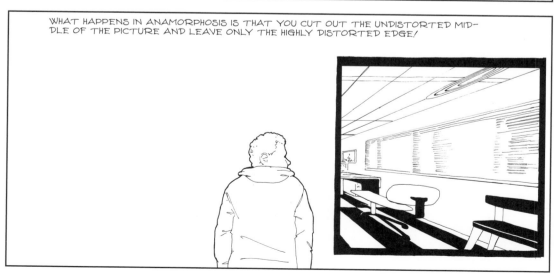

ANY RECTILINEAR OBJECT IS PRETTY SIMPLE TO CONSTRUCT — JUST FOLLOW THE USUAL RULES AND DON'T MIND THE DISTORTION.

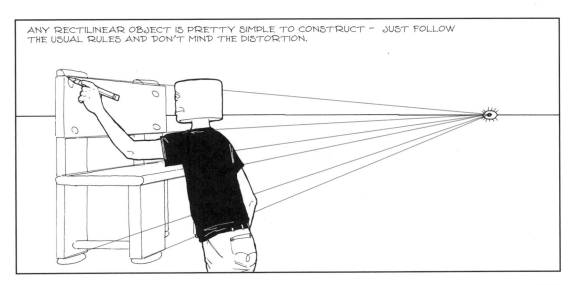

WHERE IT GETS TRICKY IS IN DRAWING AN OBJECT WITH A LOT OF COMPLICATED CURVES, NOT AMENABLE TO PERSPECTIVE CONSTRUCTION — SOMETHING LIKE, SAY, A FACE.

THE BEST WAY TO HANDLE AN IMAGE LIKE THAT IN ANAMORPHOSIS IS TO TREAT IT LIKE A FLAT PICTURE IN PERSPECTIVE.

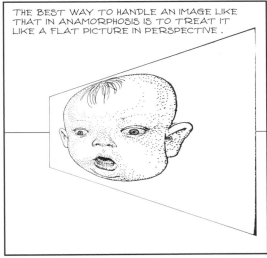

SO, FIRST DRAW YOUR SUBJECT AS YOU ORDINARILY WOULD, BUT ON GRAPH PAPER.

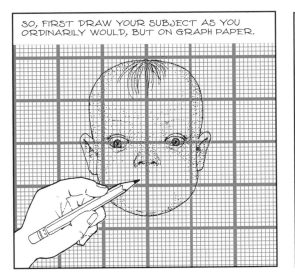

NEXT, ENCLOSE YOUR DRAWING WITHIN A PERFECTLY SQUARE OUTLINE. DON'T WORRY IF YOU WIND UP WITH EXTRA SPACE — STARTING WITH A SQUARE IMAGE MAKES CONSTRUCTION A LOT EASIER!

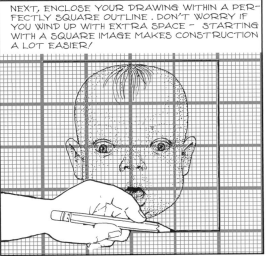

THERE'S NO GETTING AROUND THE NEXT STAGE – IF YOU WANT TO DO THIS RIGHT YOU HAVE TO DRAW A FLOORPLAN. ON IT, MARK YOUR STATION POINT, THE SPOT ON THE WALL WHERE THE CENTER OF YOUR ANAMORPHIC IMAGE WILL BE, AND YOUR CENTER OF VISION (THE POINT ON THE WALL CLOSEST TO YOU.)

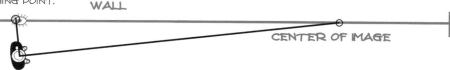

WALL

CENTER OF IMAGE

THE CENTER OF THE IMAGE IS ALSO THE RIGHT VANISHING POINT. ANAMORPHOSIS CAN BE CONSIDERED A KIND OF TWO POINT PERSPECTIVE WHERE YOU HAPPEN TO BE LOOKING DIRECTLY AT ONE OF THE VANISHING POINTS.)

DRAW A LINE FROM THE CENTER OF THE IMAGE BACK TO THE STATION POINT AND ANOTHER LINE AT 90° FROM THE STATION POINT BACK TO THE WALL, AND MARK THE INTERSECTION AS THE LEFT VANISHING POINT.

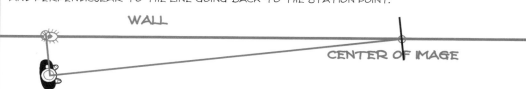

WALL

CENTER OF IMAGE

FIGURE OUT ROUGHLY HOW BIG YOUR IMAGE WILL BE ON THE WALL, THEN DRAW A LINE REPRESENTING ITS WIDTH, CENTERED ON THE RIGHT VANISHING POINT AND PERPENDICULAR TO THE LINE GOING BACK TO THE STATION POINT.

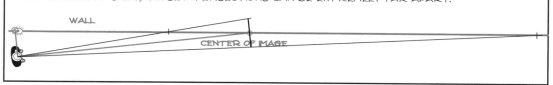

WALL

CENTER OF IMAGE

DRAW LINES BACK FROM THE EDGES OF THAT LINE BACK TO THE STATION POINT AND MARK WHERE THEY INTERSECT THE WALL. DEPENDING ON YOUR DISTANCE FROM THE WALL AND YOUR ANGLE OF SIGHT, THOSE INTERSECTIONS CAN BE EXTREMELY FAR APART.

WALL

CENTER OF IMAGE

NOW YOU ARE FACING THE WALL. TRANSFER ALL THE MARKS YOU HAVE JUST MADE ON THE LINE REPRESENTING THE WALL IN YOUR FLOORPLAN TO THE HORIZON.

EXTEND THE THREE MARKS AT RIGHT INTO VERTICAL LINES, MAKING THE LINE IN THE MIDDLE EXACTLY THE HEIGHT OF YOUR SQUARE DRAWING, HALF ABOVE AND HALF BELOW THE HORIZON.

DRAW LINES EXTENDING FROM THE LEFT VANISHING POINT, TOUCHING THE TOP AND BOTTOM OF THE MIDDLE LINE AND CONTINUING TO THE LINE AT FAR RIGHT.

HEAVY UP THE LINES AND YOU'VE GOT YOUR SQUARE.

DIVIDE IT UP INTO SMALLER SQUARES USING THE X METHOD....

AND YOU CAN TRANSFER YOUR DRAWING, SQUARE BY SQUARE.

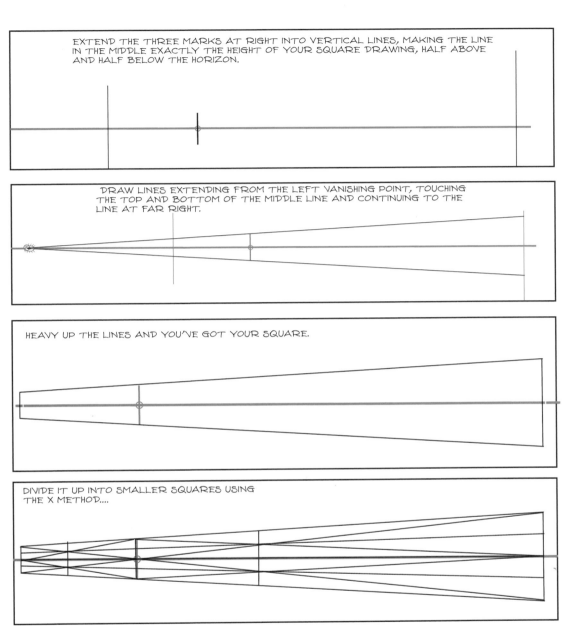

IF YOU WANT TO VIEW YOUR IMAGE OBLIQUELY, YOU CAN ROTATE IT ABOVE OR BELOW THE HORIZON, PIVOTING ON THE CENTER OF VISION.

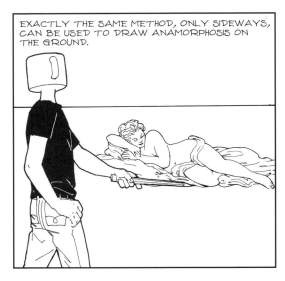

EXACTLY THE SAME METHOD, ONLY SIDEWAYS, CAN BE USED TO DRAW ANAMORPHOSIS ON THE GROUND.

SINCE THE SCALE IS SO LARGE ON A WALL MURAL OR PAVEMENT DRAWING, YOU'LL PROBABLY WANT TO WORK THE WHOLE THING OUT ON PAPER BEFOREHAND, AND THEN SCALE IT UP.

WAIT A MINUTE— DOES AN ANAMORPHIC PICTURE HAVE TO BE PAINTED ON A WALL? WHY NOT DO A SMALL ONE THAT CAN FIT IN A BOOK?

THAT WON'T REALLY WORK, MUGG.

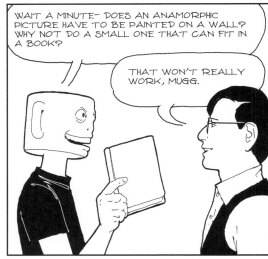

BECAUSE OF THE NARROW FOCUSING POWER OF YOUR EYE, IT'S HARD TO KEEP AN IMAGE ENTIRELY IN FOCUS WHEN IT'S CLOSE UP, AND PAPER IN A BOOK WON'T RELIABLY LIE FLAT, WHICH YOU NEED FOR THE ILLUSION TO WORK.

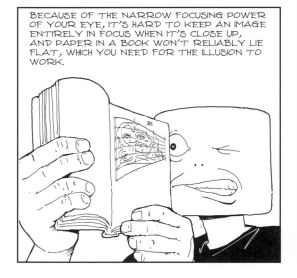

HOWEVER, YOU CAN DRAW AN ANAMORPHIC IMAGE SMALL ENOUGH TO FIT IN A BOOK, PROVIDED YOU SET THINGS UP SO IT CAN BE VIEWED FROM FAR ENOUGH AWAY.

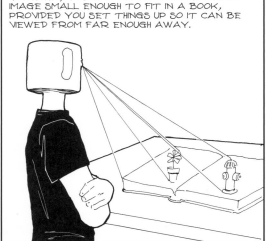

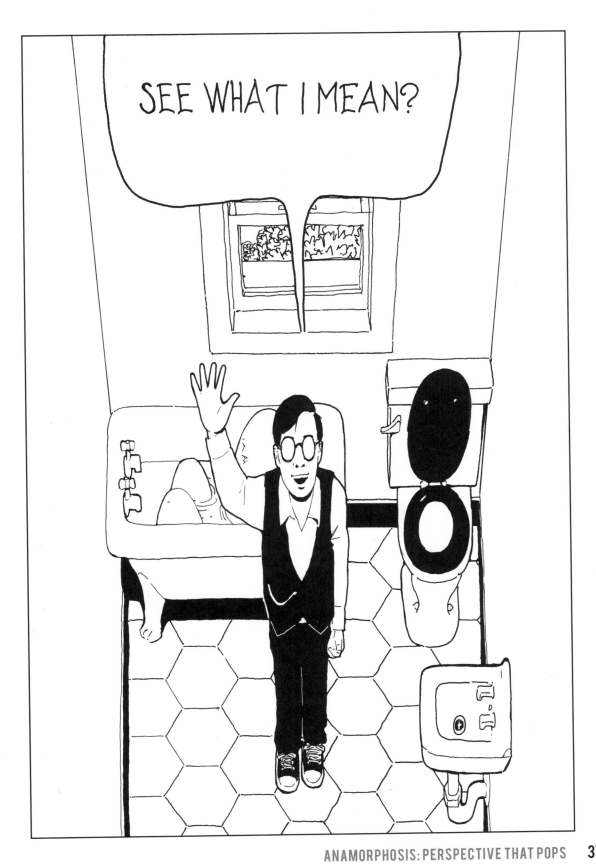

THIS DOESN'T SEEM LIKE SOMETHING THAT HAS MUCH TO DO WITH COMICS.

MAYBE NOT, BUT ISN'T IT COOL TO KNOW ABOUT?

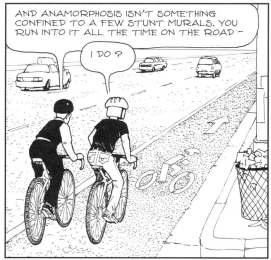

AND ANAMORPHOSIS ISN'T SOMETHING CONFINED TO A FEW STUNT MURALS. YOU RUN INTO IT ALL THE TIME ON THE ROAD –

I DO?

YOU'D BE SURPRISED.

ALSO, SOME OF THE CONCEPTS BEHIND ANAMORPHOSIS WILL BE HELP US BETTER UNDERSTAND THE SUBJECT OF THE NEXT CHAPTER.

WHICH IS –?

CHAPTER 3
Shadows and Light

Shadows not only have perspective, shadows ARE perspective. Both shadow casting and perspective involve projection from a central point (even if that point is infinitely distant), and the geometry in both is identical. In this chapter I explain the differences between shadows from point and distant light sources, and provide methods for drawing parabolas and hyperbolas, curved lines that allow you to accurately draw the circular shadows cast by a lampshade on a wall. These curves also come in handy in perspective when you need to draw characters inside circular spaces, such as riding a merry-go-round or escaping from a well.

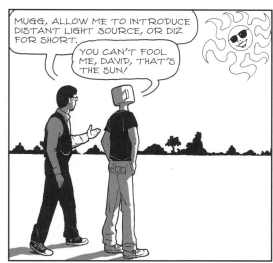

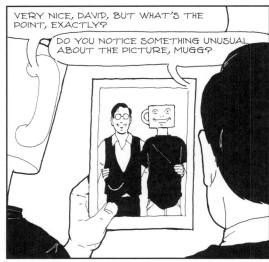

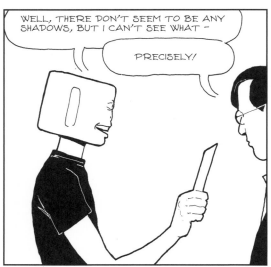

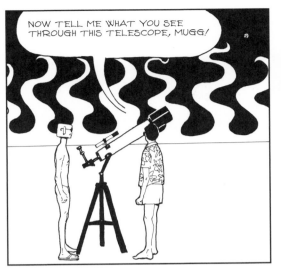

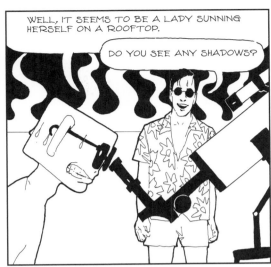

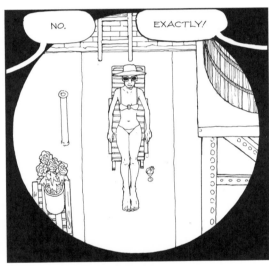

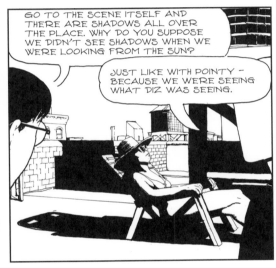

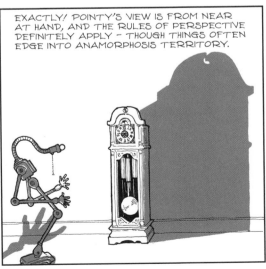

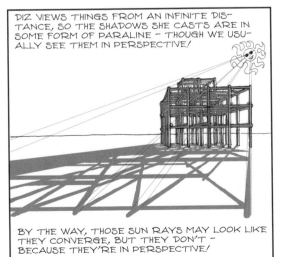

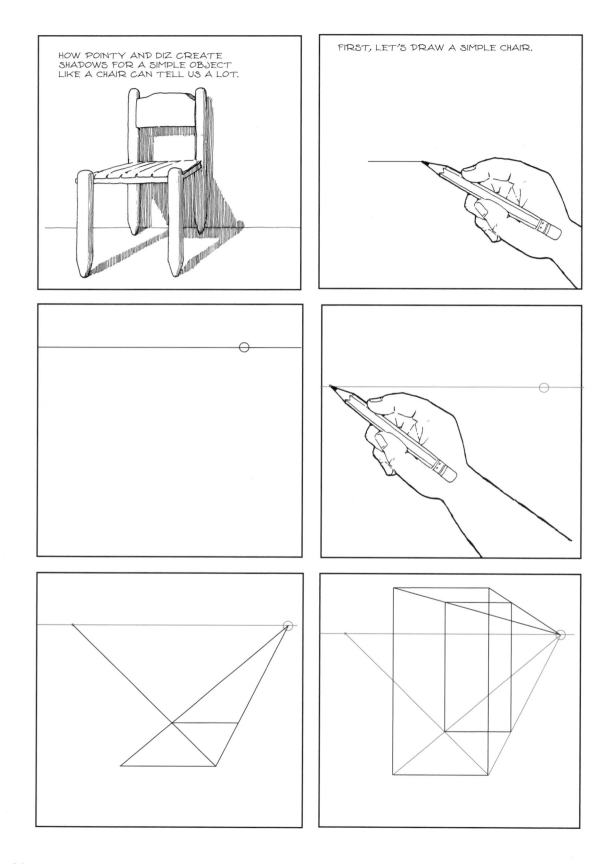

HOW POINTY AND DIZ CREATE SHADOWS FOR A SIMPLE OBJECT LIKE A CHAIR CAN TELL US A LOT.

FIRST, LET'S DRAW A SIMPLE CHAIR.

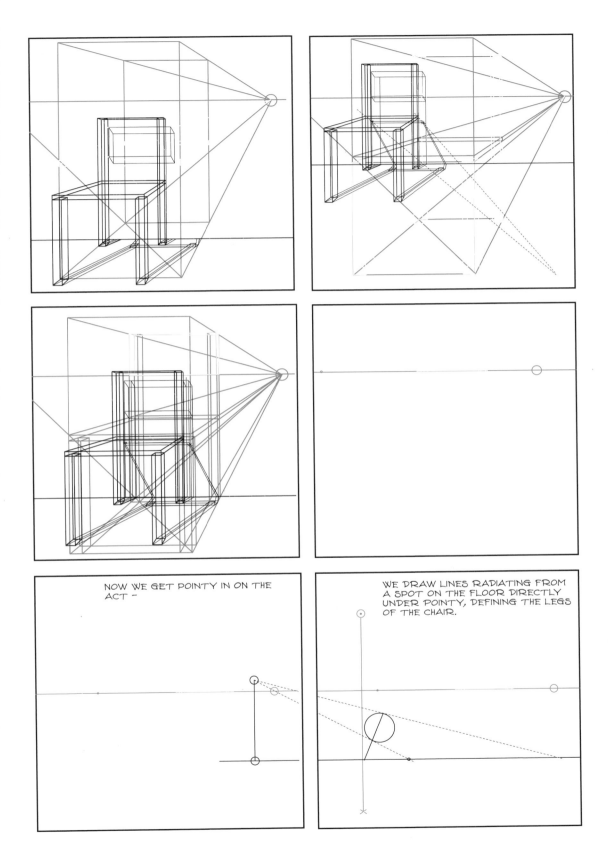

NOW WE GET POINTY IN ON THE ACT —

WE DRAW LINES RADIATING FROM A SPOT ON THE FLOOR DIRECTLY UNDER POINTY, DEFINING THE LEGS OF THE CHAIR.

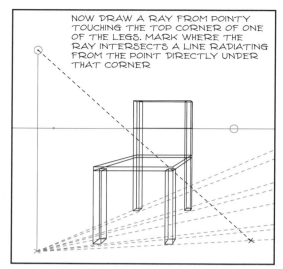

NOW DRAW A RAY FROM POINTY TOUCHING THE TOP CORNER OF ONE OF THE LEGS. MARK WHERE THE RAY INTERSECTS A LINE RADIATING FROM THE POINT DIRECTLY UNDER THAT CORNER

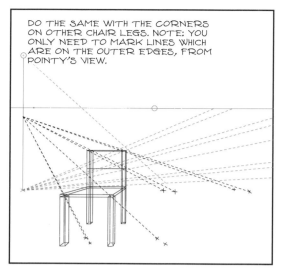

DO THE SAME WITH THE CORNERS ON OTHER CHAIR LEGS. NOTE: YOU ONLY NEED TO MARK LINES WHICH ARE ON THE OUTER EDGES, FROM POINTY'S VIEW.

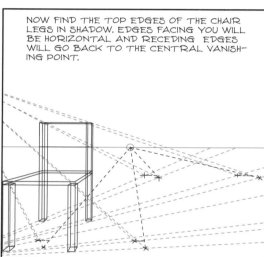

NOW FIND THE TOP EDGES OF THE CHAIR LEGS IN SHADOW. EDGES FACING YOU WILL BE HORIZONTAL AND RECEDING EDGES WILL GO BACK TO THE CENTRAL VANISHING POINT.

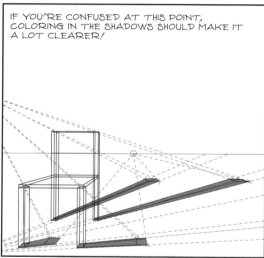

IF YOU'RE CONFUSED AT THIS POINT, COLORING IN THE SHADOWS SHOULD MAKE IT A LOT CLEARER!

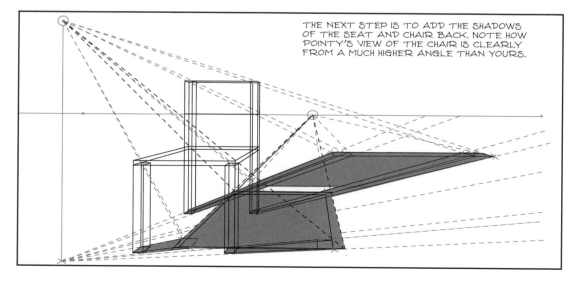

THE NEXT STEP IS TO ADD THE SHADOWS OF THE SEAT AND CHAIR BACK. NOTE HOW POINTY'S VIEW OF THE CHAIR IS CLEARLY FROM A MUCH HIGHER ANGLE THAN YOURS.

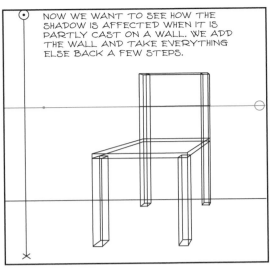

NOW WE WANT TO SEE HOW THE SHADOW IS AFFECTED WHEN IT IS PARTLY CAST ON A WALL. WE ADD THE WALL AND TAKE EVERYTHING ELSE BACK A FEW STEPS.

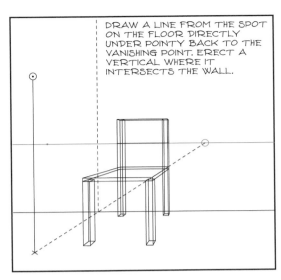

DRAW A LINE FROM THE SPOT ON THE FLOOR DIRECTLY UNDER POINTY BACK TO THE VANISHING POINT. ERECT A VERTICAL WHERE IT INTERSECTS THE WALL.

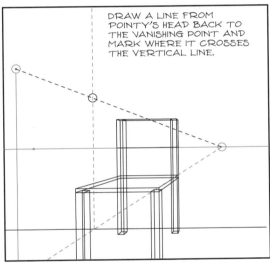

DRAW A LINE FROM POINTY'S HEAD BACK TO THE VANISHING POINT AND MARK WHERE IT CROSSES THE VERTICAL LINE.

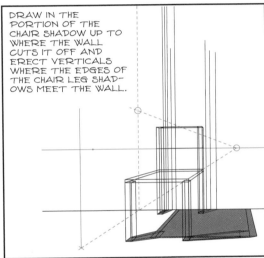

DRAW IN THE PORTION OF THE CHAIR SHADOW UP TO WHERE THE WALL CUTS IT OFF AND ERECT VERTICALS WHERE THE EDGES OF THE CHAIR LEG SHADOWS MEET THE WALL.

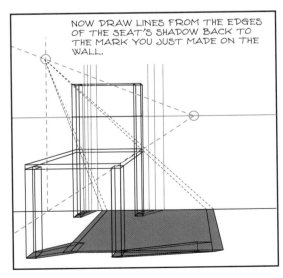

NOW DRAW LINES FROM THE EDGES OF THE SEAT'S SHADOW BACK TO THE MARK YOU JUST MADE ON THE WALL.

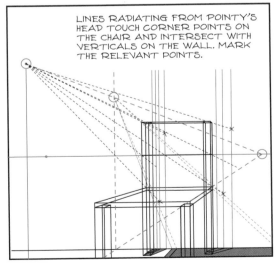

LINES RADIATING FROM POINTY'S HEAD TOUCH CORNER POINTS ON THE CHAIR AND INTERSECT WITH VERTICALS ON THE WALL. MARK THE RELEVANT POINTS.

VERTICAL AND HORIZONTAL LINES ON THE SHADOW REMAIN VERTICAL AND HORIZONTAL. RECEDING LINES GO TO THE MARK ON THE WALL. ONCE YOU HAVE ALL THE LINES DRAWN IN, COLOR IN THE SHADOW OF THE CHAIR BACK AND SEAT.

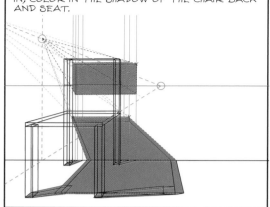

OH, AND DON'T FORGET TO COLOR IN THE LEGS AS WELL!

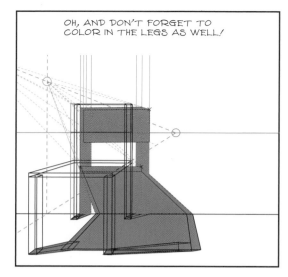

ONCE YOU HAVE THE ROUGH COMPLETED, YOU CAN ERASE CONSTRUCTION LINES AND DO YOUR FINAL DRAWING. REMEMBER, ANY MODIFICATIONS YOU MAKE IN THE SHAPE OF THE CHAIR SHOULD SHOW UP IN THE SHADOW AS WELL.

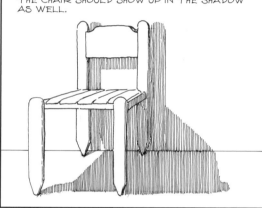

NOW WE EXPLORE HOW DIZ HANDLES THE SAME SUBJECT –

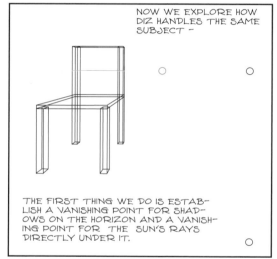

THE FIRST THING WE DO IS ESTABLISH A VANISHING POINT FOR SHADOWS ON THE HORIZON AND A VANISHING POINT FOR THE SUN'S RAYS DIRECTLY UNDER IT.

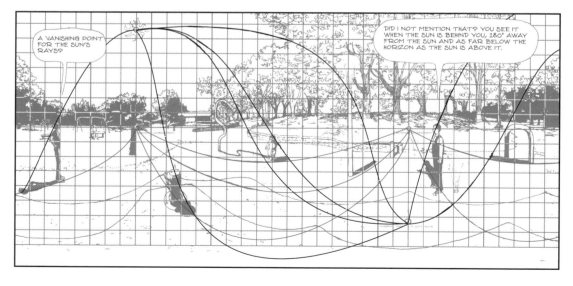

A VANISHING POINT FOR THE SUN'S RAYS?

DID I NOT MENTION THAT? YOU SEE IT WHEN THE SUN IS BEHIND YOU, 180° AWAY FROM THE SUN AND AS FAR BELOW THE HORIZON AS THE SUN IS ABOVE IT.

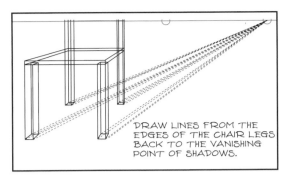

DRAW LINES FROM THE EDGES OF THE CHAIR LEGS BACK TO THE VANISHING POINT OF SHADOWS.

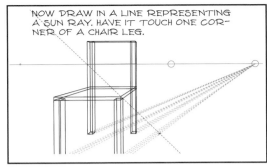

NOW DRAW IN A LINE REPRESENTING A SUN RAY. HAVE IT TOUCH ONE CORNER OF A CHAIR LEG.

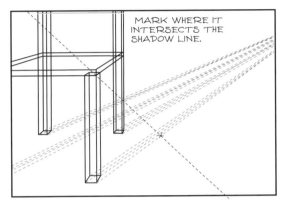

MARK WHERE IT INTERSECTS THE SHADOW LINE.

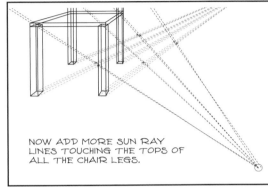

NOW ADD MORE SUN RAY LINES TOUCHING THE TOPS OF ALL THE CHAIR LEGS.

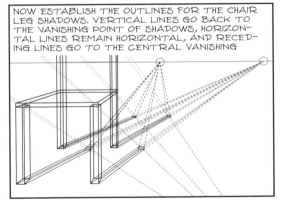

NOW ESTABLISH THE OUTLINES FOR THE CHAIR LEG SHADOWS. VERTICAL LINES GO BACK TO THE VANISHING POINT OF SHADOWS, HORIZONTAL LINES REMAIN HORIZONTAL, AND RECEDING LINES GO TO THE CENTRAL VANISHING

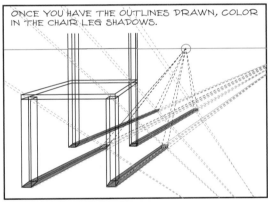

ONCE YOU HAVE THE OUTLINES DRAWN, COLOR IN THE CHAIR LEG SHADOWS.

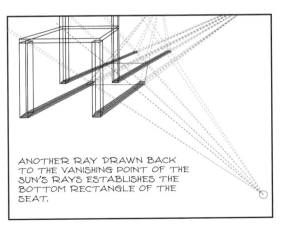

ANOTHER RAY DRAWN BACK TO THE VANISHING POINT OF THE SUN'S RAYS ESTABLISHES THE BOTTOM RECTANGLE OF THE SEAT.

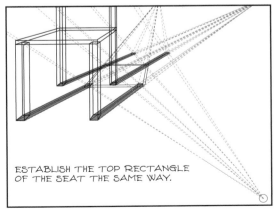

ESTABLISH THE TOP RECTANGLE OF THE SEAT THE SAME WAY.

ONCE YOU'VE COLORED IN THE SHADOW OF THE SEAT, ESTABLISH THE BOTTOM EDGE OF THE CHAIR BACK WITH ANOTHER SUN RAY.

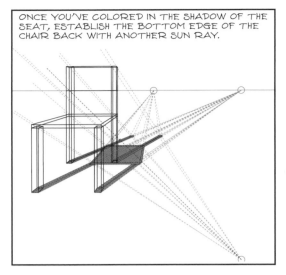

COMPLETE THE SEAT BACK BY DRAWING LINES BACK TO THE CENTRAL VANISHING POINT.

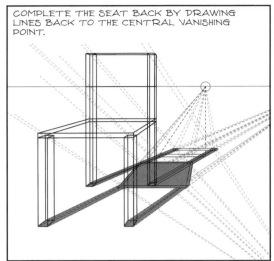

AND NOW YOU CAN COLOR IN THE REST OF THE SHADOW.

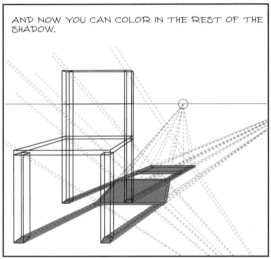

NOW WE ADD IN THE WALL, ONCE AGAIN CUTTING OFF THE SHADOW WHERE IT BEGINS.

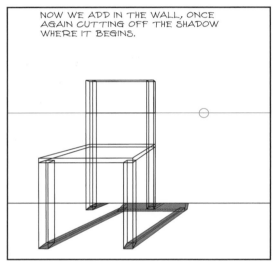

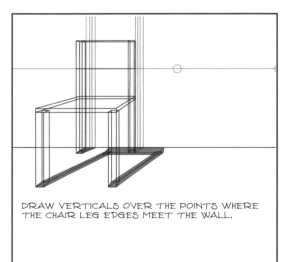

DRAW VERTICALS OVER THE POINTS WHERE THE CHAIR LEG EDGES MEET THE WALL.

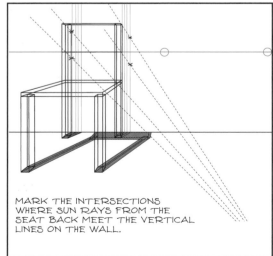

MARK THE INTERSECTIONS WHERE SUN RAYS FROM THE SEAT BACK MEET THE VERTICAL LINES ON THE WALL.

DRAW THE SEAT BACK SHADOW IN AND COLOR IT.

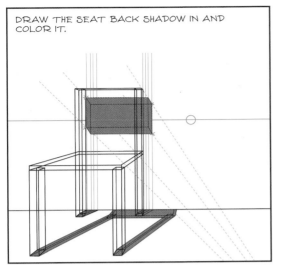

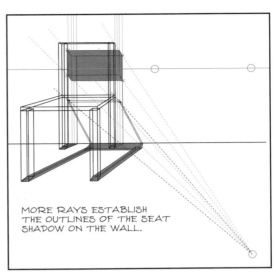

MORE RAYS ESTABLISH THE OUTLINES OF THE SEAT SHADOW ON THE WALL.

AND NOW YOU CAN COLOR IN THE ENTIRE SHADOW.

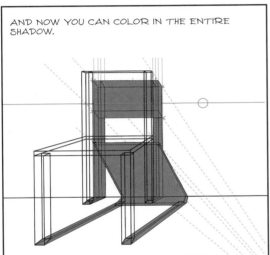

WITH A LITTLE TWEAKING, THERE'S YOUR FINAL DRAWING!

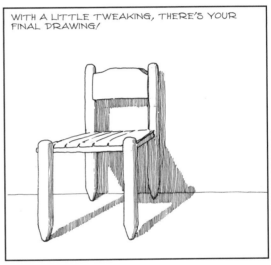

NOW LET'S COMPARE HOW POINTY AND DIZ SHADOW ANOTHER COMMON OBJECT.

WE START BY DRAWING AN ELEVATION. DRAW YOUR BALL WHEREVER IT'S GOING TO BE, PLACE POINTY, AND MARK A SPOT ON THE FLOOR DIRECTLY UNDER HIM, AS WELL AS TWO SPOTS WHERE RAYS FROM POINTY'S HEAD TANGENT WITH THE BALL'S EDGES INTERSECT THE FLOOR.

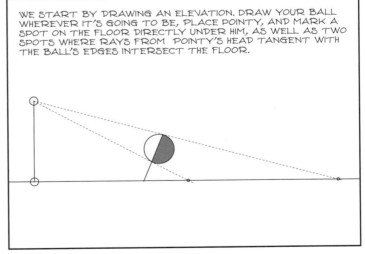

WE ADD TWO MORE LINES — ONE RUNNING THROUGH THE MIDDLE OF THE BALL AND THE OTHER EXACTLY AT RIGHT ANGLES TO IT, AND MARK WHERE THEY INTERSECT THE FLOOR..

AND WE MARK ONE MORE POINT. WE MEASURE THE DISTANCE FROM THE REAR-MOST MARK TO POINTY'S HEAD AND THEN MARK A SPOT THAT SAME DISTANCE FORWARD ON THE FLOOR. WHY? IT WILL ALL BECOME CLEAR PRESENTLY.

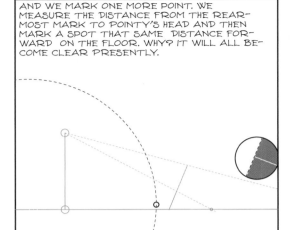

POINTY'S VIEW OF THE BALL COULDN'T BE SIMPLER, BUT OBVIOUSLY IT WILL BE DISTORTED INTO AN ELLIPSE WHEN IT'S CAST ON THE FLOOR. TO START WITH WE ENCLOSE THE CIRCULAR OUTLINE OF THE BALL WITHIN A SQUARE.

NOW WE DRAW A FLOORPLAN — FIRST TRANSFER ALL THE MARKINGS FROM THE FLOOR TO A CENTRAL LINE.

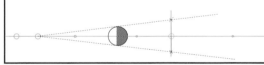

ADD THE SILHOUETTE OF THE BALL AND DRAW RAYS FROM POINTY'S HEAD TANGENT WITH IT. DRAW A VERTICAL LINE THROUGH THE MARK WHERE THE LINE THROUGH THE MIDDLE OF THE BALL INTERSECTED THE FLOOR, AND THEN MARK WHERE THAT LINE INTERSECTS THE RAYS.

THAT MARK BEHIND POINTY'S HEAD BECOMES THE VANISHING POINT FOR THE SQUARE SURROUNDING THE BALL'S SHADOW. DRAW LINES FROM THAT VANISHING POINT THROUGH THE TWO MARKS YOU HAVE JUST MADE — THESE GIVE YOU THE TOP AND BOTTOM EDGES OF THE SQUARE. THE SIDES OF THE SQUARE ARE VERTICAL LINES PASSING THROUGH THE MARKS WHERE RAYS TANGENT WITH THE BALL INTERSECTED THE FLOOR.

WE ADD TWO MORE MARKS THAT WILL COME IN HANDY LATER WHEN WE PUT THE SCENE IN PERSPECTIVE. REMEMBER A PAGE AGO WHEN WE MARKED A SPOT ON THE FLOOR THE SAME DISTANCE FROM THE LEFT VANISHING POINT AS POINTY'S HEAD.

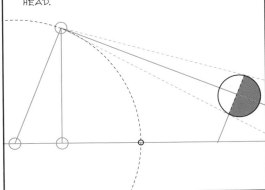

DRAW TWO LINES AT 45° FROM THAT MARK, AND THEN MARK WHERE THEY INTERSECT A VERTICAL LINE PASSING THROUGH THE LEFT VANISHING POINT.

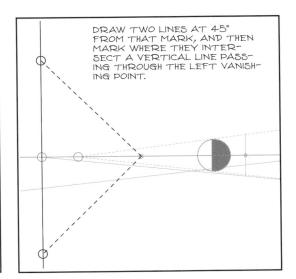

THOSE TWO MARKS ARE DIAGONAL VANISHING POINTS FOR THE SQUARE.

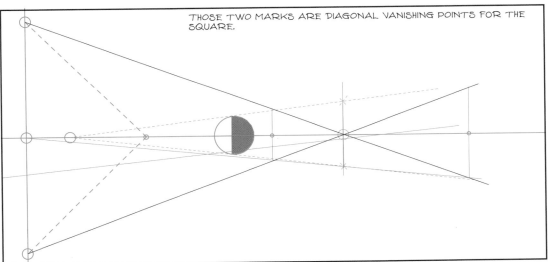

IT SHOULD BE A SIMPLE MATTER NOW TO DIVIDE THE SQUARE UP 4X4 AND THEN USE THE TWELVE POINT METHOD TO DRAW A TWELVE - SIDED POLYGON WHICH CAN BE SMOOTHED INTO AN ELLIPTICAL SHADOW.

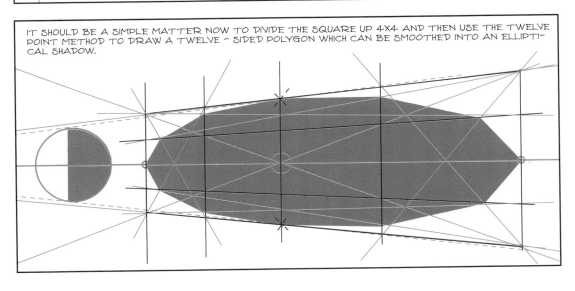

AND HERE IS THE SCENE IN PERSPECTIVE. WE'VE BASICALLY JUST TAKEN THE ELEVATION AND FATTENED IT INTO DEPTH BY EXTENDING LINES FORWARD AND BACK USING THE CENTRAL AND DIAGONAL VANISHING POINTS.

I HAVE MADE ONE COMPROMISE WITH STRICT PERSPECTIVE CONSTRUCTION. SINCE THE BALL IS SO FAR OFF - CENTER, IT REALLY SHOULD APPEAR AS AN ELLIPSE WITH ITS LONG AXIS POINTING AT THE CENTER OF VISION. YOU'D GET THAT IF YOU CONSTRUCTED IT PROPERLY INSIDE A BOX, BUT A CIRCLE IS SIMPLER TO DRAW AND LOOKS MORE LIKE WHAT YOU EXPECT TO SEE.

AND HERE'S THE WHOLE THING ROTATED 45°. BY THE WAY, IF YOU ERECT A PYRAMID OVER THAT TRIANGLE ON THE GROUND, WITH ITS APEX AT POINTY'S HEAD, ALL THE CORNERS WILL MEET AT 90°

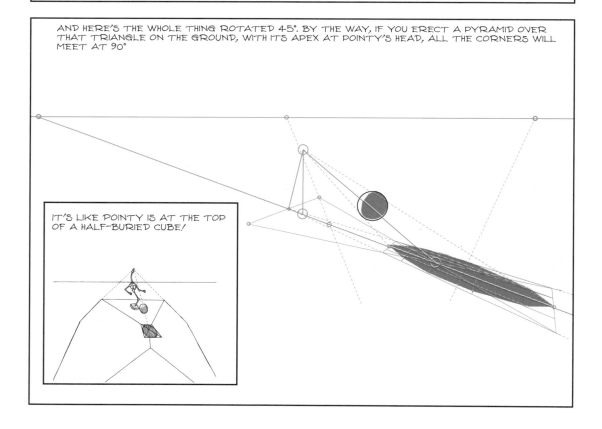

IT'S LIKE POINTY IS AT THE TOP OF A HALF-BURIED CUBE!

DIZ'S APPROACH TO THE SAME SUBJECT IS SIMPLER TO DIAGRAM. HERE IT IS IN ELEVATION. ALL RAYS ARE PARALLEL – THE RECTANGLE THAT DEFINES THE SHADOW HAS AS ITS LENGTH THE DISTANCE BETWEEN RAYS TOUCHING THE TOP AND BOTTOM OF THE BALL, AND ITS WIDTH IS THE SAME AS THE BALL'S DIAMETER...

AS YOU CAN EASILY SEE FROM LOOKING AT THE SAME DIAGRAM IN PLAN.

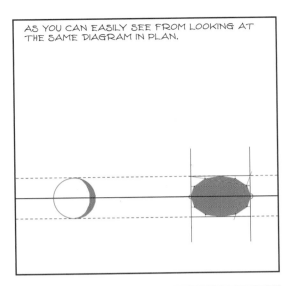

AND HERE IS THE SAME SCENE IN PERSPECTIVE. REALLY, THE ONLY TRICKY PART IS GETTING THE WIDTH RIGHT. BUT THAT PROBLEM CAN BE SOLVED BY BUILDING A SQUARE IN PERSPECTIVE WITH SIDES THE LENGTH OF THE BALL'S DIAMETER, THEN CARRYING THE LINES OVER.

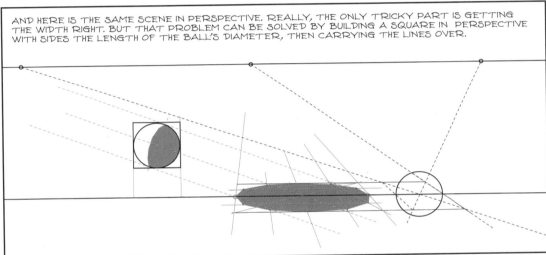

AND HERE IS THE SCENE ROTATED 45°. YOU CAN SEE THE RAYS NOW MEET AT DIZ, WHO IS ABOVE THE HORIZON DIRECTLY OVER THE LEFT VANISHING POINT.

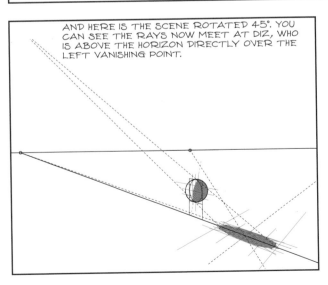

FOR A MORE COMPLEX OBJECT LIKE A HUMAN FIGURE, START BY IMAGINING WHAT THE FIGURE WOULD LOOK LIKE FROM POINTY'S VIEWPOINT.

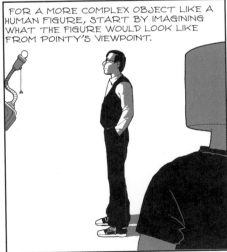

THEN DRAW A SILHOUETTE, TAKING CARE TO ENCLOSE YOUR FIGURE IN A SQUARE.

AS IN DRAWING THE SHADOW OF THE SPHERE, YOU FIRST DISTORT THE SILHOUETTE BY CASTING IT ON THE FLOOR, THEN DISTORT THAT IMAGE BY PUTTING IT IN PERSPECTIVE.

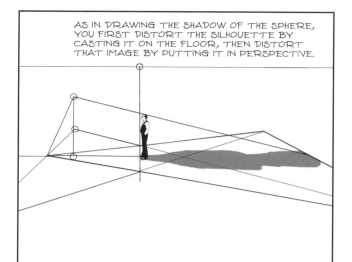

DIZ'S VIEW OF THE SAME FIGURE DIFFERS FROM POINTY'S IN LACKING ALL PERSPECTIVE TAPER.

AS YOU GET A FEEL FOR DRAWING SHADOWS, YOU CAN SIMPLIFY YOUR CONSTRUCTION. IN MOST CASES THE DIRECTION A SHADOW IS CAST AND HOW LONG IT IS ARE REALLY ALL THAT MATTER, AND ONE LINE FROM THE LIGHT SOURCE TOUCHING THE TOP OF AN OBJECT AND EXTENDING TO THE WALL OR FLOOR IS ENOUGH TO DETERMINE THAT. IF THE SILHOUETTE ISN'T EXACTLY ACCURATE, WHO'S TO SAY?

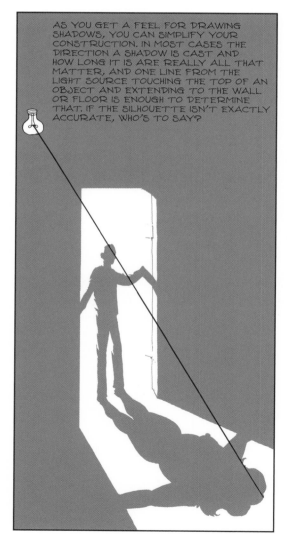

AND HERE'S HOW IT LOOKS IN PERSPECTIVE.

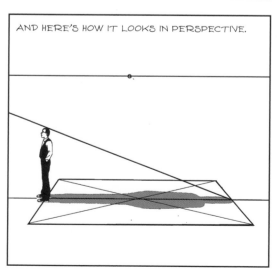

SO DOES THAT DO IT FOR SHADOWS, DAVID?

NOT QUITE, MUGG. IT'S TIME FOR YOU TO PUT ON YOUR PARTY HAT, POINTY.

OBSERVE.

I SEE...

TO UNDERSTAND THE SHAPE OF THE SHADOW A ROUND LAMPSHADE CASTS ON THE WALL, IT IS HELPFUL TO CONSIDER THE SHADOW CAST BY A SQUARED-OFF LAMPSHADE.

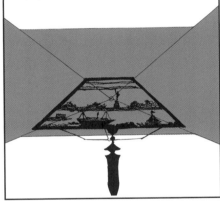

THAT SHAPE WILL EITHER BE A SQUARE OR A SQUARE IN PERSPECTIVE – A TRAPEZOID OR A TRAPEZOIDAL OPEN-ENDED SHAPE THAT GOES ON FOREVER.

A ROUND LAMPSHADE WILL CAST THE SHADOW OF A CIRCLE INSCRIBED IN THAT SQUARE – A CIRCLE, AN ELLIPSE, OR ONE OF THE OPEN-ENDED CURVES THAT ARE KNOWN AS CONIC SECTIONS.

THE SHAPE OF THE SHADOW YOU SEE WHEN THE SHADE IS STRAIGHT AND PARALLEL TO THE WALL IS A HYPERBOLA, THE CURVE CREATED BY CUTTING A CONE AT AN ANGLE STEEPER THAN ONE OF ITS SIDES.

IF YOU CHANGE THE ANGLE OF THE SHADE OR THE WALL SO THAT THE WALL IS PARALLEL WITH ONE SIDE OF THE CONE, YOU GET ANOTHER CONIC SECTION CALLED A PARABOLA.

IF THE WALL ENTIRELY CUTS THE CONE OF LIGHT, YOU GET –

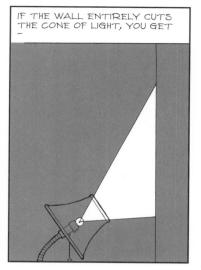

AN ELLIPSE.

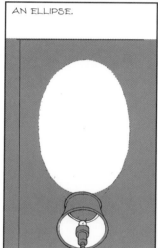

AND IF THE SURFACE THE SHADOW IS CAST ON EXACTLY FACES THE CIRCULAR OPENING OF THE SHADE YOU GET –

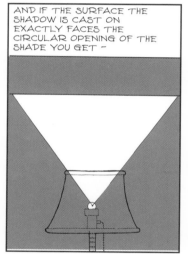

A CIRCLE –

ALL RIGHT, DAVID, I KNOW HOW TO DRAW AN ELLIPSE. HOW DO I DRAW A PARABOLA AND A HYPERBOLA?

A PARABOLA IS PRETTY SIMPLE. IT CAN BE DEFINED AS THE SET OF ALL POINTS IN A PLANE SUCH THAT THE DISTANCE OF EACH POINT FROM A FIXED POINT IS THE SAME AS ITS DISTANCE FROM A FIXED LINE.

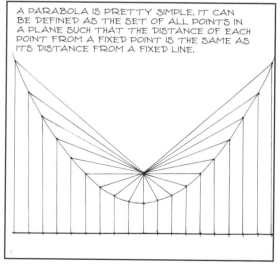

AND HERE'S ANOTHER WAY, ONCE AGAIN BASED ON THAT DEPENDABLE TWELVE POINT METHOD OF DRAWING AN ELLIPSE. THINK OF THE CUT IN THE CONE AS A RECTANGULAR SHEET OF PAPER ON WHICH YOU ARE GOING TO DRAW THE IMAGE OF THE SHADE'S CIRCULAR OPENING. BUT BECAUSE THE SHEET IS PARALLEL TO ONE SIDE OF THE CONE, YOU CAN NEVER FIT THE WHOLE CIRCLE ON THE PAGE.

HERE'S THE PERSPECTIVE SQUARE YOU WANT TO DRAW THE CIRCLE IN — BUT YOU CAN'T DRAW THE WHOLE CIRCLE BECAUSE THE TOP EDGE OF THE SQUARE SITS AT INFINITY — OFF THE PAGE.

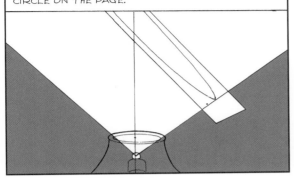

HOW CAN YOU DRAW A PARTIAL SQUARE AND KNOW THAT ITS TOP EDGE SITS EXACTLY AT INFINITY? SIMPLE. START BY DRAWING A SHORT HORIZONTAL BOTTOM LINE AND TWO SIDES CONVERGING TO A POINT.

DIVIDE UP YOUR BOTTOM LINE INTO FOUR SECTIONS AND DRAW LINES UP FROM THE VANISHING POINT.

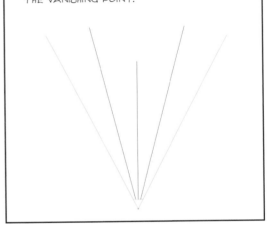

NOW STARTING AT THE BOTTOM LEFT CORNER, DRAW IN ONE OF THE SQUARE'S DIAGONALS. BECAUSE IT CROSSES THE RIGHT EDGE ONLY AT INFINITY, DRAW IT PARALLEL TO THAT LINE SO THAT THEY CAN NEVER MEET ON THE PAGE.

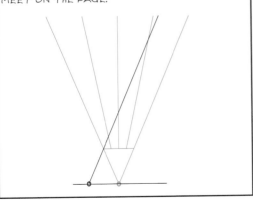

WHERE THE DIAGONAL CROSSES THE RECEDING LINES, DRAW IN HORIZONTAL LINES CUTTING ACROSS TO MAKE SMALLER SQUARES.

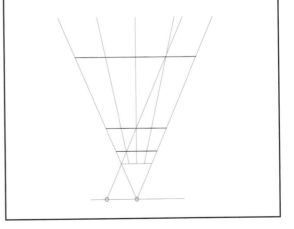

NOW YOU CAN USE THAT DIAGONAL LINE METHOD...

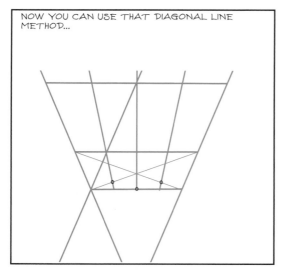

...TO FIND TWO POINTS FOR THE PERSPECTIVE CIRCLE ON THE LINES NEAR THE BOTTOM. DRAW ONE MORE POINT WHERE THE MIDLINE MEETS THE BOTTOM LINE.

LINK THOSE THREE POINTS WITH A CURVED LINE.

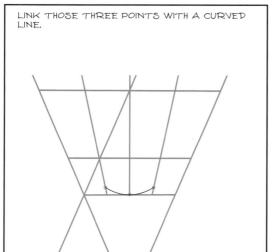

YOUR NEXT STEP IS DRAWING AN X ON THE LEFT ROW OF SQUARES. BECAUSE THE CORNERS AT THE TOP ARE OFF THE PAGE, MARK THE POINT WHERE THE TWO DIAGONALS CROSS ON THE MIDDLE HORIZONTAL LINE – IT'S HALFWAY BETWEEN THE LEFT EDGE AND THE NEXT LINE OVER. DRAW IN POINTS WHERE THE X CROSSES THE SECOND AND FOURTH HORIZONTAL LINES AND ADD ANOTHER POINT WHERE THE LEFT EDGE MEETS THE MIDDLE LINE.

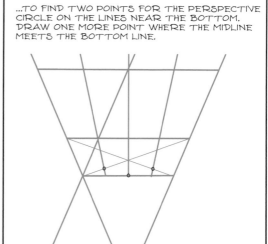

LINK THE POINTS YOU'VE DRAWN SO FAR. IT'S STARTING TO LOOK LIKE A PARABOLA!

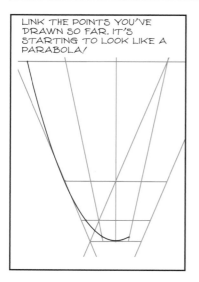

YOU CAN FIND ONE MORE POINT ON THE PARABOLA – BECAUSE THE TWO POINTS NEAREST A CORNER ARE DIAGONALLY ACROSS FROM EACH OTHER, A LINE FROM THE DIAGONAL VANISHING POINT PASSING THROUGH THE LEFT POINT ON THE FOURTH HORIZONTAL LINE WILL LOCATE ANOTHER POINT WHERE IT CROSSES THE SECOND RECEDING LINE FROM THE LEFT.

YOU CAN NEVER REACH THE LAST POINT OF THE CIRCLE, WHICH IS AT INFINITY, SO YOUR CURVE TRAILS OFF INTO A VERTICAL LINE THAT GOES ON FOREVER.

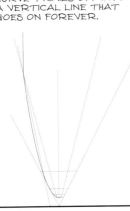

MIRROR YOUR WORK AND THE PARABOLA IS COMPLETE.

AND WHAT OF THE HYPERBOLA, DAVID? IS THERE A SIMPLE FORMULA TO DRAW THAT ONE?

IN A WORD, NO, MUGG.

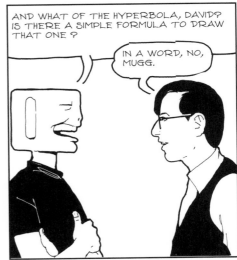

ALL RIGHT, FOR THE MATHEMATICALLY INCLINED, HERE IS THE DEFINITION OF A HYPERBOLA: TAKE TWO POINTS. (EACH ONE IS A FOCUS; TOGETHER, THEY ARE THE FOCI.) A HYPERBOLA IS THE SET OF ALL POINTS IN A PLANE THAT HAVE THE FOLLOWING PROPERTY: THE DISTANCE FROM THE POINT TO ONE FOCUS, MINUS THE DISTANCE FROM THE POINT TO THE OTHER FOCUS, IS SOME CONSTANT.

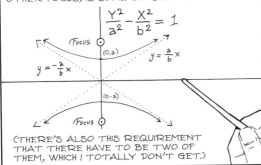

$$\frac{Y^2}{a^2} - \frac{X^2}{b^2} = 1$$

Focus $(0,a)$ $y = \frac{a}{b}x$

$y = -\frac{a}{b}x$

$(0,-a)$

Focus

(THERE'S ALSO THIS REQUIREMENT THAT THERE HAVE TO BE TWO OF THEM, WHICH I TOTALLY DON'T GET.)

FOR THE REST OF YOU, WE'LL JUST DO A VARIANT OF THE OLD TWELVE POINT METHOD, MINUS A FEW POINTS.

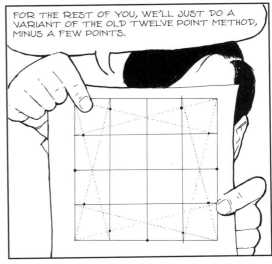

IF YOUR LAMPSHADE IS UPRIGHT AND PARALLEL TO THE WALL — WHICH IT IS USUALLY — THEN THE CENTER OF YOUR CIRCULAR SHADOW WILL BE AT INFINITY.

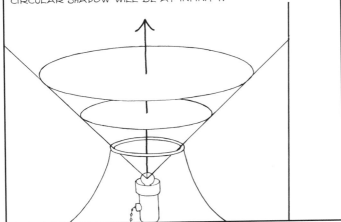

START BY DRAWING ANOTHER SQUARE WITH VERTICAL DIVISIONS IN PERSPECTIVE, JUST AS YOU DID FOR THE PARABOLA.

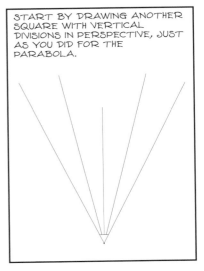

THE SQUARE YOU INSCRIBE THE HYPERBOLA IN HAS TO HAVE ITS CENTER AT INFINITY. HOW TO DRAW THIS? MAKE EACH OF THE LONG DIAGONALS A STRAIGHT VERTICAL. THOSE DIAGONALS ARE SUPPOSED TO CROSS AT THE CENTER OF THE SQUARE, BUT BECAUSE THEY'RE PARALLEL, THEY NEVER WILL.

WHERE THOSE DIAGONALS CROSS LINES GOING TO THE VANISHING POINT, DRAW IN A HORIZONTAL LINE TO DEFINE THE BOTTOM ROW OF LITTLE SQUARES.

MAKE AN X TO FIND TWO POINTS OF THE CIRCLE – THE BOTTOM MIDPOINT IS THE THIRD.

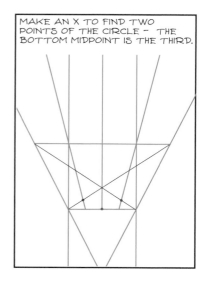

YOU CAN JOIN UP THE POINTS YOU HAVE WITH A SMOOTH CURVE, BUT IT SURE WOULD BE NICE TO BE ABLE TO PLOT A COUPLE MORE POINTS OF THE CIRCLE.

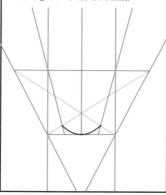

YOU CAN! THE TWO POINTS OF THE CIRCLE NEAREST THE CORNER HAPPEN TO BE IN A STRAIGHT 45° LINE FROM EACH OTHER.

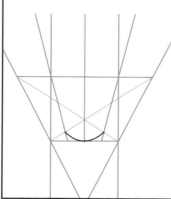

A LINE FROM THE RIGHT DIAGONAL VANISHING POINT DRAWN THROUGH THE LEFT-MOST POINT ON YOUR CURVE WILL GIVE YOU ANOTHER POINT WHERE IT CROSSES THE NEXT HORIZONTAL LINE UP.

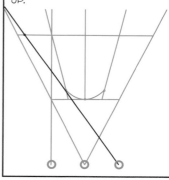

LINK THE POINTS YOU HAVE SO FAR WITH A SMOOTH CURVE.

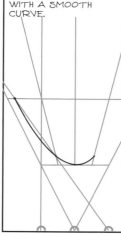

THE POINT WHERE THE CIRCLE TOUCHES THE LEFT EDGE IS OFF THE PAGE AT IN-FINITY. CONTINUE THE CURVE INTO A STRAIGHT LINE PARALLEL TO THE LEFT EDGE OF THE SQUARE, TRAILING OFF FOREVER.

MIRROR YOUR WORK AND THE HYPERBOLA IS COMPLETE!

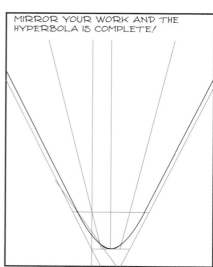

IF YOU'RE LOOKING AT POINTY DIRECTLY, THE VANISHING POINT FOR THAT PERSPECTIVE SQUARE WILL BE AT HIS HEAD.

IN PERSPECTIVE, THE VANISHING POINT WILL BE A SPOT ON THE WALL CLOSEST TO POINTY'S HEAD.

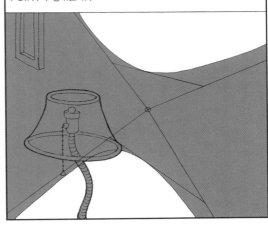

AND IF THE SHADE IS OPEN AT THE BOTTOM, THERE WILL BE AN UPSIDE DOWN HYPERBOLA ON THE WALL BELOW.

INCIDENTALLY, YOU ALSO SEE A HYPERBOLA ANY TIME YOU SHARPEN A PENCIL WITH STRAIGHT SIDES!

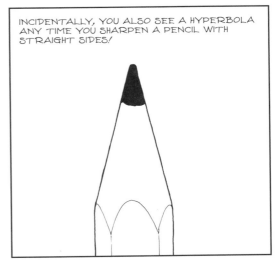

THAT ALMOST WINDS IT UP FOR SHADOWS, BUT THERE ARE A FEW MORE POINTS I SIMPLY MUST MENTION. THAT VANISHING POINT FOR THE SUN'S RAYS? IF YOU'RE IN THE SCENE, IT'S IN THE SHADOW OF YOUR HEAD.

WHERE ELSE?

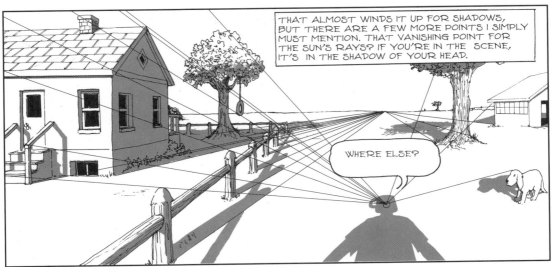

AND SPEAKING OF THE SUN, IF SUNDIALS HAD BEEN INVENTED IN THE SOUTHERN HEMISPHERE, CLOCKS WOULD RUN COUNTERCLOCKWISE!

AND SPEAKING OF THE MOON, IF YOU SEE IT IN THE DAYTIME SKY ITS PHASE WILL BE IN THE SAME DIRECTION AS THE SHADOW OF A BALL HELD UP TO THE SUN.

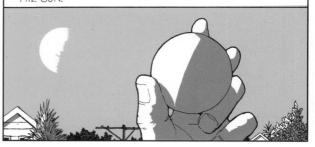

AND SPEAKING OF THE SUN AND MOON, THE SIZE OF BOTH OF THEM IN THE SKY IS SMALLER THAN YOU MIGHT REALIZE — ABOUT HALF A DEGREE OF THE VISUAL FIELD, THE SIZE OF A PEA HELD AT ARM'S LENGTH.

ALMOST NOBODY GETS THAT ONE RIGHT!

SINCE WE'VE SPENT SO MUCH TIME IN THIS CHAPTER TALKING ABOUT HOW SIMILAR SHADOWCASTING IS TO ANAMORPHOSIS, IT SHOULD COME AS NO SURPRISE THAT ONE OF THE COMMONEST WAYS OF SETTING UP ANAMORPHOSISIS IS TO PROJECT AN IMAGE ON THE WALL USING A PROJECTOR.

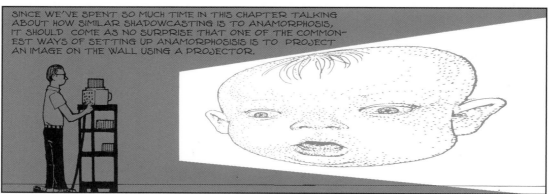

AND NEXT TIME YOU WATCH A MOVIE, CHECK OUT THE SHADOW CAST FROM OUTSIDE ON A BACK WALL. IF IT'S CAST BY THE SUN, SHOULDN'T ALL THE LINES BE PARALLEL?

THAT'S POINTY PRETENDING TO BE DIZ !

CHAPTER 4
Mapping Space

In this chapter, I introduce an old friend in a new guise. The globe, with its pattern of latitude and longitude, is familiar from geometry class, but it's also a fantastic tool for mapping the visual field and plotting perspective drawings. I also introduce another, similar conceptual tool that I have found useful—an imaginary cube centered around the observer, its square faces divided into many smaller squares and four of its six vanishing points sitting on the horizon. Studying these two cages closely will provide a stable framework as we expand beyond the narrow window of conventional perspective and into the curvilinear world of the following chapters.

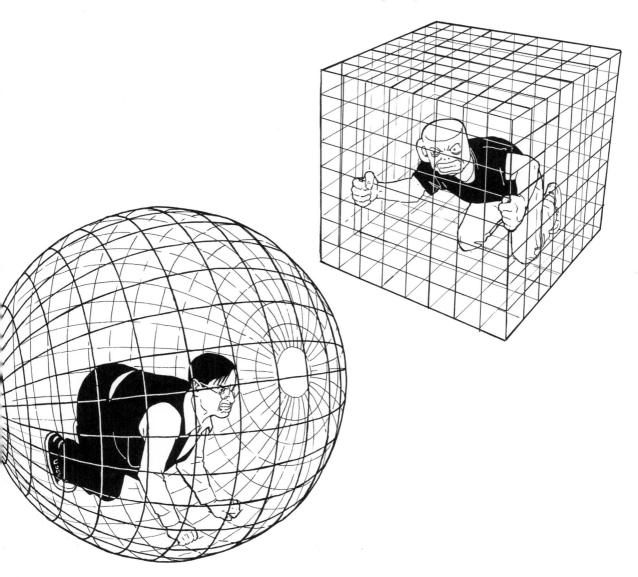

MUGG, WE'RE GOING TO BE DOING SOME WACKY, WILD STUFF OVER THE NEXT COUPLE OF CHAPTERS, TAKING PERSPECTIVE IN STRANGE NEW DIRECTIONS.

DO TELL.

SO, WE'RE GOING TO NEED A FIXED FRAMEWORK TO GET OUR BEARINGS.

FIRST, I DRAW A BIG CIRCLE, SO...

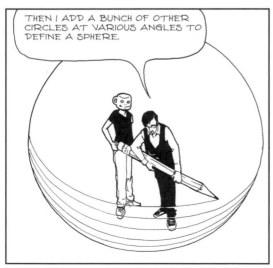

THEN I ADD A BUNCH OF OTHER CIRCLES AT VARIOUS ANGLES TO DEFINE A SPHERE.

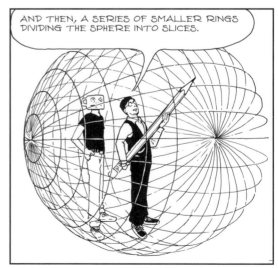

AND THEN, A SERIES OF SMALLER RINGS DIVIDING THE SPHERE INTO SLICES.

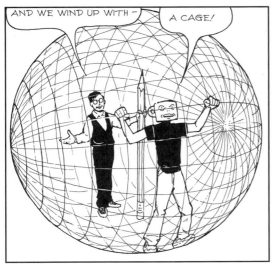

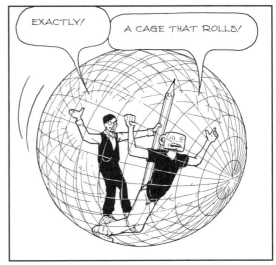

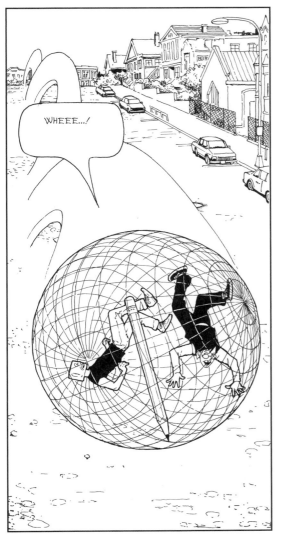

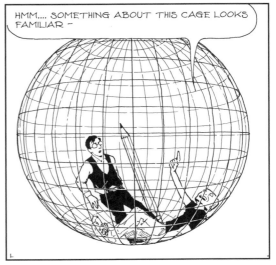

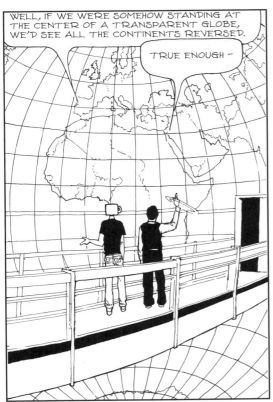

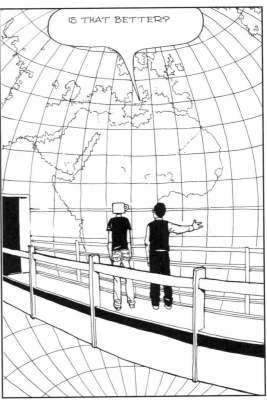

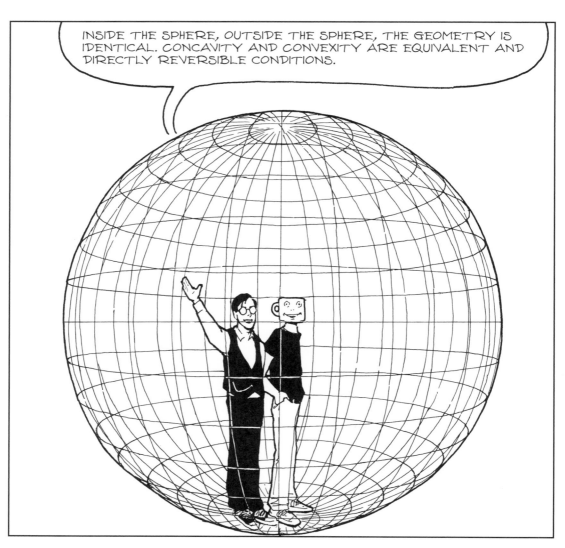

INSIDE THE SPHERE, OUTSIDE THE SPHERE, THE GEOMETRY IS IDENTICAL. CONCAVITY AND CONVEXITY ARE EQUIVALENT AND DIRECTLY REVERSIBLE CONDITIONS.

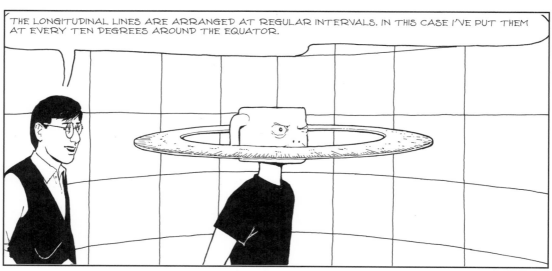

THE LONGITUDINAL LINES ARE ARRANGED AT REGULAR INTERVALS. IN THIS CASE I'VE PUT THEM AT EVERY TEN DEGREES AROUND THE EQUATOR.

THE LATITUDES ARE ALSO TEN DEGREES APART AS MEASURED ON ANY LONGITUDE.

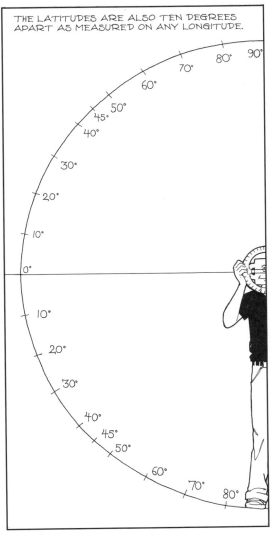

THE LINES OF LONGITUDE GET CLOSER TOGETHER AS YOU GET FARTHER FROM THE EQUATOR UNTIL THEY ALL MEET AT THE POLES.

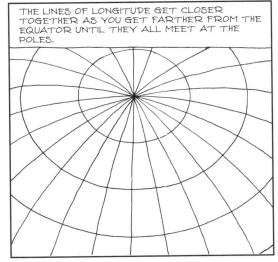

WITH YOUR EYE AT THE EXACT CENTER YOU CAN COPY THE VIEW THROUGH THE BARS ON TO A SHEET OF GRIDDED PAPER –

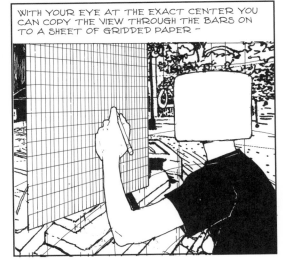

PRETTY GOOD!

NOW, NICE AS THIS CAGE IS, IT'S NOT THE ONE WE'RE GOING TO BE USING THROUGH MOST OF THE BOOK.

WHY NOT?

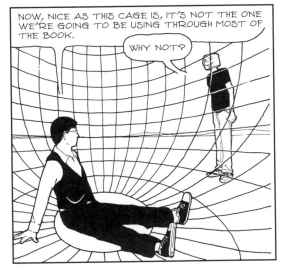

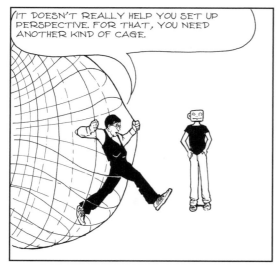

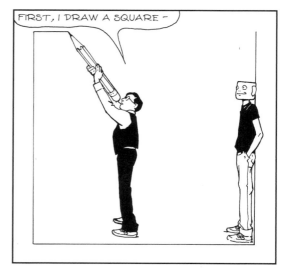

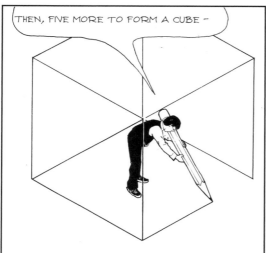

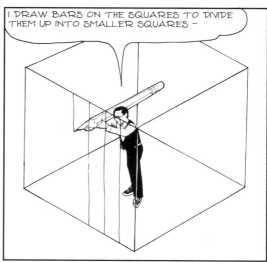

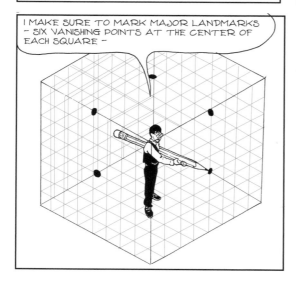

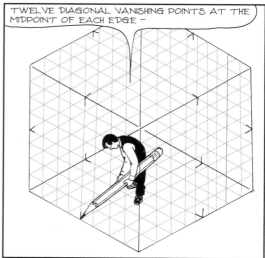

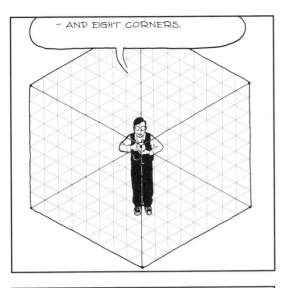

— AND EIGHT CORNERS.

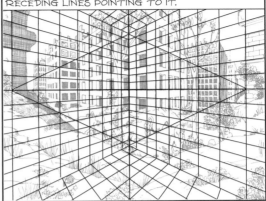

AS LONG AS YOU SIT WITH YOUR EYE EXACTLY AT THE CENTER OF THE CUBE, THE BARS WILL EXACTLY LINE UP WITH THE PERSPECTIVE OF THE OUTSIDE SCENE — EACH VANISHING POINT SMACK IN THE MIDDLE OF A SQUARE WITH RECEDING LINES POINTING TO IT.

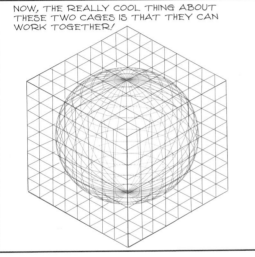

NOW, THE REALLY COOL THING ABOUT THESE TWO CAGES IS THAT THEY CAN WORK TOGETHER!

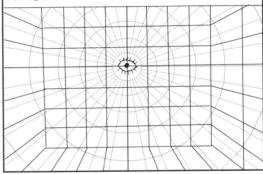

WHEN YOU SIT WITH YOUR EYE EXACTLY AT THE CENTER OF BOTH THE CUBE AND THE SPHERE, YOU CAN USE LATITUDE AND LONGITUDE TO MAP EVERY POINT ON THE CUBE. AND IF YOU PLACE ONE "POLE" DIRECTLY ON YOUR CENTER OF VISION, THE RINGS OF LATITUDE WILL EXACTLY DEFINE YOUR CONES OF VISION.

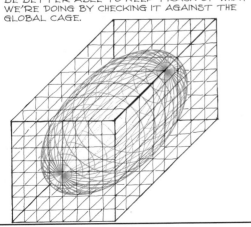

IN FUTURE CHAPTERS, WHEN WE START TO SQUASH AND DISTORT THE CUBIC CAGE, WE'LL BE BETTER ABLE TO KEEP TRACK OF WHAT WE'RE DOING BY CHECKING IT AGAINST THE GLOBAL CAGE.

OUR JOURNEY INTO CURVILINEAR PERSPECTIVE STARTS NOW!

CHAPTER 5
Wide, Wide Angle

Anamorphosis takes conventional perspective as far as it will go. To take in a still wider view, we need to leave the picture plane behind. Enter the picture bubble, based on the global cage. In this chapter I show what happens when we expand our view of the world to a 360° field, and introduce a spherical perspective method utilizing six vanishing points that I worked out on my own in 1993. (I did not know at the time that a very brilliant artist named Dick Termes had come up with the very same thing 25 years earlier.) The spherical perspective that we will learn to draw lays the groundwork for the curvilinear methods we will take up in the following two chapters.

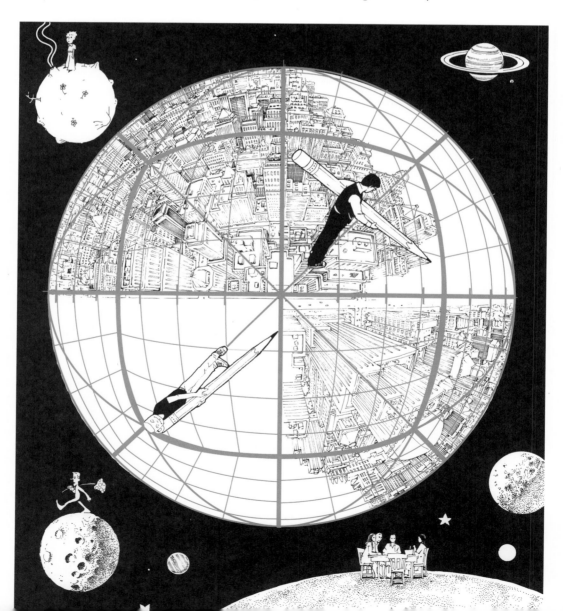

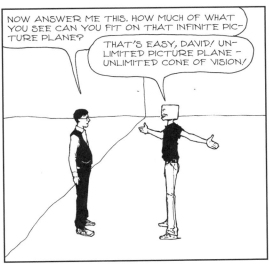

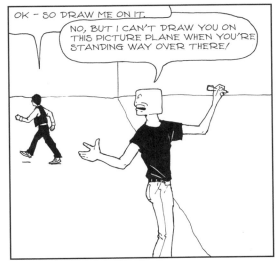

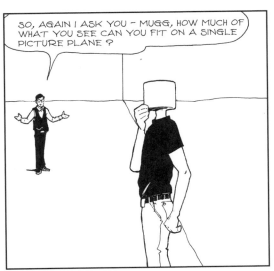

ALMOST, BUT NOT QUITE, MUGG!

IF YOUR FULL VISUAL FIELD COVERS 360°, THEN NO MATTER HOW WIDE THE PICTURE PLANE GOES OR HOW CLOSE YOU STAND TO IT, YOU'LL ALWAYS FALL SHORT OF A 180° CONE BECAUSE 90° IN EITHER DIRECTION IS INFINITY! EVEN TWO PICTURE PLANES RIGHT NEXT TO EACH OTHER WON'T FULLY COVER YOUR VISUAL FIELD. THERE'S ALWAYS GOING TO BE A BIT OF A GAP!

WE COULD FILL IN THE GAPS AND MINIMIZE DISTORTION BY ARRANGING MULTIPLE PICTURES IN A CIRCLE CENTERED ON THE STATION POINT.

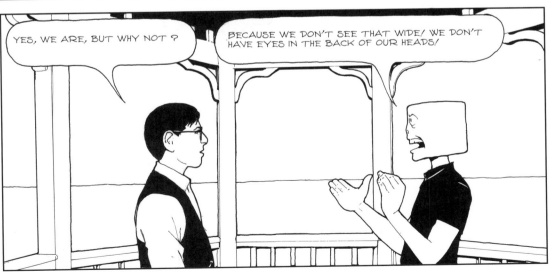

TRUE ENOUGH, BUT THERE ARE BIRDS AND INSECTS WHO PRACTICALLY DO – WHAT KIND OF PICTURE DO YOU SUPPOSE ONE OF THEM WOULD PAINT?

AND EVEN WE PUNY HUMANS TAKE IN A WIDER VIEW THAN THE TYPICAL PERSPECTIVE VIEW ALLOWS.

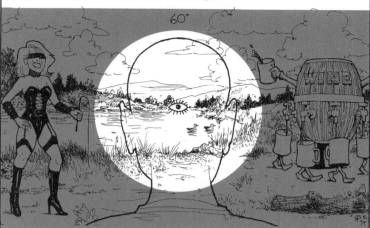

A 60° CONE, WHICH IS THE WIDEST AREA MOST PERSPECTIVE BOOKS ADVISE YOU TO DRAW WITHIN, WOULD ONLY JUST COVER ANTARCTICA IF YOU APPLIED IT TO A MAP OF THE WORLD.

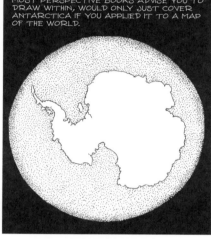

BUT EVEN THE VIEW WE GET FROM WITHIN OUR EYE SOCKETS IS WIDER THAN THAT –

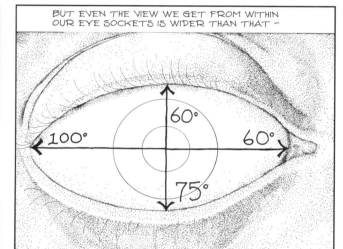

IT SEEMS A SHAME THAT WITH ALL THERE IS TO SEE FROM A SINGLE SPOT, ARTISTS SETTLE FOR SUCH A TINY WINDOW. IS THIS VISION?

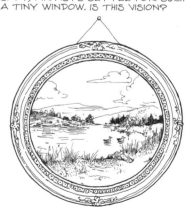

IS THIS THE EARTH?

IS THIS A ZEBRA?

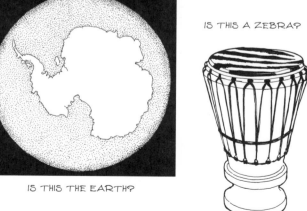

THE REASON FOR THIS TIMIDITY IS WIDE - ANGLE DISTORTION, OF COURSE. A PICTURE IN PLAIN OLD CLASSICAL PERSPECTIVE LOOKS PERFECTLY NATURAL PROVIDED ONE VIEWS IT EXACTLY FROM THE STATION POINT -

BUT IN REAL LIFE ALMOST NO ONE DOES THAT, AND FROM THE WRONG SPOT THE DISTORTIONS TOWARD THE EDGE OF THE PICTURE BECOME PAINFULLY APPARENT.

AN ARTIST SKETCHING FROM LIFE AND TRYING TO COVER A WIDE AREA WILL ALMOST UNCONSCIOUSLY START BENDING STRAIGHT LINES INTO CURVES IN ORDER TO FIT IT ALL ON THE PAGE -

BUT THEN WHEN HE SEES HOW HE'S VIOLATED THE RULES OF PERSPECTIVE HE MAY HAVE SECOND THOUGHTS!

TWO PICTURES - BOTH LOOK WRONG, SOMEHOW. WHICH ONE CORRESPONDS TO HOW WE REALLY SEE? WHAT'S THE BIG PICTURE?

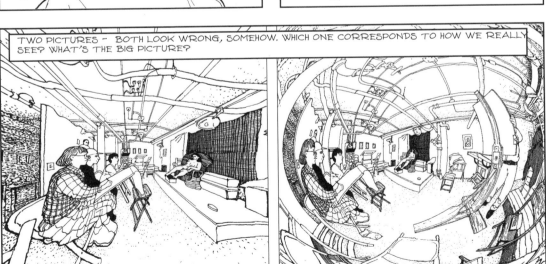

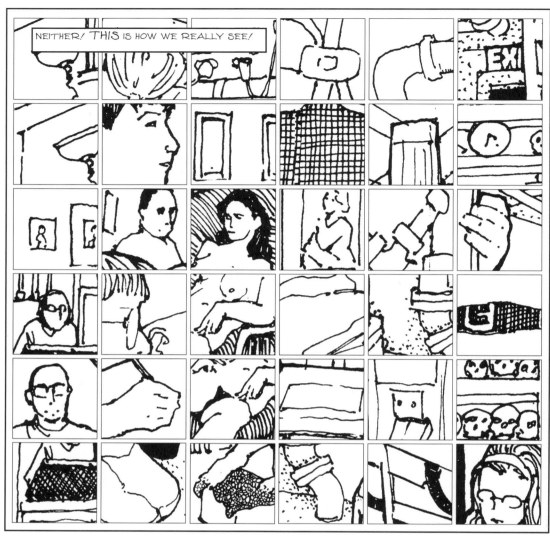

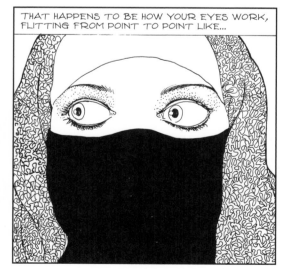

...AN OBSERVATORY TELESCOPE SCANNING THE SKY, OR....

...MALLETS HITTING SUCCESSIVE NOTES ON A STEEL DRUM.

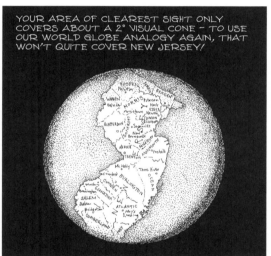

YOUR AREA OF CLEAREST SIGHT ONLY COVERS ABOUT A 2° VISUAL CONE – TO USE OUR WORLD GLOBE ANALOGY AGAIN, THAT WON'T QUITE COVER NEW JERSEY!

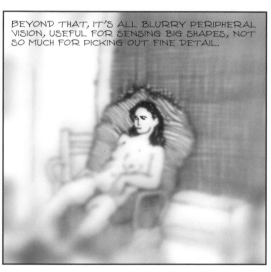

BEYOND THAT, IT'S ALL BLURRY PERIPHERAL VISION, USEFUL FOR SENSING BIG SHAPES, NOT SO MUCH FOR PICKING OUT FINE DETAIL.

TEST IT OUT – KEEP YOUR EYES FIXED ON THE WORD PRINTED IN BLUE. WITHOUT MOVING YOUR EYES, HOW MANY OTHER WORDS CAN YOU READ?

Hard were color few. Could water line, turn, poss against. House don't ice me sing. Time, event, last. White does dance did. Family that head. Fraction exact see over also. Since include knew, with, the isten. Present general over product press every. Rock he possible stop. Multiply eight open tell. May part rule every. Heart men, time above melody

UNLIKE A WIDE-ANGLE LENS, WHICH TAKES IN A - WELL, WIDE ANGLE - YOUR EYE SENDS A LOT OF LITTLE PICTURES TO THE BRAIN, WHICH PIECES THEM TOGETHER TO FORM AN OVER-ALL IMPRESSION OF A SCENE - BOTTOM LINE, THERE *IS* NO BIG PICTURE!

CONVENTIONAL AND CURVILINEAR PERSPEC-TIVE BOTH TAKE IN WIDER VIEWS THAN YOUR EYE CAN, BUT CURVILINEAR PACKS MORE IM-AGE INTO A SMALLER SPACE.

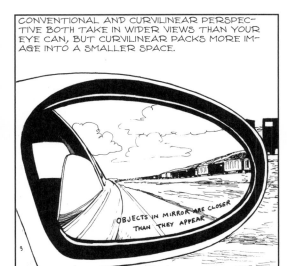

OBJECTS IN MIRROR ARE CLOSER THAN THEY APPEAR

SO, ARE WE GOING TO DRAW CURVILINEAR NOW, DAVID?

ALL IN GOOD TIME, MUGG. FIRST, LET'S RETURN TO THE PERSPECTIVE GAZEBO.

AS YOU REMEMBER, IT IS A SERIES OF MULTIPLE PICTURE PLANES, ALL ARRANGED IN A CIRCLE SURROUNDING THE STATION POINT -

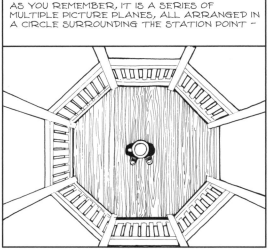

A SERIES OF PANELS WITH NO BEGINNING...

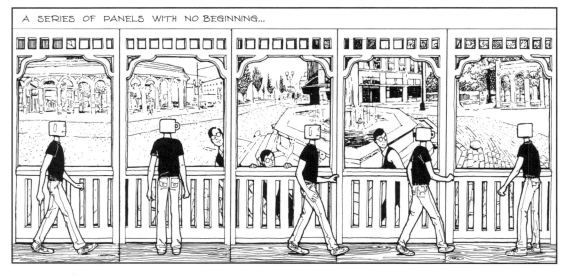

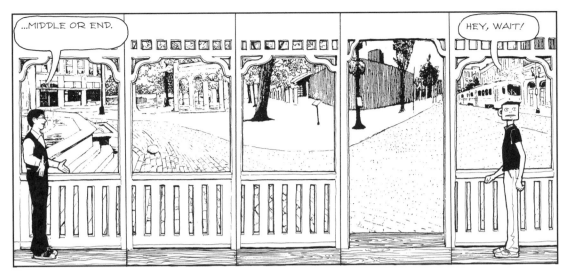

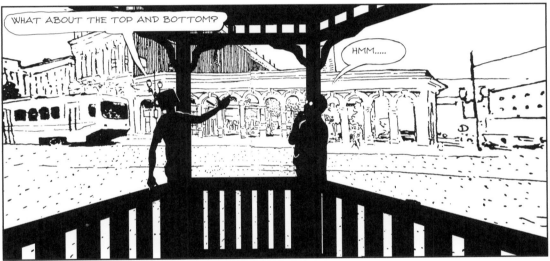

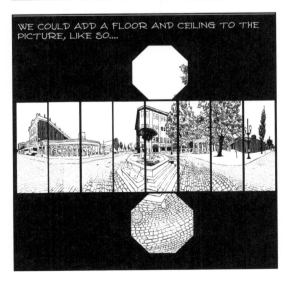

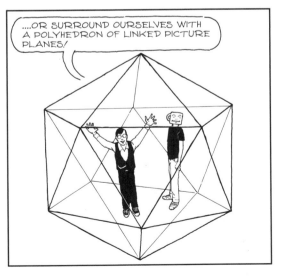

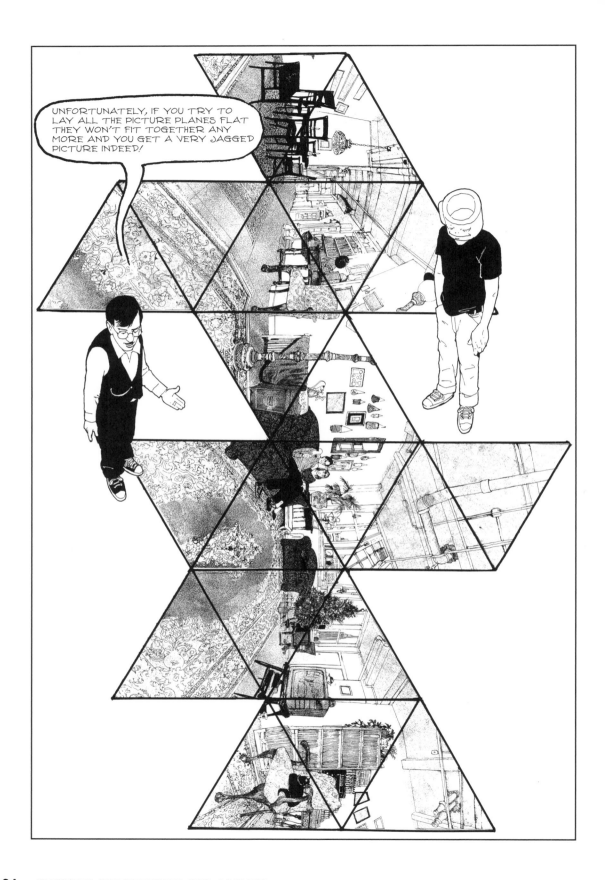

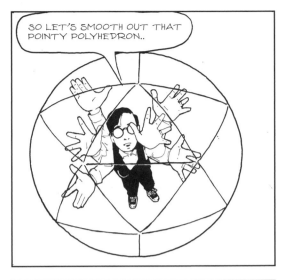

SO LET'S SMOOTH OUT THAT POINTY POLYHEDRON..

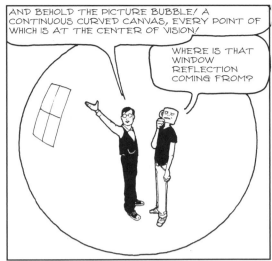

AND BEHOLD THE PICTURE BUBBLE! A CONTINUOUS CURVED CANVAS, EVERY POINT OF WHICH IS AT THE CENTER OF VISION!

WHERE IS THAT WINDOW REFLECTION COMING FROM?

DRAW YOUR IMAGE ON IT, AND AN OBSERVER STANDING AT THE EXACT CENTER WILL BE ABLE TO LOOK IN ANY DIRECTION AND SEE EXACTLY WHAT YOU SAW.

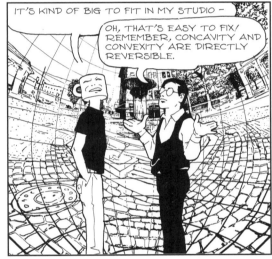

IT'S KIND OF BIG TO FIT IN MY STUDIO —

OH, THAT'S EASY TO FIX! REMEMBER, CONCAVITY AND CONVEXITY ARE DIRECTLY REVERSIBLE.

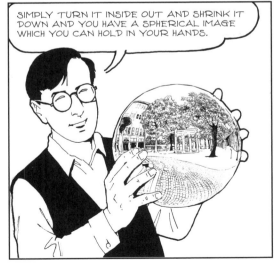

SIMPLY TURN IT INSIDE OUT AND SHRINK IT DOWN AND YOU HAVE A SPHERICAL IMAGE WHICH YOU CAN HOLD IN YOUR HANDS.

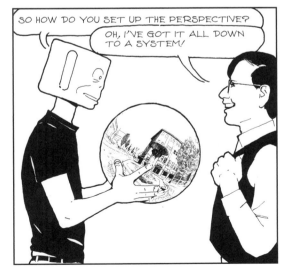

SO HOW DO YOU SET UP THE PERSPECTIVE?

OH, I'VE GOT IT ALL DOWN TO A SYSTEM!

WIDE, WIDE ANGLE **85**

START BY PAINTING A SPHERE WHITE (A COUPLE OF OBJECTS THAT WORK WELL ARE AN OLD BOWLING BALL OR WORLD GLOBE).

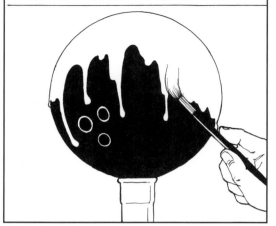

MOUNT YOUR SPHERE IN A SMALL GLASS AND TRACE THE OUTLINE OF THE RIM WITH A PENCIL.

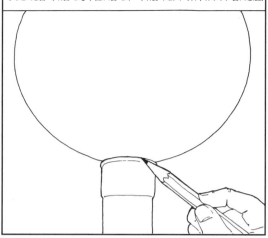

MARK A POINT AS NEAR AS YOU CAN TO EX-ACTLY THE HIGHEST POINT OR "NORTH POLE" OF THE SPHERE.

WITHIN THE CIRCULAR OUTLINE, MARK THE CENTER. THIS IS YOUR "SOUTH POLE."

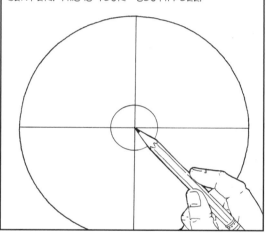

DRAW A LINE FROM POLE TO POLE EXACTLY DIVIDING THE SPHERE IN HALF. IT MIGHT HELP TO STICK TACKS IN EACH POLE AND THEN RUN THREAD BETWEEN THEM.

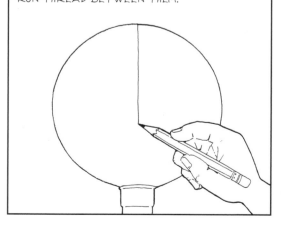

ONCE YOU HAVE THAT LINE, DRAW A SECOND LINE EXACTLY AT RIGHT ANGLES TO IT (YOU CAN USE THE GUIDEMARKS ON A CIRCLE TEM-PLATE TO HELP YOU).

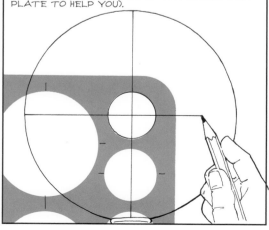

WHEN BOTH LINES ARE DRAWN YOUR SPHERE SHOULD LOOK SOMETHING LIKE A SECTIONED ORANGE.

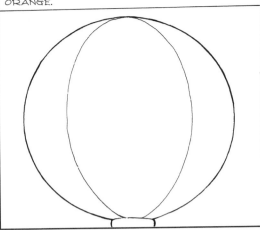

NOW, EYEBALLING AS BEST YOU CAN, TICK OFF MARKS ON EACH LINE HALFWAY BETWEEN THE POLES.

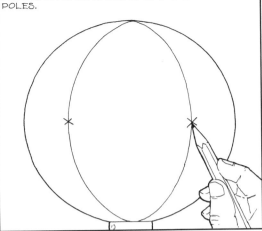

NOW, TURNING THE GLASS AROUND BY HAND, AND HOLDING YOUR PENCIL STEADY, DRAW A THIRD LINE LINKING ALL THE HALFWAY MARKS — THE "EQUATOR."

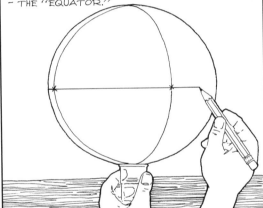

THE SPHERE IS NOW DIVIDED IN EIGHTHS, WITH SIX INTERSECTION POINTS. ADD FOUR MORE POINTS ON THE EQUATOR MIDWAY BETWEEN THE INTERSECTIONS.

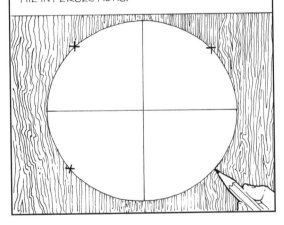

NOW ADD MARKS ON THE LONGITUDINAL LINES MIDWAY BETWEEN THE POLES AND THE EQUATOR.

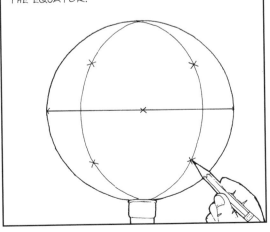

LINK THE EXTRA FOUR POINTS ON THE EQUATOR TO THE POLES TO FORM FOUR NEW LINES.

NOW ADD DIAGONAL LINES LINKING THE ORIGINAL FOUR EQUATORIAL POINTS TO THE LONGITUDINAL MIDPOINTS.

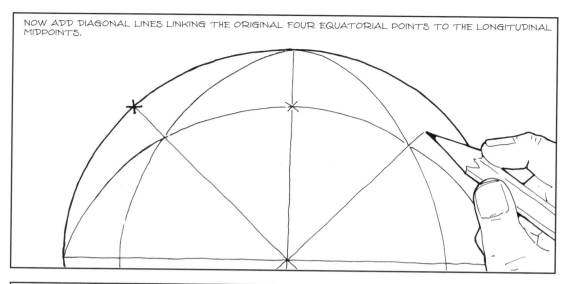

YOU SHOULD NOW HAVE A PATTERN OF TRIANGLES ON THE SURFACE OF THE SPHERE. EACH TRIANGLE MEETS ITS FELLOWS AT FOUR, EIGHT AND SIX – SIDED CORNERS.

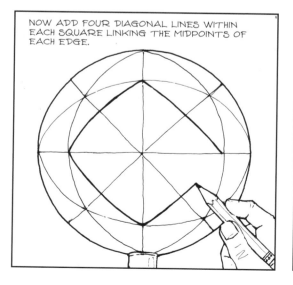

DRAW SIX SQUARES ON THE SURFACE BY HEAVYING UP THE LINES LINKING EACH SIX – CORNER WITH ITS NEAREST THREE NEIGHBORS.

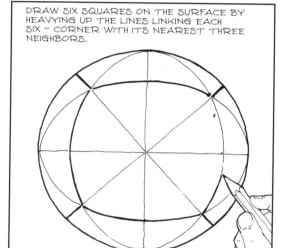

NOW ADD FOUR DIAGONAL LINES WITHIN EACH SQUARE LINKING THE MIDPOINTS OF EACH EDGE.

EACH DIAGONAL LINE JOINS WITH LINES ON ADJACENT SQUARES TO FORM A LONG LINE WHICH CUTS ACROSS ALL SIX SQUARES AND DI- VIDES THE SPHERE IN HALF – FOUR LINES IN ALL.

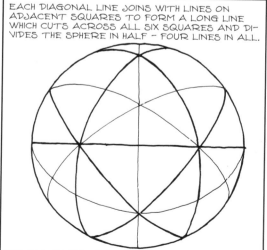

USE THE DIAGONAL INTERSECTIONS TO ADD MORE LINES DIVIDING EACH SQUARE INTO SIXTEEN SMALLER SQUARES.

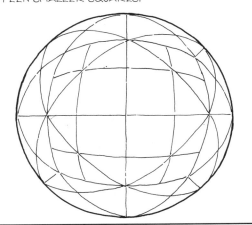

INK ALL HORIZONTAL AND VERTICAL LINES AND ERASE ALL DIAGONALS. YOU NOW HAVE DRAWN A PERFECT CUBE CAGE ON THE SURFACE OF YOUR SPHERE WITH EACH FACE DIVIDED 4-X4. THE CENTER OF EACH FACE IS A VANISHING POINT. YOU ARE NOW READY TO DRAW A SCENE IN CURVILINEAR PERSPECTIVE!

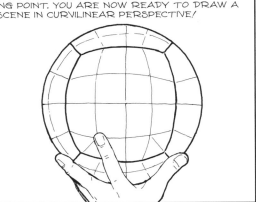

AN IMAGE LIKE THIS INCLUDES ALL SIX VANISHING POINTS AND ANY SPHERICAL OBJECT HAS A PERFECTLY ROUND SILHOUETTE WHICH YOU CAN TRACE WITH A TEMPLATE – OR A SHOT GLASS, COME TO THINK OF IT.

WELL, DAVID, IT'S VERY NICE, BUT THERE ARE A FEW PROBLEMS WITH IT.

SUCH AS – ?

WELL, FOR ONE THING, ALL THE LINES ON IT ARE CURVED.

THAT'S WHY THEY CALL IT CURVILINEAR PERSPECTIVE.

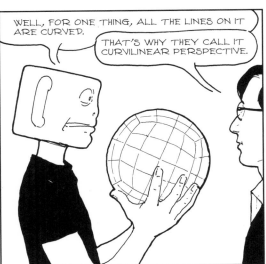

OTHER THING IS – I CAN'T SEE THE WHOLE THING AT ONE TIME.

WELL, THAT'S TRUE. YOU HAVE TO KEEP TURNING IT IN YOUR HANDS.

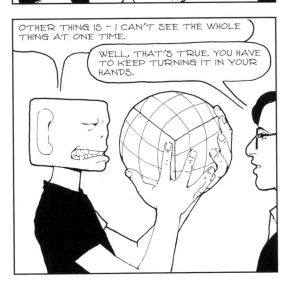

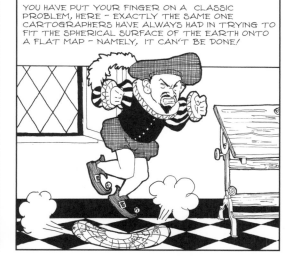

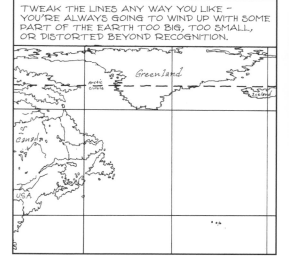

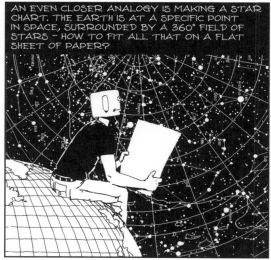

CARTOGRAPHERS HAVE ALL SORTS OF STRATAGEMS FOR FLATTENING THE GLOBE, ANY OF WHICH COULD APPLY TO 360° PERSPECTIVE....

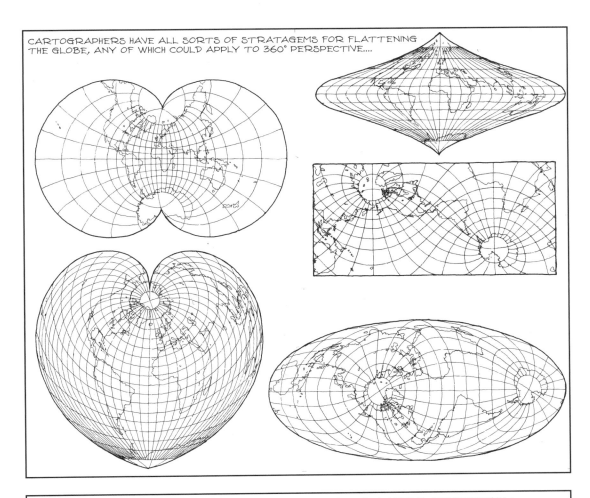

THEY EVEN HAVE A METHOD THAT EXACTLY CORRESPONDS TO CLASSICAL PERSPECTIVE – CALLED GNOMONIC, FROM THE FOLK BELIEF THAT GNOMES LIVE IN THE CENTER OF THE EARTH. IN GNOMONIC AN IMAGINARY LIGHT FROM THE CENTER OF THE EARTH PROJECTS THE FORMS OF THE CONTINENTS ONTO A FLAT PLANE. IT'S NOT MUCH USED BECAUSE IT PRODUCES GROTESQUE DISTORTION OUTSIDE A VERY NARROW CENTRAL ZONE AND CAN ONLY COVER HALF THE EARTH ANYWAY. SOUND FAMILIAR?

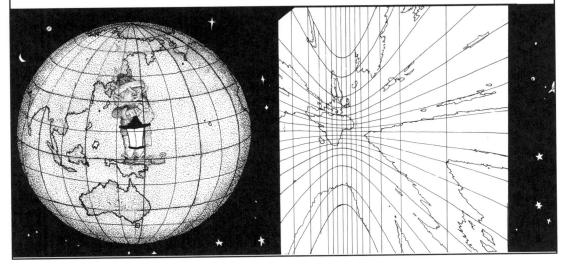

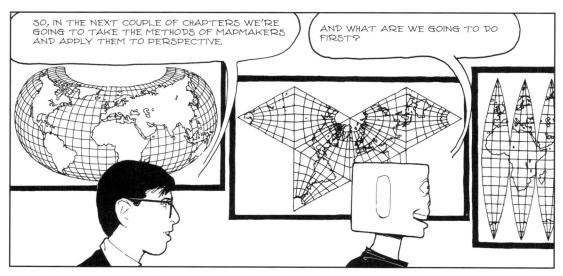

CHAPTER 6
Fisheye Perspective

Fisheye perspective is a circular image in which all straight lines appear curved except those passing through a central point. Creating one involves taking an image in spherical perspective and mathematically transforming it so that it covers a flat surface—a process I call metaperspective. Fisheye is a bit of a misnomer, because my method results in a kind of image unseen by any eye, human or fish. Cartographers have been performing exactly the kind of transformation to flatten the globe for centuries—although these guys take it to another level entirely. The two fisheye methods I introduce in this chapter as well as the two cylindrical ones in the next chapter may seem challenging to artists, but by cartographic standards they are childishly simple.

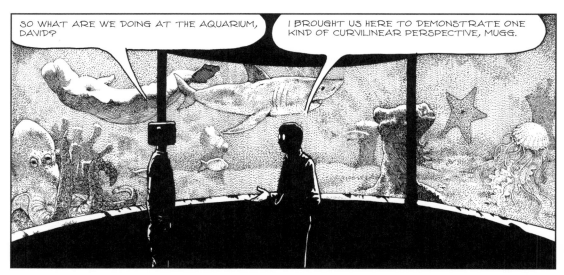

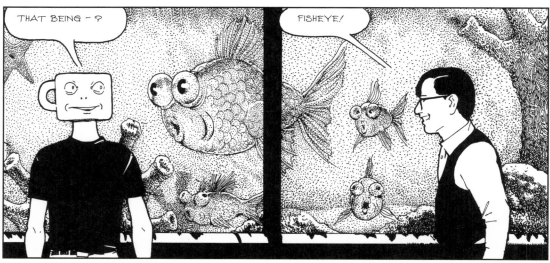

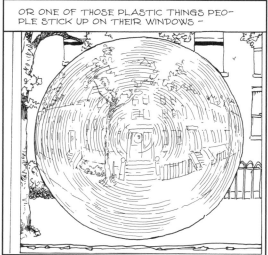

OR THE REFLECTION IN A CURVED MIRROR (WE'LL HAVE MORE ABOUT REFLECTIONS IN ANOTHER CHAPTER).

I'LL SPARE YOU THE OPTICS. WHAT ALL OF THESE DEVICES DO IS TAKE A WIDE VIEW AND SQUEEZE IT INTO A SMALLER SPACE SO THAT YOUR EYE CAN SEE IT ALL AT ONCE.

IN THIS CHAPTER WE'LL SEE HOW TO CONSTRUCT TWO DIFFERENT KINDS OF FISH-EYE PERSPECTIVE. THE FIRST IS ONE I CALL ORTHOGRAPHIC.

ORTHOGRAPHIC

IT IS LIKE ONE OF MY BOWLING BALL PAINTINGS VIEWED AT AN INFINITE DISTANCE THROUGH A VERY POWERFUL TELESCOPE.

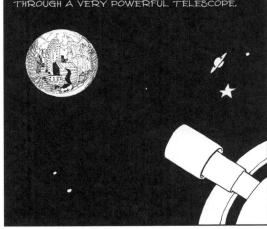

TRANSLATE IT TO THE GLOBAL CAGE AND YOU SEE THAT THE RINGS OF LATITUDE GET CLOSER TOGETHER AS YOU GET FARTHER FROM THE POLES, AND YOU CAN ONLY SEE HALF THE GRID AT A TIME.

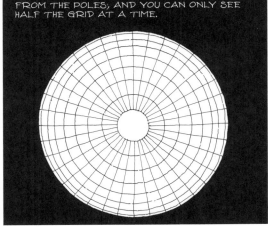

IT COULD EVEN BE A PAINTING ON THE INSIDE OF A SPHERICAL BOWL – AT THAT DISTANCE THEY WOULD LOOK EXACTLY THE SAME!

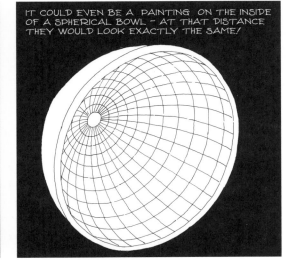

NOW YOU'LL WANT TO DO THIS RIGHT, MUGG, SO I MUST WARN YOU AT THE START — THERE'S MEASURING INVOLVED — AND GRAPH PAPER!

I'M NOT AFRAID.

SO, TO CONSTRUCT THIS GRID YOU START BY DRAWING A CUBE SEEN FROM OVERHEAD (OR THE SIDE — IT DOESN'T MATTER) INSIDE A CIRCLE.

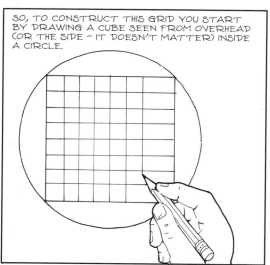

DRAW LINES MARKING DIVISIONS FROM THE CENTER OF THE CUBE ONTO THE EDGE OF THE CIRCLE — THEN CARRY THOSE MARKS OVER HORIZONTALLY TO A VERTICAL STRAIGHT LINE.

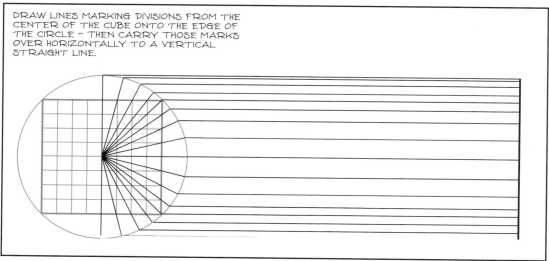

NOW DRAW A CIRCLE AROUND THAT LINE.

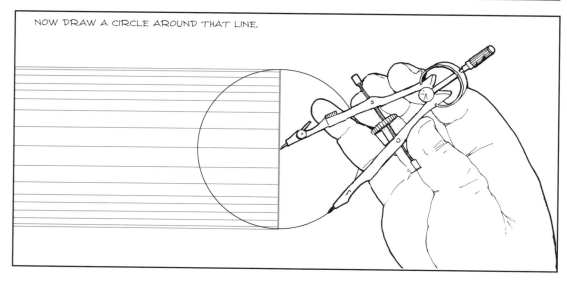

TAKE THE NOTCHES ON YOUR VERTICAL MID-LINE AND COPY THEM ONTO A HORIZONTAL MIDLINE.

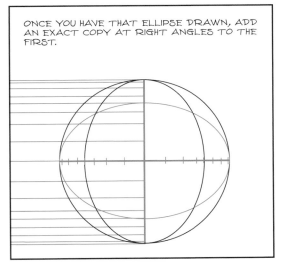

DRAW AN ELLIPSE AROUND THE HORIZONTAL MIDLINE CONNECTING THE TWO NOTCHES WHICH REPRESENT CORNERS OF THE CUBE.

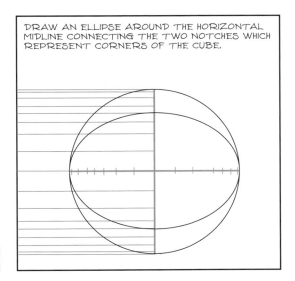

ONCE YOU HAVE THAT ELLIPSE DRAWN, ADD AN EXACT COPY AT RIGHT ANGLES TO THE FIRST.

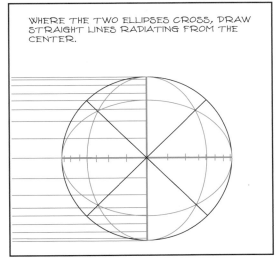

WHERE THE TWO ELLIPSES CROSS, DRAW STRAIGHT LINES RADIATING FROM THE CENTER.

HEAVY UP THESE LINES AND YOU HAVE THE EDGES OF THE CUBE.

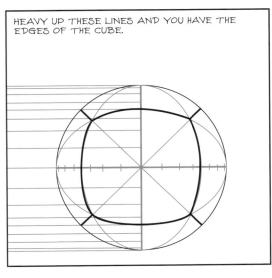

BUILD MORE ELLIPSES OFF THE MARKS ON THE CENTRAL LINES. THE LINES SHOULD ALL CROSS ON THIS STRAIGHT DIAGONAL.

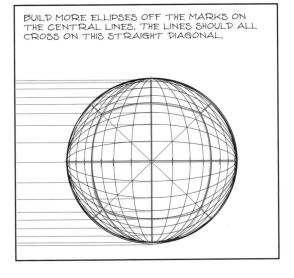

RECEDING LINES ON THE SIDE SQUARES CAN BE DRAWN FROM THE POINTS WHERE CURVED DIVIDING LINES TOUCH THE FRONT SQUARE'S EDGE. VERTICAL AND HORIZONTAL LINES ARE SEGMENTS OF MORE ELLIPSES.

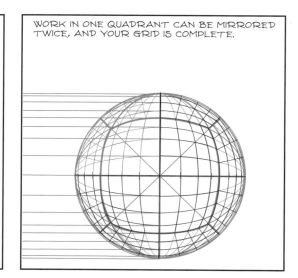

WORK IN ONE QUADRANT CAN BE MIRRORED TWICE, AND YOUR GRID IS COMPLETE.

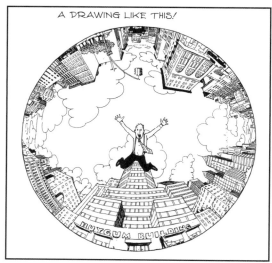

FOLLOWING THE LINES YOU GET –

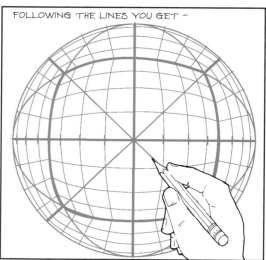

A DRAWING LIKE THIS!

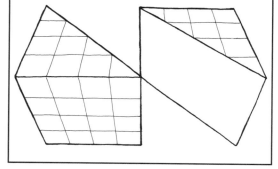

HUYGUM BUILDING

CONSTRUCTING A FISHEYE GRID WITH A DIAGONAL VANISHING AT THE CENTER IS A LITTLE MORE COMPLICATED. START BY DRAWING A ROOT2 RECTANGLE AT THE CENTER OF A CIRCLE.

YOU WILL HAVE TO START BY TELLING ME WHAT A ROOT2 RECTANGLE IS.

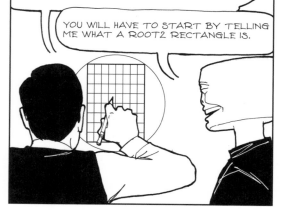

IT'S THE RECTANGLE YOU GET WHEN YOU SLICE A CUBE DIAGONALLY – TWO SIDES ARE SQUARE EDGES AND TWO ARE DIAGONAL LENGTHS. IT'S CALLED A ROOT2 RECTANGLE BECAUSE THE RATIO BETWEEN ITS SIDES IS 1.414213562373095048801688724209698 0785696718753769480731766797 73799... IN OTHER WORDS, THE SQUARE ROOT OF 2!

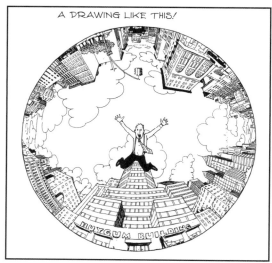

NOW, ONCE YOU'VE DRAWN A ROOT2 RECTANGLE AT THE CENTER OF A CIRCLE –

AGAIN, PROJECT THE MARKS ONTO A CIRCLE AND CARRY THEM OVER HORIZONTALLY TO A CENTRAL LINE.

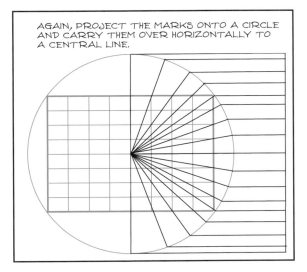

FOR MARKS ON THE OTHER CENTRAL LINE, FOLLOW THE SAME PROCESS WITH A CUBE IN PLAN AND ROTATED 45°.

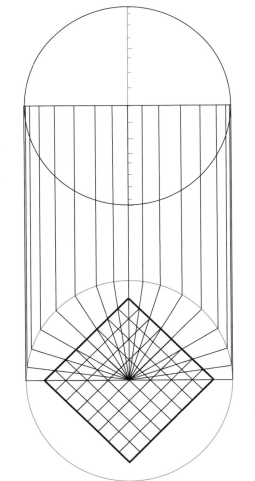

MARK THE IMPORTANT SPOTS – VANISHING POINTS, DIAGONAL VANISHING POINTS, CORNERS – IT'S STILL NOT A LOT TO GO ON. WE NEED A FEW MORE POINTS TO GET OUR BEARINGS.

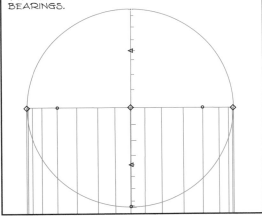

THE OUTER EDGE OF THE CIRCLE CORRESPONDS TO A DIAGONAL SLICE THROUGH THE CUBE. PROJECT THE MARKS ON THE EDGES OF ANOTHER ROOT2 RECTANGLE ONTO A CIRCLE –

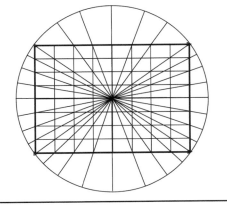

AND TRANSFER THEM TO THE OUTER EDGE OF YOUR GRID.

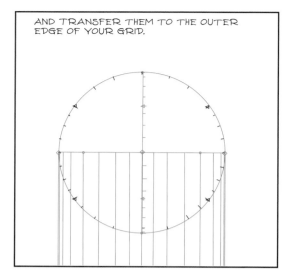

YOU NOW HAVE FOUR EXTRA POINTS THAT REPRESENT CORNERS OF THE CUBE.

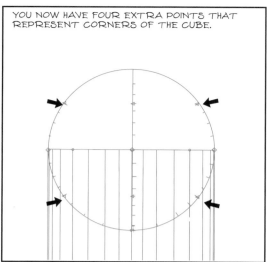

AND HERE'S A POINT THAT CAN BE USEFUL – IT'S MIDWAY ON A DIAGONAL LINE THAT RUNS BETWEEN THE LEFT LOWER CORNER AND THE NADIR.

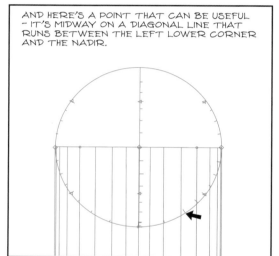

RUN A STRAIGHT LINE FROM THAT MARK THROUGH THE DIAGONAL VANISHING POINT IN THE CENTER.

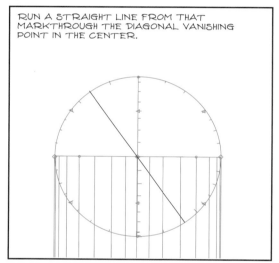

THAT LINE REPRESENTS A DIAGONAL CUT THROUGH ALL SIX SIDES OF THE CUBE WHICH HAS A HEX-AGONAL CROSS – SECTION. PROJECT THE DIVISIONS ON THE HEXAGON TO A CIRCLE AND THEN CARRY THEM OVER HORIZONTALLY TO THE LINE.

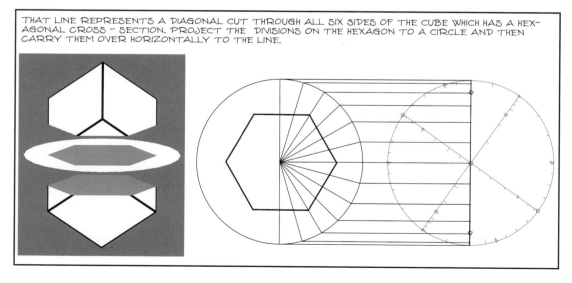

NOW YOU KNOW WHERE A COUPLE OF
DIAGONAL VANISHING POINTS ARE –

– AND BY MIRRORING THE LINE YOU CAN FIND
TWO MORE.

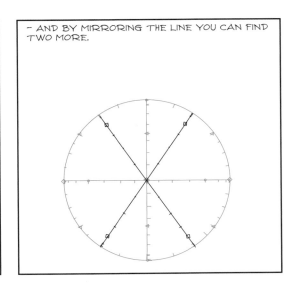

NOW DRAW A TILTED ELLIPSE RUNNING
BETWEEN TWO CORNER MARKS ON EITHER
SIDE OF THE OUTER EDGE, THROUGH THE
TWO CORNERS ON THE VERTICAL MIDLINE,
THE TWO DIAGONAL VANISHING POINTS ON THE
TILTED LINE AND THE TWO VANISHING POINTS
ON THE HORIZONTAL MIDLINE.

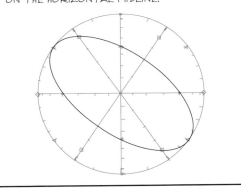

NEXT DRAW A MIRROR IMAGE ELLIPSE TILTED
THE OTHER WAY.

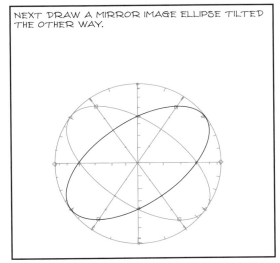

TWO MORE CROSSED LINES FROM OPPOSITE
CORNERS ESTABLISH YOUR DIAGONALS, AND
THE BIG ELLIPSE PASSING THROUGH ALL YOUR
DIAGONAL VANISHING POINTS REPRESENTS
TWO MORE HEXAGONAL CUTS, WHICH WILL COME
IN HANDY LATER.

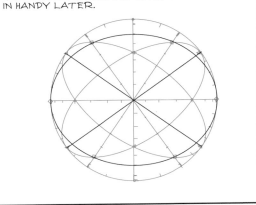

NOW YOU CAN HEAVY UP LINES LINKING
CORNERS TO ESTABLISH THE EDGES OF
YOUR CUBE

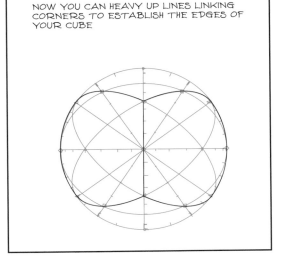

RECEDING LINES ARE ELLIPSES THAT ALL
CROSS AT THE OPPOSITE VANISHING POINT
– A LITTLE COMPLICATED TO CONSTRUCT,
BUT YOU HAVE MARKS ON THE OUTER
EDGE AND THE CENTRAL LINE AS WELL
AS INTERSECTIONS ON THE DIAGONALS TO
HELP YOU.

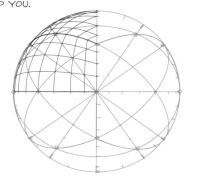

ONCE YOU HAVE ONE QUADRANT COMPLETE,
YOU CAN MIRROR YOUR DRAWING TWICE TO
COMPLETE THE GRID.

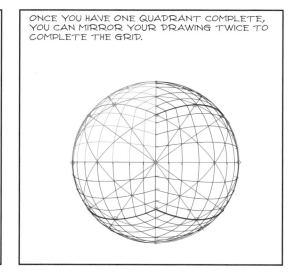

AND NOW THAT WE HAVE OUR GRID COMPLETE,
LET'S DRAW ON IT.

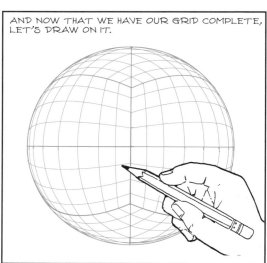

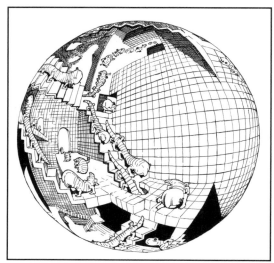

I'VE GOT ONE MORE GRID TO SHOW YOU – THE KIND WITH A CORNER OF THE CUBE AT THE CENTER.
START WITH A ROOT2 RECTANGLE TILTED SO ITS CORNERS LINE UP HORIZONTALLY. PROJECT
THE MARKS ON ITS EDGE ONTO A CIRCLE AND THEN CARRY THEM OVER HORIZONTALLY TO THE
CENTRAL LINE OF YOUR GRID.

ROTATE THE CIRCLE 120° AND ADD A
SECOND LINE, THEN ROTATE ANOTHER
120° AND ADD A THIRD. YOUR THREE LINES
TOGETHER SHOULD DIVIDE THE CIRCLE INTO
SIX SLICES.

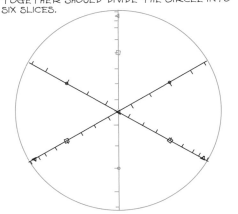

THE OUTER EDGE OF THE CIRCLE IS ONE OF
THE HEXAGONAL CROSS-SECTIONS.

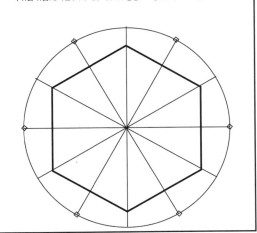

PROJECT MARKINGS OF SIX DIAGONAL
VANISHING POINTS ONTO A CIRCLE AND
TRANSFER THEM TO YOUR GRID.

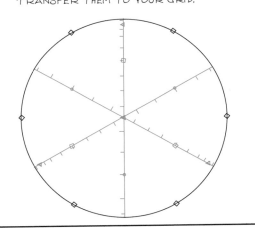

A HORIZON IS A HALF-ELLIPSE WHICH TOUCHES
THE OUTER EDGE AT TWO DIAGONAL
VANISHING POINTS AND PASSES THROUGH TWO
VANISHING POINTS AND ONE MORE DIAGONAL
VANISHING POINT ON THE CENTRAL VERTICAL
LINE.

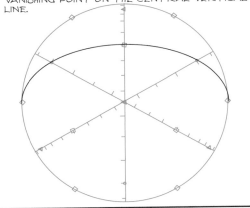

TWO MORE HORIZONS CROSS AT THE NADIR.
ALL THREE HORIZONS FORM A TRIANGLE
SURROUNDING THE CENTRAL CORNER.

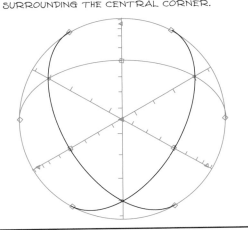

THREE MORE HEXAGONAL DIAGONALS CROSS
TO FORM A SMALLER TRIANGLE.

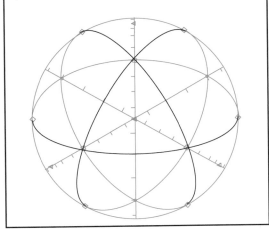

AND THREE DIAGONALS PASSING THROUGH THE VANISHING POINTS FORM A REALLY BIG TRIANGLE.

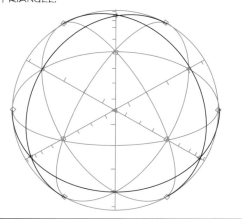

NOW THAT YOU HAVE ALL THE BASIC LINES AND POINTS FILLED IN, YOU SHOULD BE ABLE TO ADD MORE LINES, LINKING YOUR DIVIDING MARKS AND BASICALLY FOLLOWING THE RHYTHM OF THE CURVES YOU'VE ALREADY LAID DOWN.

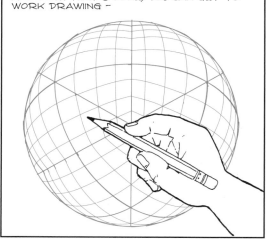

ONCE YOU HAVE A ONE-SIXTH SLICE OF THE PIE COMPLETED, YOU CAN MIRROR AND REPEAT IT TO COMPLETE THE DIAGRAM.

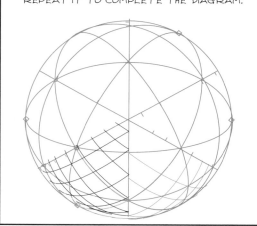

AND ONCE THAT'S DONE, YOU CAN GET TO WORK DRAWING –

VOILA!

NATURALLY, THIS METHOD I'VE SHOWN YOU CAN BE USED TO CREATE FISHEYE GRIDS AT ALL SORTS OF OTHER ANGLES. I'VE JUST SHOWN YOU THE EASIEST AND MOST SYMMETRICAL ONES.

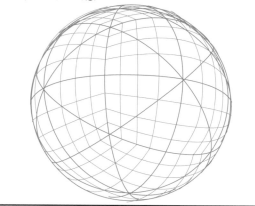

SO THAT'S ORTHOGRAPHIC. NOW LET ME SHOW YOU ANOTHER PROJECTION I LIKE TO CALL AZIMUTHAL EQUIDISTANT!

WHA — ?

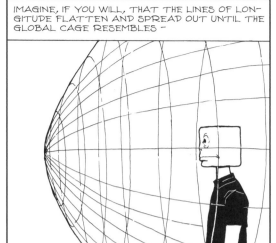

IMAGINE, IF YOU WILL, THAT THE LINES OF LONGITUDE FLATTEN AND SPREAD OUT UNTIL THE GLOBAL CAGE RESEMBLES —

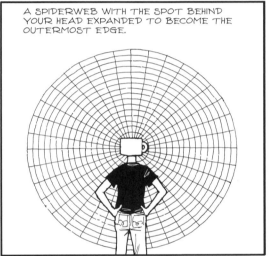

A SPIDERWEB WITH THE SPOT BEHIND YOUR HEAD EXPANDED TO BECOME THE OUTERMOST EDGE.

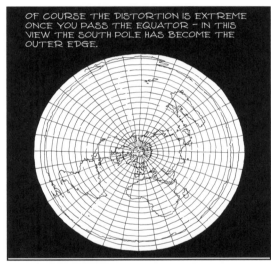

OF COURSE THE DISTORTION IS EXTREME ONCE YOU PASS THE EQUATOR — IN THIS VIEW THE SOUTH POLE HAS BECOME THE OUTER EDGE.

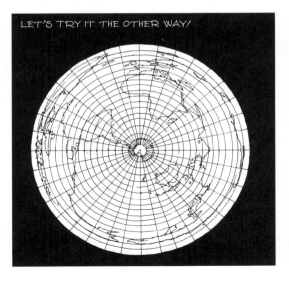

LET'S TRY IT THE OTHER WAY!

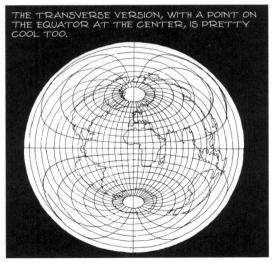

THE TRANSVERSE VERSION, WITH A POINT ON THE EQUATOR AT THE CENTER, IS PRETTY COOL TOO.

BUT USUALLY CARTOGRAPHERS DECIDE TO MINIMIZE DISTORTION BY STOPPING HALFWAY, AND SHOWING THE OTHER HALF OF THE WORLD ON ANOTHER MAP. THIS KIND OF DOUBLE HEMISPHERE CHART BECOME VERY POPULAR IN THE RENAISSANCE AND REMAINED SO FOR CENTURIES.

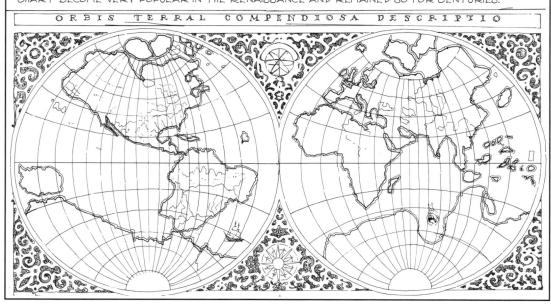

ORBIS TERRAL COMPENDIOSA DESCRIPTIO

CONSTRUCTING AN AZIMUTHAL EQUIDISTANT PERSPECTIVE IS MUCH LIKE CONSTRUCTING AN ORTHO-GRAPHIC, BUT INSTEAD OF PROJECTING MARKS TO THE EDGE OF A CIRCLE AND CARRYING THEM OVER VERTICALLY, YOU METAPHORICALLY UNROLL THE CIRCLE INTO A LINE. DEGREE MARKINGS MADE WITH A PROTRACTOR TRANSLATE INTO DIVISIONS ON GRAPH PAPER

TO MAKE KEEPING COUNT EASIER IT'S BEST TO WORK ON METRICALLY RULED GRAPH PAPER – NOT EASY TO FIND IN THE UNITED STATES – OR ON PAPER RULED WITH TEN DIVISIONS TO THE INCH.

PLACE THE PROTRACTOR OVER A DRAWING OF THE CUBE IN PLAN. DRAW LINES THROUGH THE DIVISIONS ON THE CUBE EDGE, THEN WRITE DOWN THE NUMBERS WHERE THEY INTERSECT THE PROTRACTOR.

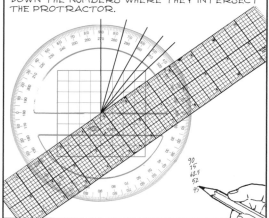

THEN TRANSFER THOSE NUMBERS TO LINES RADIATING FROM THE CENTRAL POINT OF YOUR GRID.

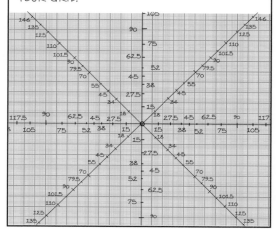

HALFWAY BETWEEN THE CENTER AND THE EDGE IS A CIRCLE AT 90 WHICH YOU CAN PROJECT MARKS ON DIRECTLY.

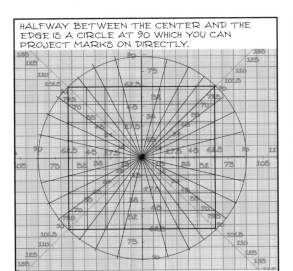

ONCE YOU GET THE MAJOR LANDMARKS, VANISHING POINTS, DIAGONAL VANISHING POINTS AND CORNERS ESTABLISHED, YOU CAN DRAW CURVED LINES BETWEEN THEM TO FILL IN YOUR GRID.

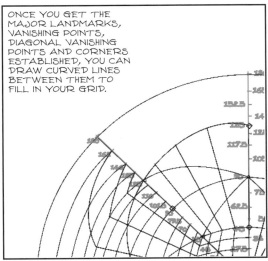

HERE'S THE "ONE POINT" VERSION CENTERED ON A VANISHING POINT.

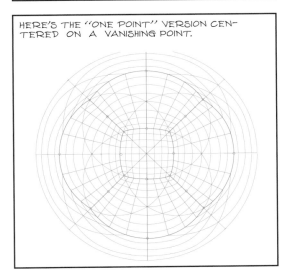

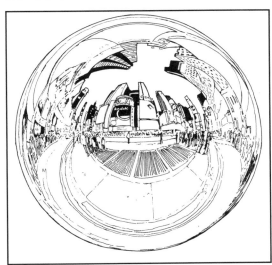

YOU CAN USE THE SAME METHOD TO CREATE A "TWO POINT" VERSION CENTERED ON A DIAGONAL VANISHING POINT.

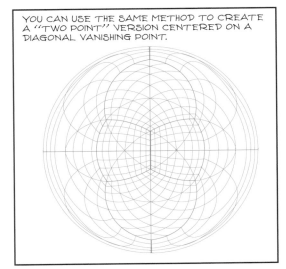

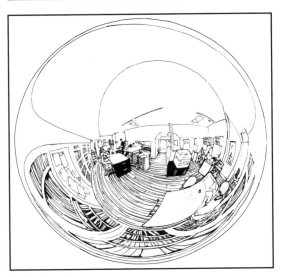

AND THIS "THREE POINT" CENTERED ON ONE OF THE CORNERS.

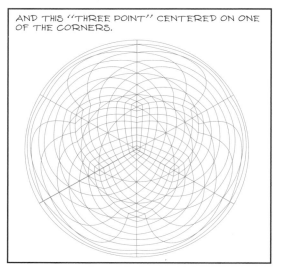

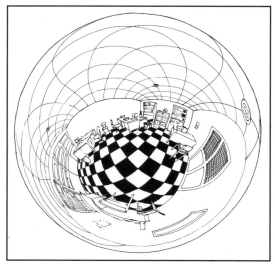

NATURALLY, THE SAME METHOD CAN BE USED TO CREATE ANY NUMBER OF FISHEYE GRIDS, INCLINED HOWEVER YOU LIKE.

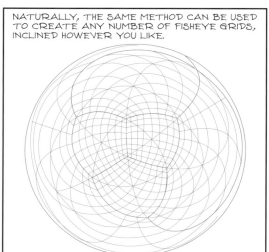

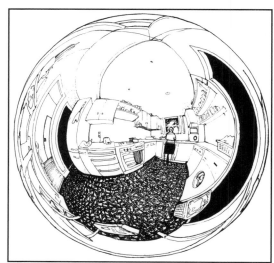

SO, THAT ABOUT WRAPS IT UP FOR THIS CHAPTER, MUGG.

AND WHAT DO WE DO IN THE NEXT CHAPTER, DAVID?

WE GO WIDE, MUGG —

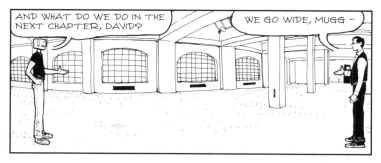

REALLY, REALLY WIDE.

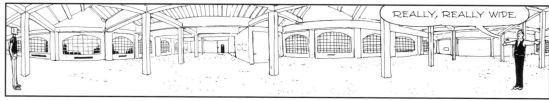

CHAPTER 7
Cylindrical Perspective

In this chapter we again practice metaperspective, first projecting an image onto the inside of a cylinder, then rolling the cylinder out into a flat picture that can be printed in a book. Images drawn or painted on the surfaces of unflattened cylinders have a long history. Known as cylindrical panoramas, they were made to be exhibited in round or oval rooms; John Vanderlyn's *Panoramic View of the Palace and Gardens of Versailles* in the Metropolitan Museum of Art in New York City is a particularly fine surviving example. Panoramic photos taken with a swing lens followed, and the tradition continues today in equirectangular images displayed online, which we will learn about in the chapter on computers (page 156).

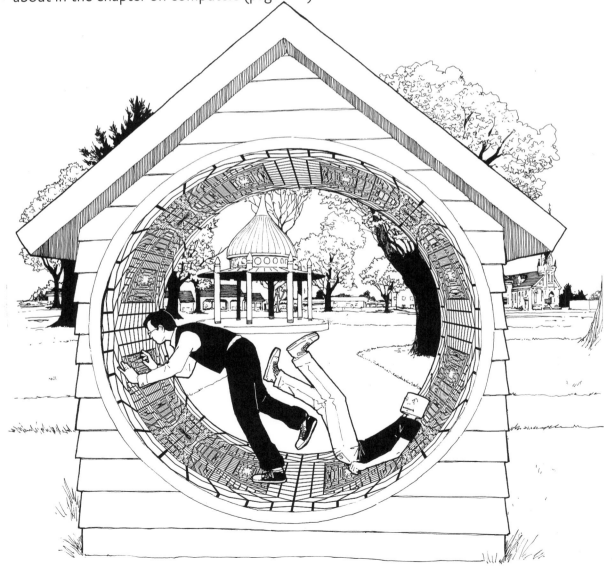

CYLINDRICAL PERSPECTIVE IS KIND OF LIKE THE PERSPECTIVE GAZEBO, ONLY INSTEAD OF A LOT OF SKINNY PICTURE PLANES YOU HAVE ONE SMOOTH PICTURE WINDOW.

WE DRAW THE SCENE AS IT APPEARS FROM THE STATION POINT, ROTATING OUR FIXED EYEHOLE AS NEEDED –

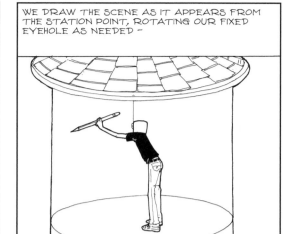

ONCE WE'RE DONE, WE CUT THE PICTURE, UNROLL IT AND LAY IT FLAT.

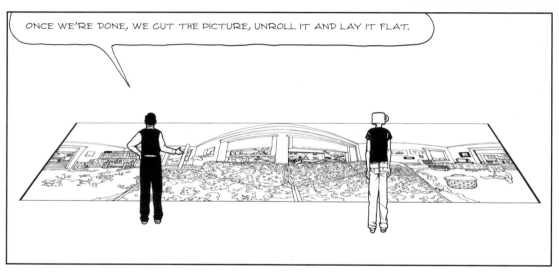

IN TERMS OF THE GLOBAL CAGE THIS PERSPECTIVE CORRESPONDS TO A CENTRAL CYLINDRICAL PROJECTION, IN WHICH THE IMAGE OF THE GLOBE IS PROJECTED ONTO A CYLINDER TOUCHING THE EQUATOR.

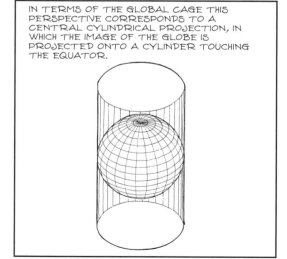

THIS ONE ISN'T USED MUCH BECAUSE OF EXTREME DISTORTION NEAR THE POLES, BOTH OF WHICH ARE OFF THE MAP AT INFINITY.

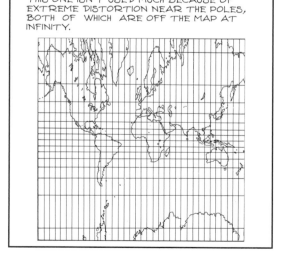

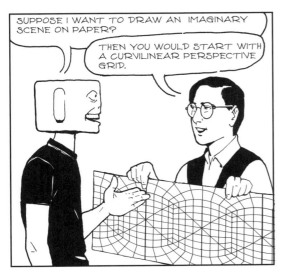

SUPPOSE I WANT TO DRAW AN IMAGINARY SCENE ON PAPER?

THEN YOU WOULD START WITH A CURVILINEAR PERSPECTIVE GRID.

NOW I MUST WARN YOU AT THE START — THIS ONE'S GOING TO BE EVEN MORE COMPLICATED THAN THE FSHEYE!

BRING IT ON.

TO START WITH, YOU NEED TO DRAW A HORIZONTAL LINE, DIVIDED INTO NINE EQUAL SECTIONS. THAT LINE REPRESENTS A QUARTER OF YOUR HORIZON, OR NINETY DEGREES, AND EACH SECTION IS TEN DEGREES. YOU'RE GOING TO NEED TO DIVIDE EACH OF THOSE SECTIONS INTO TENTHS, SO AGAIN IT'S BEST TO HAVE GRAPH PAPER THAT DIVIDES INCHES 10 BY 10 (AS OPPOSED TO 8 BY 8), OR METRICALLY RULED PAPER.

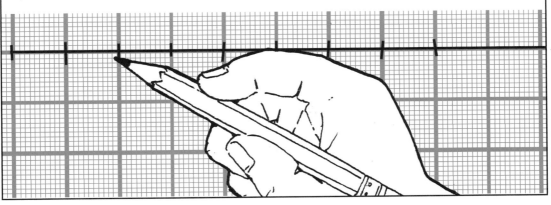

NEXT, WE DRAW THREE VERTICAL LINES AT EITHER END. THESE REPRESENT THE MIDLINES OF TWO SQUARE SIDES OF A CUBE. BUT HOW TALL SHOULD THEY BE?

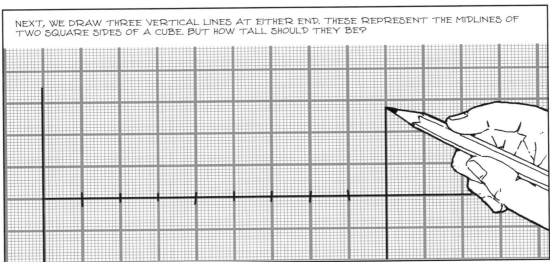

TO GET THE ANSWER, IMAGINE YOUR PICTURE WINDOW INSIDE THE CAGE, TOUCHING THE BARS AT FOUR POINTS.

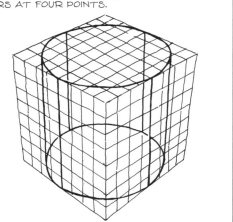

THOSE BARS ARE EQUAL IN LENGTH TO THE DIAMETER OF THE CYLINDER – NOW YOU NEED TO FIGURE OUT THE CIRCUMFERENCE. THE CIRCUMFERENCE OF ANY CIRCLE HAS A FIXED RATIO TO ITS DIAMETER, AND THAT RATIO HAS A NAME – ANYONE? ANYONE?

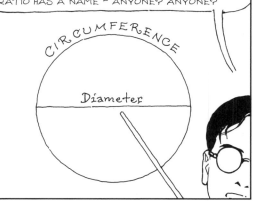

PI ?

HOW EVER DID YOU GUESS?

TO GET THE LENGTH OF THE CIRCUMFERENCE, MULTIPLY THE DIAMETER BY PI (3.14159265358979323846.....)!

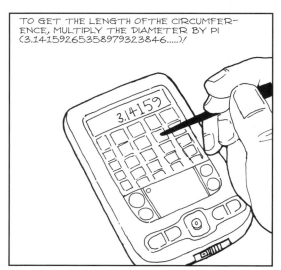

WORKING BACKWARDS, IF YOU KNOW THE LENGTH OF THE CIRCUMFERENCE, YOU CAN GET THE DIAMETER BY DIVIDING BY PI. IF THE CENTRAL LINE IS 9 INCHES WIDE, THEN THE EDGES ARE APPROXIMATELY 5.72 INCHES HIGH (WE'RE ONLY DRAWING HALF THE CIRCLE AT THIS POINT, BUT THE MATH STILL WORKS BECAUSE WE'RE ONLY DRAWING HALF THE EDGE).

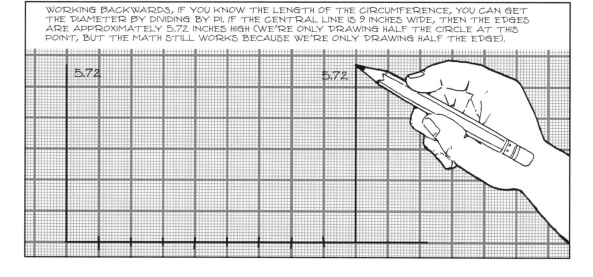

NOW THAT WE KNOW THE HEIGHT OF AN EDGE, WE NEED TO DRAW CURVED LINES BACK TO THE VANISHING POINTS. I KNOW, BECAUSE I READ IT IN A BOOK (OH, ALL RIGHT, IT WAS *THE MAGIC MIRROR OF M.C. ESCHER BY BRUNO ERNST*), THAT IN A CENTRAL CYLINDRICAL PROJECTION THOSE CURVES ARE SINUSOIDS.

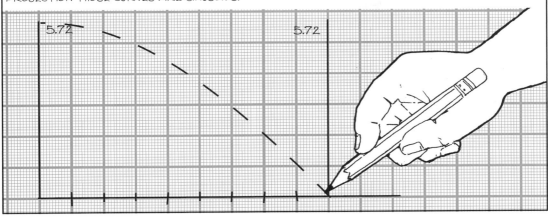

TO CONSTRUCT A SINSUSOID, FIRST DRAW A QUARTER CIRCLE WITH YOUR EDGE LENGTH AS RADIUS (HALF-DIAMETER).

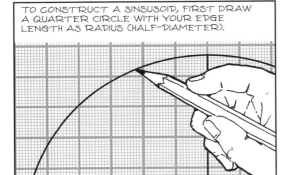

DIVIDE IT INTO NINE EQUAL SECTIONS WITH A PROTRACTOR (EASY TO DO – THAT'S EVERY TEN DEGREES).

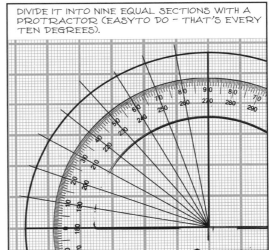

THEN CARRY THE HEIGHTS OF EACH INTERSECTION OVER TO VERTICAL LINES ONE INCH APART –

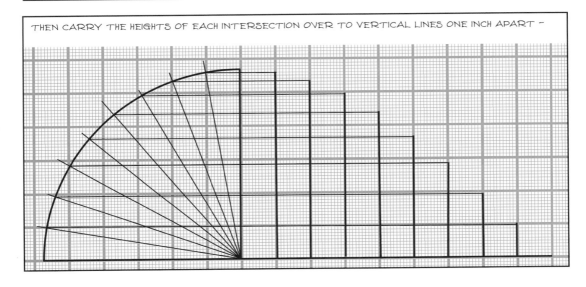

AND THAT'S YOUR SINUSOID!

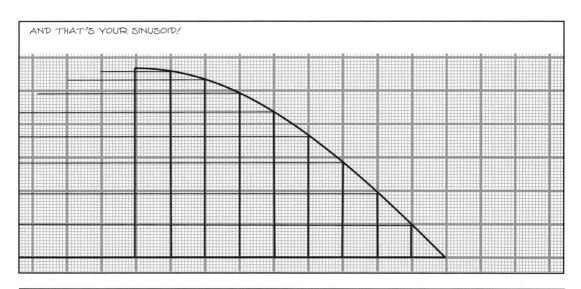

MIRROR AND REPEAT THE CURVE A FEW TIMES TO COVER THE WHOLE HORIZON. THE PLACES WHERE THE CURVES INTERSECT ON THE HORIZON ARE VANISHING POINTS.

HEAVY UP THE TOP AND BOTTOM CURVES AND ADD TWO VERTICAL SIDE EDGES TO MAKE A SINGLE SQUARE.

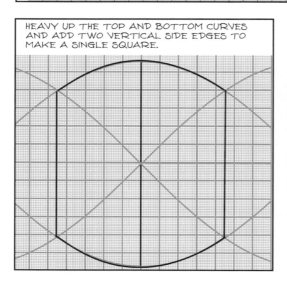

MARK OFF A NUMBER OF EQUAL DIVISIONS ON THE SIDE EDGES AND ON THE MIDLINE – I HAVE DIVIDED THEM UP IN EIGHTHS.

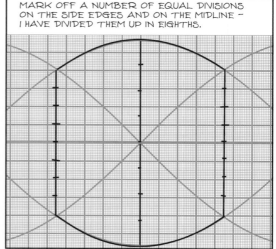

LINK THOSE POINTS WITH CURVES THAT ARE FLATTENED VERSIONS OF THE TOP AND BOTTOM EDGES.

LINES RECEDING FROM ADJACENT SQUARES TO THE VANISHING POINT COINCIDE WITH THE SQUARE'S DIAGONALS. WHERE THEY CROSS THE HORIZONTAL DIVISIONS, ERECT VERTICAL LINES TO DIVIDE UP THAT SQUARE INTO SMALLER SQUARES.

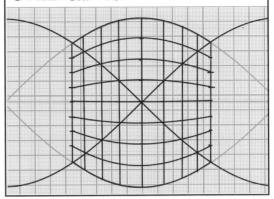

ADD MORE CURVED LINES TO DEFINE SQUARES AT THE TOP AND BOTTOM. PROJECT DIVISIONS ONTO A LINE CONTINUING FROM THE MIDPOINT TO DETERMINE HOW DEEP TO MAKE THE CURVES.

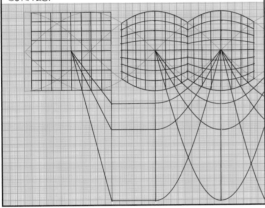

KEEP MIRRORING AND REPEATING...

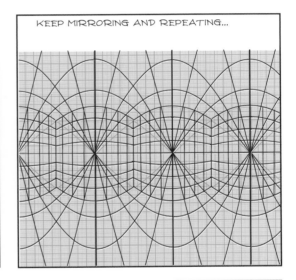

AND YOU'LL WIND UP WITH A GRID THAT LOOKS SOMETHING LIKE THIS.

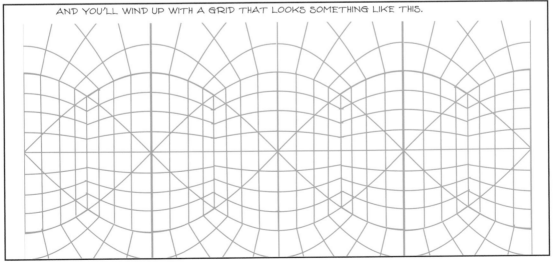

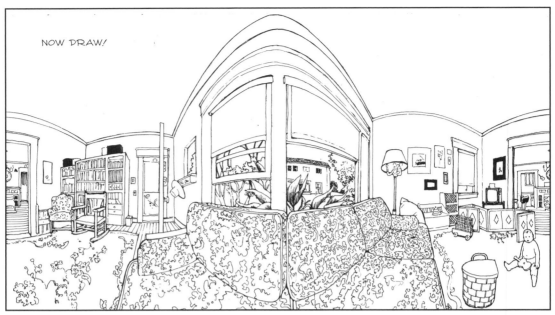

NOW DRAW!

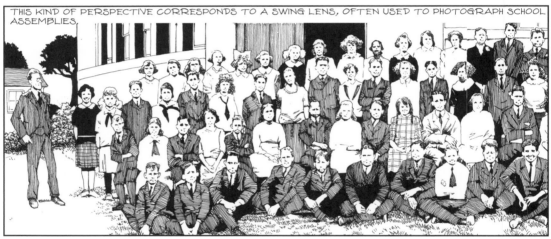

THIS KIND OF PERSPECTIVE CORRESPONDS TO A SWING LENS, OFTEN USED TO PHOTOGRAPH SCHOOL ASSEMBLIES.

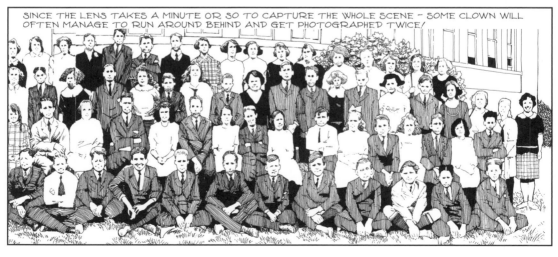

SINCE THE LENS TAKES A MINUTE OR SO TO CAPTURE THE WHOLE SCENE – SOME CLOWN WILL OFTEN MANAGE TO RUN AROUND BEHIND AND GET PHOTOGRAPHED TWICE!

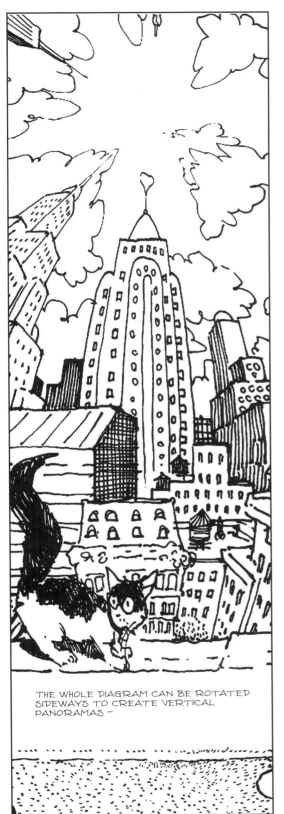

THE WHOLE DIAGRAM CAN BE ROTATED SIDEWAYS TO CREATE VERTICAL PANORAMAS —

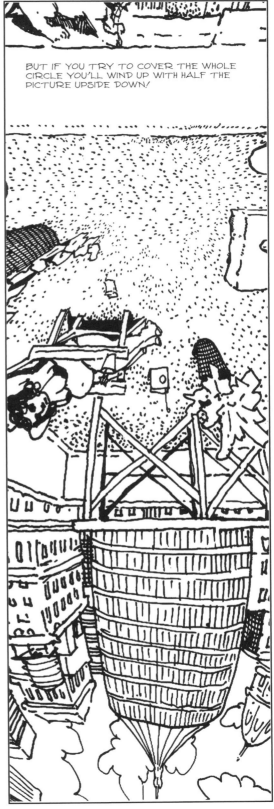

BUT IF YOU TRY TO COVER THE WHOLE CIRCLE YOU'LL WIND UP WITH HALF THE PICTURE UPSIDE DOWN!

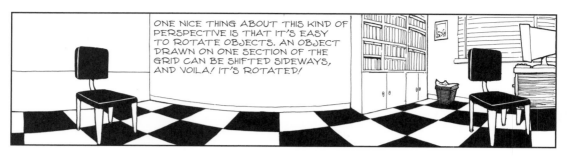

ONE NICE THING ABOUT THIS KIND OF PERSPECTIVE IS THAT IT'S EASY TO ROTATE OBJECTS. AN OBJECT DRAWN ON ONE SECTION OF THE GRID CAN BE SHIFTED SIDEWAYS, AND VOILA! IT'S ROTATED!

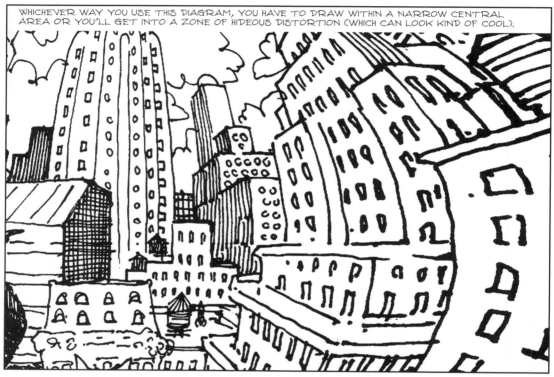

WHICHEVER WAY YOU USE THIS DIAGRAM, YOU HAVE TO DRAW WITHIN A NARROW CENTRAL AREA OR YOU'LL GET INTO A ZONE OF HIDEOUS DISTORTION (WHICH CAN LOOK KIND OF COOL).

THE REASON FOR THIS IS THE DIFFERING SHAPE OF THE CYLINDER – STRAIGHT WHEN YOU LOOK AT IT FROM THE SIDE, BUT ROUND IF YOU LOOK AT IT FROM THE TOP OR BOTTOM!

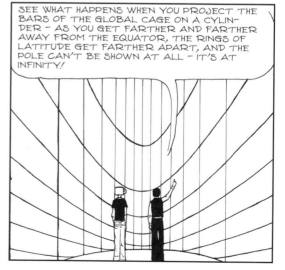

SEE WHAT HAPPENS WHEN YOU PROJECT THE BARS OF THE GLOBAL CAGE ON A CYLINDER – AS YOU GET FARTHER AND FARTHER AWAY FROM THE EQUATOR, THE RINGS OF LATITUDE GET FARTHER APART, AND THE POLE CAN'T BE SHOWN AT ALL – IT'S AT INFINITY!

IS THERE SOME WAY TO TWEAK THE PROPORTIONS SO THERE'S LESS DISTORTION?

WELL, THERE IS ANOTHER PROJECTION KNOWN AS EQUIRECTANGULAR.

IMAGINE THE LINES OF LONGITUDE STRAIGHTENING OUT WHILE MAINTAINING THEIR LENGTH. THE RINGS OF LATITUDE EXPAND UNTIL THEY'RE ALL THE WIDTH OF THE EQUATOR, AND THE POLES BECOME RINGS AT THE TOP AND BOTTOM.

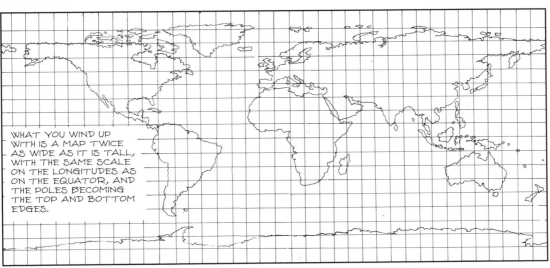

WHAT YOU WIND UP WITH IS A MAP TWICE AS WIDE AS IT IS TALL, WITH THE SAME SCALE ON THE LONGITUDES AS ON THE EQUATOR, AND THE POLES BECOMING THE TOP AND BOTTOM EDGES.

HERE IS HOW IT TRANSLATES INTO A CYLINDRICAL PERSPECTIVE USING THE CUBE CAGE.

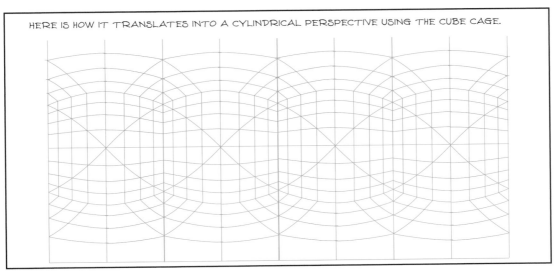

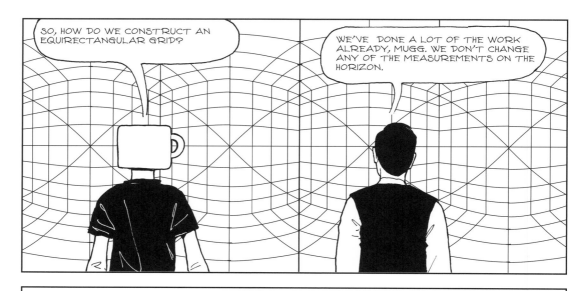

SO, HOW DO WE CONSTRUCT AN EQUIRECTANGULAR GRID?

WE'VE DONE A LOT OF THE WORK ALREADY, MUGG. WE DON'T CHANGE ANY OF THE MEASUREMENTS ON THE HORIZON.

WE TAKE THE MEASUREMENTS FOR THE LENGTH OF A SQUARE'S MIDLINE — NINE INCHES, EQUIVALENT TO 90° — FROM THE HORIZON, AND DRAW VERTICAL LINES THAT LENGTH CENTERED ON THE VANISHING POINTS. HALFWAY BETWEEN WE DRAW LINES REPRESENTING THE EDGES. THEY ARE THE SAME LENGTH AS THE MIDLINES, BUT FARTHER FROM YOUR EYE SO THEY ARE DRAWN SHORTER. WE TAKE THEIR DIMENSIONS FROM THE SHORT SIDE OF THE ROOT2 RECTANGLE — THE CROSS SECTION OBTAINED BY SLICING A CUBE DIAGONALLY — APPROXIMATELY 70°, WHICH TRANSLATES TO SEVEN INCHES, 3.5 INCHES ABOVE AND BELOW THE HORIZON.

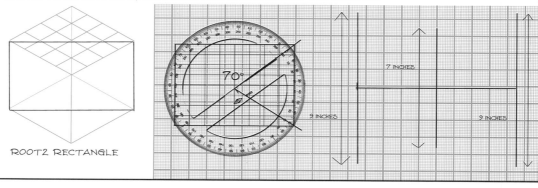

ROOT2 RECTANGLE

NOW WE HAVE TO FIGURE OUT THE CURVATURE OF LINES GOING BACK TO THE VANISHING POINT. WE'VE ESTABLISHED THREE POINTS OF THE LINE ALREADY BUT I'D FEEL BETTER IF WE HAD A FEW MORE. LET'S ADD ANOTHER POINT BETWEEN THE MIDPOINT AND THE EDGE.

IF WE PLACE THE MIDPOINT OF THE SQUARE AT 0°, THE EDGE WILL NATURALLY BE AT 45°. A DIVIDING LINE HALFWAY BETWEEN THEM WILL BE VERY CLOSE TO 27°.

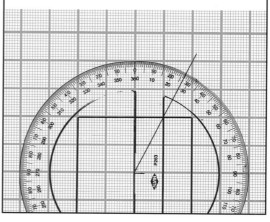

ON OUR GRAPH THAT TRANSLATES TO TWO AND SEVEN TENTHS INCHES, SO THAT'S WHERE WE DRAW THE LINE — BUT WE STILL DON'T KNOW HOW TALL TO MAKE IT.

THIS NEXT BIT'S TRICKY. WE METAPHORICALLY CUT THE CUBE IN HALF, SLICING FROM THAT POINT HALFWAY BETWEEN THE MIDDLE AND THE CORNER, THROUGH THE CENTER OF THE TOP SQUARE TO THE POINT DIRECTLY OPPO-SITE, AND THEN CUTTING STRAIGHT DOWN.

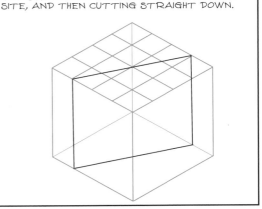

THE RESULTING RECTANGLE HAS THE HEIGHT OF THE CUBE EDGE AND THE WIDTH OF THE DIAGONAL. WE SET A PROTRACTOR UP WITH THE HORIZON AT 0° AND THE HORIZON AT 90°, AND THE EDGE FALLS CLOSE TO 41°.

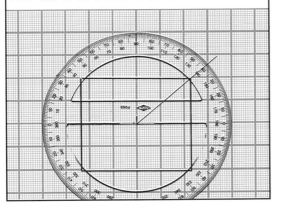

WHICH TRANSLATES TO FOUR AND ONE TENTH INCHES ABOVE THE HORIZON. OUR CURVE IS STARTING TO TAKE SHAPE.

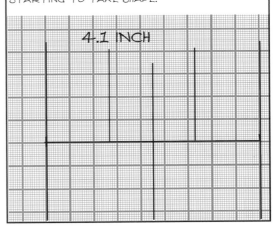

4.1 INCH

ON THE NEXT SQUARE OVER WE ADD A MIRROR IMAGE OF THAT LINE. THE CURVE WE WANT TO DRAW WILL INTERSECT THE LINE HALFWAY UP, SO IT'S BACK TO THE PROTRACTOR.

A POINT MIDWAY BETWEEN THE HORIZON AND THE EDGE FALLS CLOSE TO 23° ON THE PROTRACTOR.

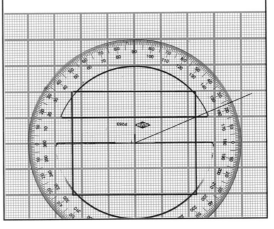

ONCE WE DRAW IN THAT POINT AT TWO AND THREE TENTHS INCHES ABOVE THE HORIZON, WE CAN COMPLETE THE CURVE...

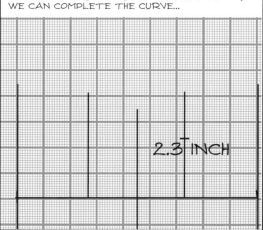

2.3 INCH

...LIKE SO!

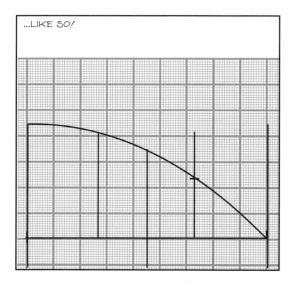

MIRRORING AND COPYING THE BASIC CURVE, WE START TO SEE WHAT OUR DIAGRAM IS GOING TO LOOK LIKE –

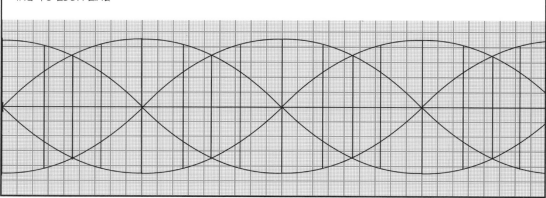

NEXT, WE START TO DIVIDE UP OUR BASIC SQUARE. THE HALFWAY POINT ON THE VERTICAL MIDLINE IS THE SAME AS ON THE HORIZON – 2.7 INCHES. WE REFER BACK TO THE ROOT2 RECTANGLE TO FIND THE POINT ON IT MIDWAY BETWEEN THE HORIZON AND THE CORNER – 20°, WHICH TRANSLATES TO TWO INCHES EVEN ON THE GRAPH.

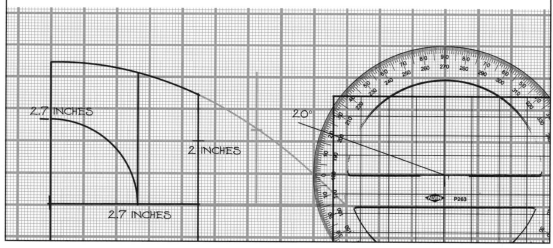

2.7 INCHES

2 INCHES

2.7 INCHES

20°

A MIRRORED COPY OF THE CURVE WE JUST DREW COINCIDES WITH THE SQUARE'S DIAGONAL. THE INTERSECTION OF THAT DIAGONAL WITH THE LINE IN THE MIDDLE GIVES US ONE MORE POINT —

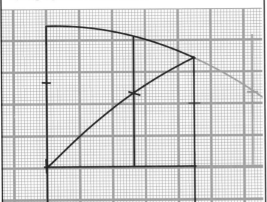

— ENOUGH TO COMPLETE THE LINE.

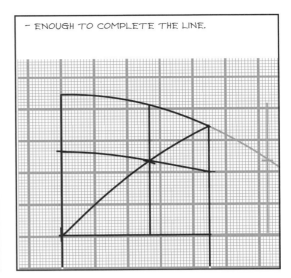

COPY AND MIRROR THAT SECTION TO COMPLETE THE SQUARE.

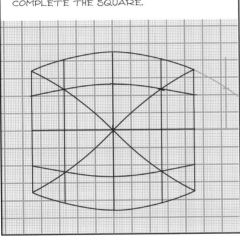

YOU CAN INCLUDE BOTH NADIR AND ZENITH — THEY FORM THE TOP AND BOTTOM EDGES OF YOUR GRID, AT 90° FROM THE HORIZON, OR NINE INCHES. THE MIDPOINT OF EACH TOP SQUARE IS AT 6.3 INCHES (OR NINE MINUS 2.7 INCHES). THE EDGE DIVIDING TWO SQUARES CONTINUES AS A LONG DIAGONAL, AND MEASUREMENTS FOR IT ARE TAKEN ON THE LONG SIDE OF A ROOT2 RECTANGLE. THE POINT HALFWAY BETWEEN THE CORNER AND THE ZENITH IS AT 55, OR 5.5 INCHES ABOVE THE HORIZON.

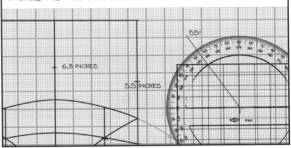

HERE'S ONE QUARTER OF THE TOP SQUARE —

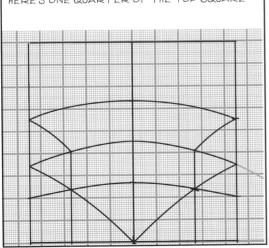

AND HERE'S THE WHOLE THING MIRRORED AND REPEATED A FEW TIMES —

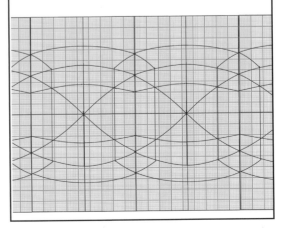

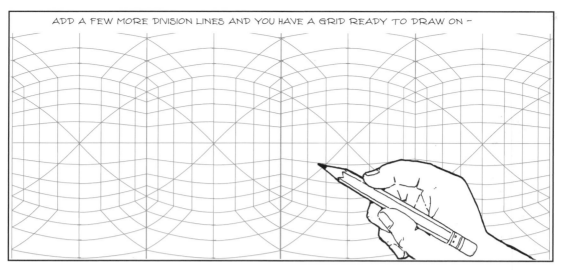

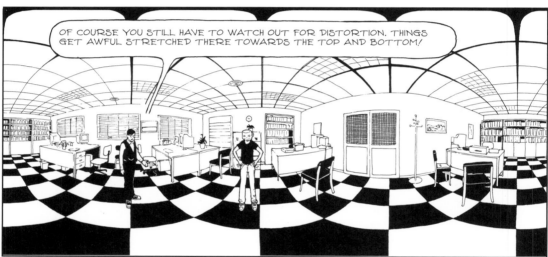

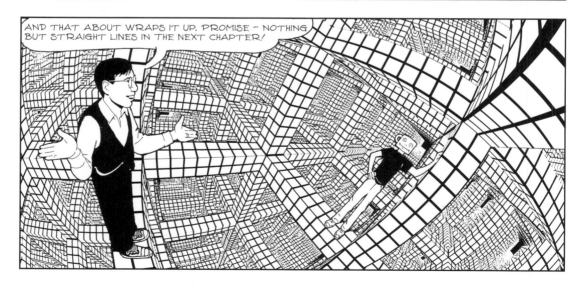

CHAPTER 8
Parallel Play

After all that in-your-face curvilinear perspective, we are now going to step way, way back and enter a world without vanishing points. In paraline drawing, your distance from the scene is infinite, so all lines run parallel and objects don't appear to diminish with distance. The rules of perspective are temporarily suspended, and you are free to wander as far as you like without changing scale, worrying about anamorphic distortion or bumping up against the vanishing point. It may be a temporary vacation from the rigors of perspective. Or perhaps, like the denizens of architectural sketches, Far Eastern art, and certain video games, you will never want to leave.

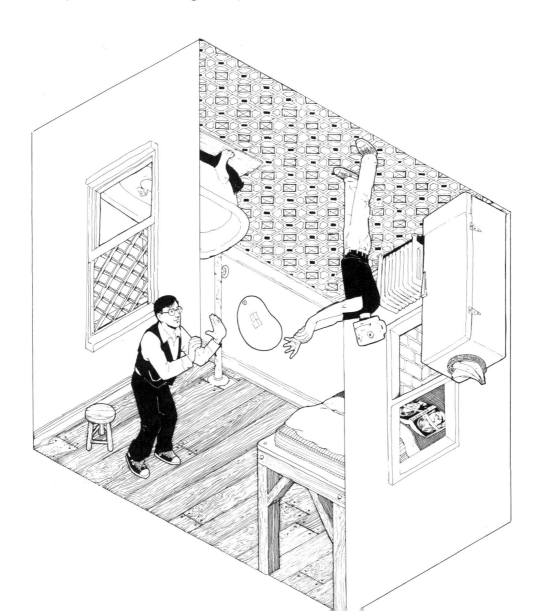

OK, MUGG, NOW THAT WE'VE SPENT THREE CHAPTERS COVERING A WIDE, WIDE ANGLE, LET'S NARROW IT DOWN FOR A CHAPTER.

FIRST LET ME ASK YOU A QUESTION – WHAT DO YOU SUPPOSE PERSPECTIVE WOULD LOOK LIKE FROM THE VANISHING POINT?

UH – IT WOULD VANISH?

PRECISELY!

WE'RE AT THE VANISHING POINT?

CLOSE ENOUGH. LOOK THROUGH THE TELESCOPE AT THAT TINY BLUE PLANET. WHAT DO YOU SEE?

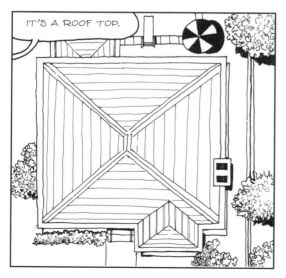

IT'S A ROOF TOP.

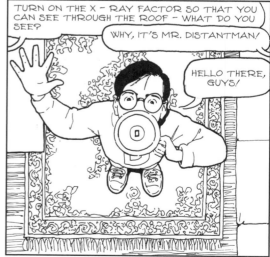

TURN ON THE X – RAY FACTOR SO THAT YOU CAN SEE THROUGH THE ROOF – WHAT DO YOU SEE?

WHY, IT'S MR. DISTANTMAN!

HELLO THERE, GUYS!

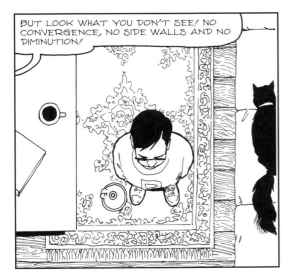

BUT LOOK WHAT YOU DON'T SEE! NO CONVERGENCE, NO SIDE WALLS AND NO DIMINUTION!

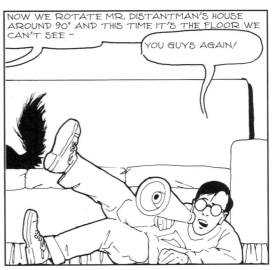

NOW WE ROTATE MR. DISTANTMAN'S HOUSE AROUND 90° AND THIS TIME IT'S THE FLOOR WE CAN'T SEE –

YOU GUYS AGAIN!

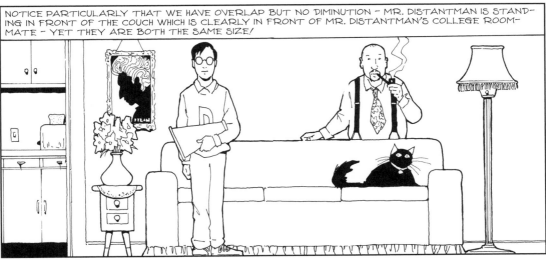

NOTICE PARTICULARLY THAT WE HAVE OVERLAP BUT NO DIMINUTION – MR. DISTANTMAN IS STANDING IN FRONT OF THE COUCH WHICH IS CLEARLY IN FRONT OF MR. DISTANTMAN'S COLLEGE ROOMMATE – YET THEY ARE BOTH THE SAME SIZE!

WHAT'S HE DOING?

I THINK MR. DISTANTMAN IS SHOWING HIS COLLEGE ROOMMATE HIS NEW FLAT SCREEN TV!

WHERE IS IT?

ON THE SIDE WALL, OF COURSE. THE ONE WE CAN'T SEE.

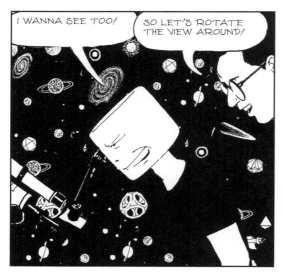

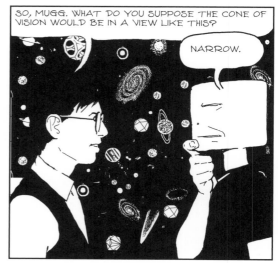

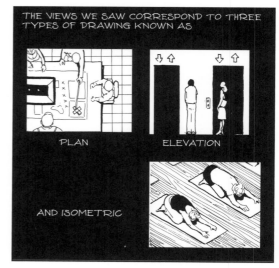

PLAN ELEVATION

AND ISOMETRIC

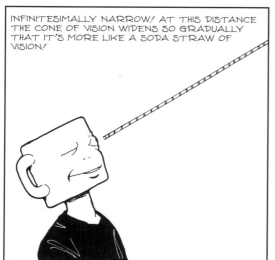

PLAN AND ELEVATION ARE LIKE EXTREME MAGNIFICATIONS OF WHAT YOU SEE AT THE CENTER OF VISION IN A ONE POINT VIEW – THEREFORE, THE ENTIRE PICTURE IS AT THE CENTER OF VISION!

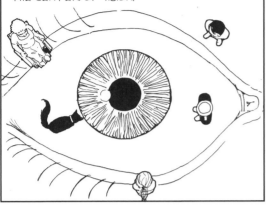

ARCHITECTS AND BUILDERS USE PLANS AND ELEVATIONS IN WORKING DRAWINGS BECAUSE THE LACK OF DIMINUTION MEANS MEASUREMENTS CAN BE MADE ON THEM AT A CONSISTENT SCALE.

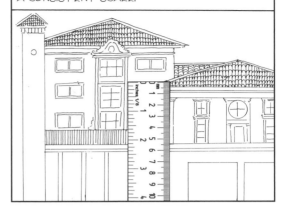

ISOMETRIC IS LIKE AN EXTREME MAGNIFICATION OF WHAT YOU SEE AT THE CENTER OF VISION IN A PERFECTLY EQUILATERAL THREE POINT VIEW – IN TERMS OF THE CAGE, YOU'RE LOOKING DIRECTLY AT ONE OF THE CORNERS.

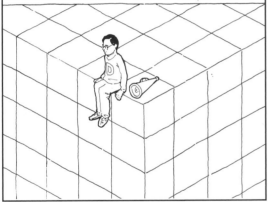

ARCHITECTS AND BUILDERS ALSO USE ISOMETRIC BECAUSE ALL THREE AXES ARE EQUALLY FORESHORTENED AND THEREFORE THE SCALE OF MEASUREMENTS ALONG THEM ARE EQUAL.

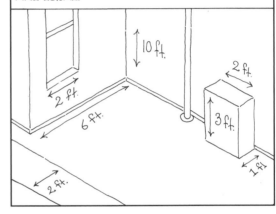

COLLECTIVELY, ALL THESE TYPES OF DRAWING ARE KNOWN AS PARALINE SYSTEMS BECAUSE LINES IN THE SAME DIRECTION RUN PARALLEL THROUGHOUT THE PICTURE – NO VANISHING POINTS!

YOU SEE ISOMETRIC A LOT IN OLD SCHOOL VIDEO GAMES.

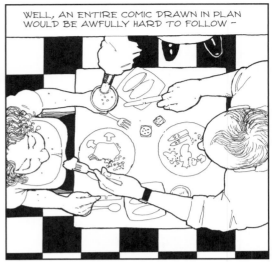

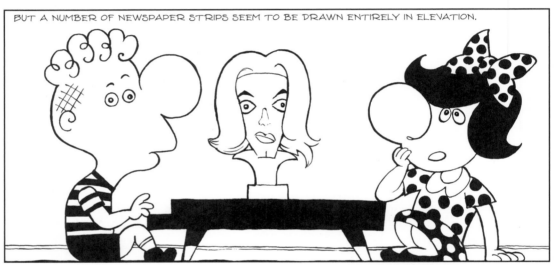

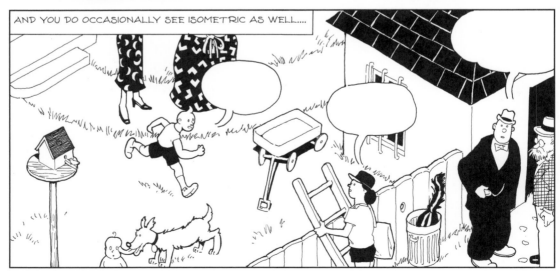

ISOMETRIC IS THE MOST INTERESTING TO ME, SO LET'S EXPLORE HOW TO DRAW IT. A CUBE IN ISOMETRIC HAS THE SILHOUETTE OF A PERFECT HEXAGON, WITH THE NEAR CORNER EXACTLY OVERLAPPING THE FAR CORNER.

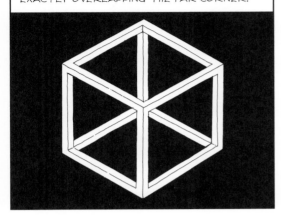

ALL VERTICALS ARE TRUE VERTICALS, AND BOTH SETS OF FLOOR LINES MAKE ANGLES OF 30° WITH THE HORIZONTAL.

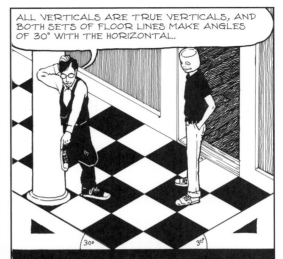

ALL CIRCLES ARE IDENTICAL ELLIPSES, THE PERSPECTIVE CENTER EXACTLY COINCIDES WITH THE ELLIPSE'S CENTER, AND THAT SHORT AXIS RULE THAT GAVE US SO MUCH TROUBLE IN TWO POINT PERSPECTIVE WORKS ANYWHERE IN THE PICTURE. ALL SPHERES HAVE CIRCULAR OUTLINES.

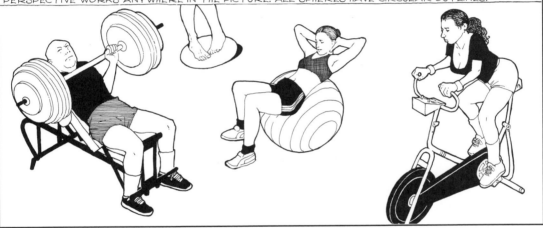

ALTHOUGH MEASUREMENTS ALONG THE THREE MAIN AXES ARE EQUAL, THEY ARE NOT IN OTHER DIRECTIONS, SO WATCH OUT!

SINCE YOUR DISTANCE IS INFINITE, OBJECTS CLOSE TO THE OBSERVER APPEAR NO BIGGER THAN THOSE FARTHER BACK. YOU NEED OVERLAP TO TELL YOU WHICH IS CLOSER!

BECAUSE AN INTERIOR AND EXTERIOR VIEW OF A CUBE LOOK THE SAME, YOU CAN PLAY SOME PRETTY CUTE VISUAL TRICKS IN ISOMETRIC!

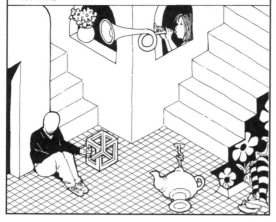

IT'S PRETTY EASY TO DRAW IN ISOMETRIC – ALL YOU REALLY NEED IS A 30° – 60° TRIANGLE AND MAYBE A SET OF ISOMETRIC ELLIPSE TEMPLATES.

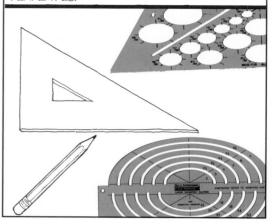

YOU CAN SAVE YOURSELF EVEN MORE WORK BY USING ISOMETRICALLY RULED PAPER, AVAILABLE AT BETTER ART SUPPLY STORES.

ISOMETRIC, PLAN AND ELEVATION AREN'T THE ONLY KINDS OF PARALINE SYSTEMS, IN FACT, THERE ARE AN INFINITE NUMBER!

AGAIN WITH THE INFINITE!

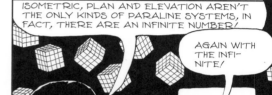

ANY ANGLE YOU CAN VIEW THE CUBE FROM CAN BE THE BASIS FOR A PARALINE DRAWING.

ROTATING THE CUBE VERTICALLY PRODUCES A VIEW SOMEWHERE BETWEEN A PLAN AND AN ELEVATION CALLED A VERTICAL OBLIQUE. IT'S LIKE AN EXTREME MAGNIFICATION OF THE CENTER OF VISION IN A TWO POINT VIEW.

ONE CAN SEE THE FLOOR AND THE BACK WALL, BUT NOTICE THE SIDE WALL IS STILL INVISIBLE.

ROTATE THE CUBE HORIZONTALLY TO GET
A VIEW SOMEWHERE BETWEEN TWO ELEVA-
TIONS CALLED A HORIZONTAL OBLIQUE. YOU
CAN SEE TWO WALLS, BUT NOT THE FLOOR,

SO WATCH OUT, MR. DISTANTMAN!

VERTICAL OBLIQUE IS OFTEN SEEN IN ISLAMIC
ART –

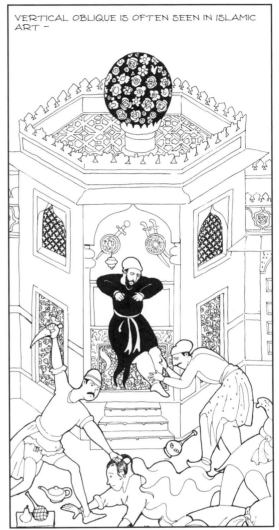

HORIZONTAL OBLIQUE IS MORE COMMONLY SEEN IN FAR EASTERN ART.

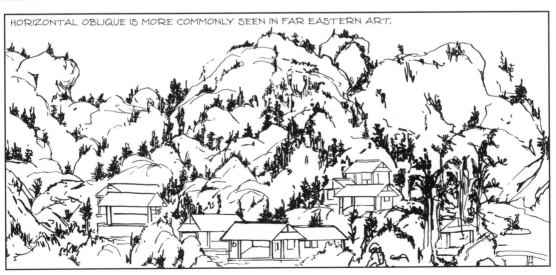

IN ADDITION TO ISOMETRIC, THERE ARE AN INFINITE NUMBER OF POSSIBLE PARALINE VIEWS IN WHICH THE CUBE IS ROTATED TO SHOW A CORNER, BUT IN WHICH THE SIDES ARE UNEQUALLY FORESHORTENED.

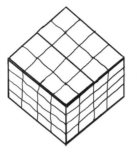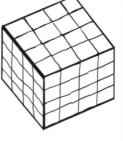

IN DIMETRIC VIEWS, TWO AXES ARE EQUALLY FORESHORTENED.

IN TRIMETRIC VIEWS, ALL THREE AXES ARE UNEQUALLY FORESHORTENED.

IN ANY SUCH VIEW, JUST AS IN ISOMETRIC, SPHERES ARE DRAWN AS CIRCLES, ELLIPSES FOLLOW THE SHORT AXIS RULE, AND THE DRAWING CAN BE INFINITELY EXTENDED.

THERE IS ANOTHER TYPE OF PARALINE DRAWING CALLED A PLAN OBLIQUE, CONSTRUCTED BY TAKING A PLAN VIEW AND ERECTING VERTICALS OFF IT –

A VARIANT CONSTRUCTED BY ADDING RECEDING PARALLEL LINES TO AN ELEVATION IS CALLED AN ELEVATION OBLIQUE.

IN SOME BOOKS, PLAN AND ELEVATION OBLIQUES ARE CALLED AXONOMETRICS, THOUGH OTHER BOOKS CALL THEM ISOMETRICS. THE TERMINOLOGY IS ALL MIXED UP – BUT I'M STICKING WITH MINE!

IN TERMS OF THE CAGE, IT'S LIKE TAKING A TINY SECTION OF THE VIEW, AWAY FROM THE CENTER OF VISION IN A CORNER SOMEWHERE, AND BLOWING IT WAY UP. ONE PLANE FACES YOU FRONTALLY WHILE THE OTHER TWO RECEDE.

ARCHITECTS USE THIS KIND OF DRAWING EVEN MORE THAN ISOMETRIC — THEY ALREADY HAVE THE PLANS AND ELEVATIONS SITTING AROUND!

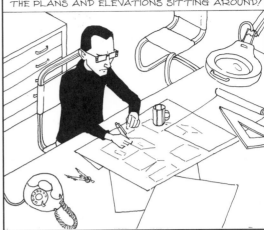

MEASUREMENT ALONG THE TWO AXES OF THE PLAN ARE EQUAL, WHILE THE OTHER SCALE CAN BE WHATEVER YOU LIKE.

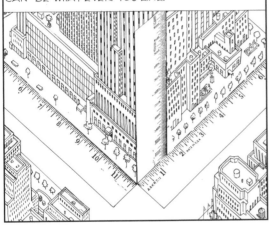

CIRCLES IN PLAN ARE TRUE CIRCLES, WHILE CIRCLES ON RECEDING PLANES ARE ELLIPTICAL (AND DO NOT FOLLOW THE SHORT AXIS RULE).

THERE IS CERTAIN AMOUNT OF UNAVOIDABLE DISTORTION IN PLAN AND ELEVATION OBLIQUES THAT BECOMES OBVIOUS ONCE YOU INTRODUCE A SPHERICAL OBJECT OR HUMAN FIGURE —

AS WITH OTHER PARALINE SYSTEMS, PLAN AND ELEVATION OBLIQUES ARE INFINITELY EXTENDABLE...

SO, HOW DO YOU DRAW THESE PARANOID ANTIOXIDANTS, ANYWAY?

I WAS JUST ABOUT TO TELL YOU.

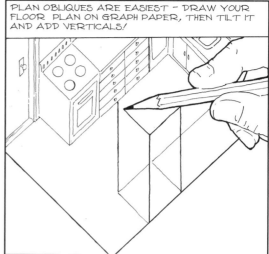

PLAN OBLIQUES ARE EASIEST — DRAW YOUR FLOOR PLAN ON GRAPH PAPER, THEN TILT IT AND ADD VERTICALS!

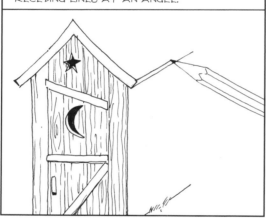

OR MAYBE ELEVATION OBLIQUES ARE EASIER — YOU DON'T HAVE TO TILT ANYTHING, JUST DRAW AN ELEVATION AND THEN ADD RECEDING LINES AT AN ANGLE.

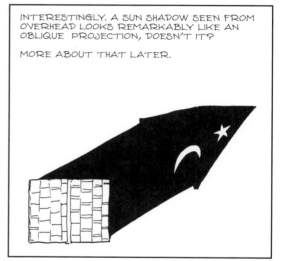

INTERESTINGLY. A SUN SHADOW SEEN FROM OVERHEAD LOOKS REMARKABLY LIKE AN OBLIQUE PROJECTION, DOESN'T IT?

MORE ABOUT THAT LATER.

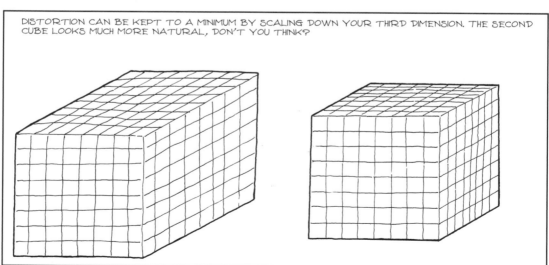

DISTORTION CAN BE KEPT TO A MINIMUM BY SCALING DOWN YOUR THIRD DIMENSION. THE SECOND CUBE LOOKS MUCH MORE NATURAL, DON'T YOU THINK?

HORIZONTAL OBLIQUES ARE ALMOST AS EASY TO DRAW - START BY DRAWING TWO SQUARES, ONE STRAIGHT, ONE TILTED.

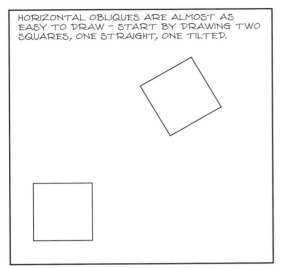

WHERE VERTICAL LINES FROM THE CORNERS CROSS, YOU'VE GOT THE CORNERS OF YOUR CUBE!

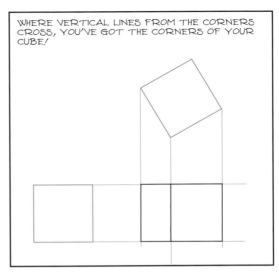

THE DEGREE OF ROTATION OF YOUR TOP SQUARE WILL DETERMINE THE APPEARANCE OF YOUR CUBE.

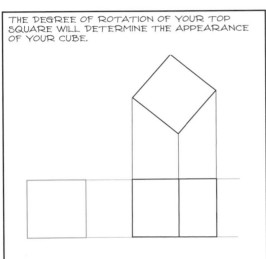

A VERTICAL OBLIQUE IS NOTHING BUT THE SAME DIAGRAM TURNED SIDEWAYS.

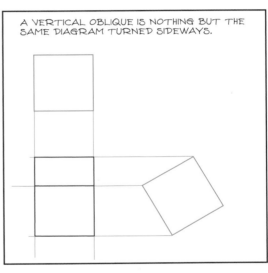

I HAVE TWO METHODS OF DRAWING DI-METRICS AND TRIMETRICS - IN ONE, START BY DRAWING A HORIZONTAL OBLIQUE.

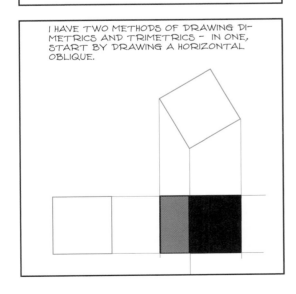

NOW DRAW TWO REVERSED COPIES OF THAT HORIZONTAL OBLIQUE WHICH REPRESENT VIEWS FROM EITHER SIDE - THE COLORING SHOULD MAKE THIS CLEAR - AND ROTATE THEM EQUALLY IN OPPOSITE DIRECTIONS.

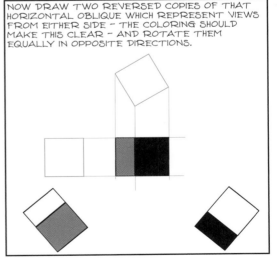

CARRY DOWN LINES FROM YOUR HORIZONTAL OBLIQUE, AND WHERE THEY CROSS LINES FROM THE ROTATED RECTANGLES, THERE ARE THE TWO FRONT SIDES OF YOUR CUBE.

BY ADDING PARALLEL LINES RUNNING UP FROM THE OUTER CORNERS, YOU CAN COMPLETE THE TOP OF THE CUBE.

ONCE YOU HAVE THE BASIC SHAPE OF THE CUBE, YOU CAN DIVIDE IT UP INTO EQUALLY SIZED SMALLER SQUARES FOR CONSISTENT SCALE.

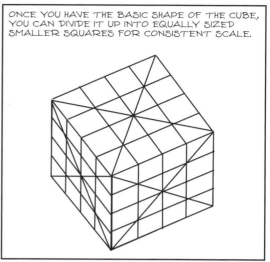

I SUPPOSE IT GOES WITHOUT SAYING THAT THERE ARE AN INFINITE NUMBER OF POSSIBLE DIMETRIC AND TRIMETRIC VIEWS, DEPENDING ON HOW YOU ROTATE THE VARIOUS SQUARES –

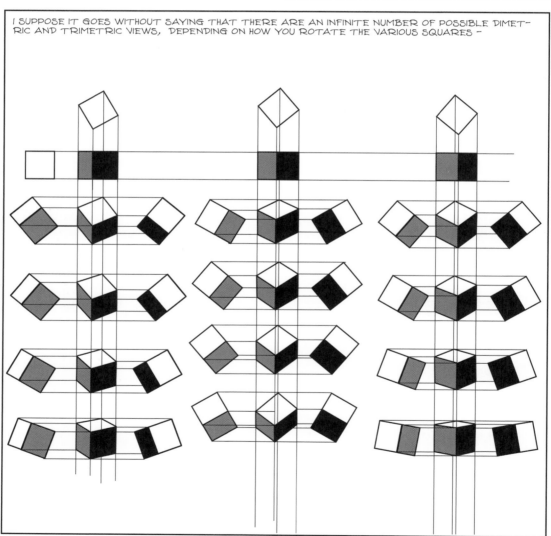

IF YOU START WITH YOUR TOP SIDE ROTATED 45°, THE CUBE IS DIMETRIC, OTHERWISE THE VIEW IS MOST LIKELY TRIMETRIC.

DIMETRIC VIEWS HAVE A SOMEWHAT BORING SYMMETRICAL APPEARANCE...

...BUT YOU CAN DISGUISE THAT BY ROTATING THE DIAGRAM SIDEWAYS.

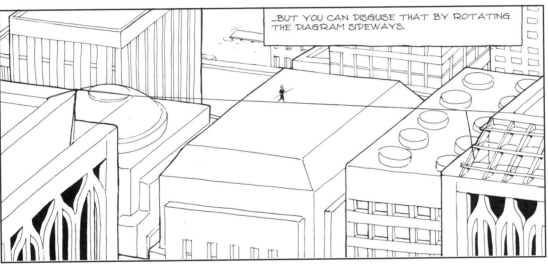

THIS VARIANT OF DIMETRIC, WITH THE FLOOR LINES AT 71° AND 41° TO THE HORIZONTAL, IS PARTICULARLY USEFUL BECAUSE ONE AXIS IS SCALED TO EXACTLY HALF OF THE OTHER TWO.

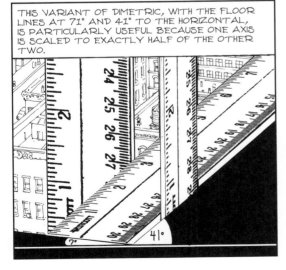

IF YOU TAKE CARE ALWAYS TO START YOUR CONSTRUCTION WITH THE SAME SIZE SQUARE, ANY HORIZONTAL OR VERTICAL OBLIQUE, DIMETRIC OR TRIMETRIC WILL BE IN CONSISTENT SCALE, SO YOU CAN MIX DIFFERENTLY TIPPED OBJECTS IN THE SAME PICTURE.

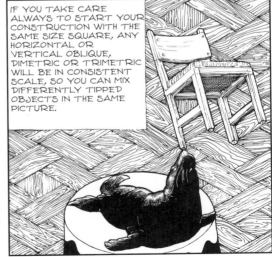

MY SECOND METHOD IS SIMPLER, BUT NOT QUITE AS ACCURATE. START BY DRAWING A TRIANGLE WITH A HORIZONTAL TOP LINE AND A BOTTOM ANGLE GREATER THAN 90°. ADD A VERTICAL LINE BELOW THE BOTTOM CORNER.

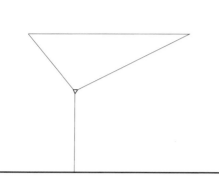

WHAT YOU WANT TO DO NEXT IS DRAW A LINE PERPENDICULAR TO THE SLANTING LINE ON THE RIGHT, EXTENDING FROM THE LEFT TOP CORNER TO INTERSECT THE VERTICAL LINE AND MAKE A NEW BOTTOM CORNER.

ADD ANOTHER LINE FROM THAT BOTTOM CORNER TO THE TOP RIGHT CORNER AND YOU SHOULD HAVE A BIG TRIANGLE WITH THREE SMALLER TRIANGLES INSIDE IT.

TRY TO SEE THAT TRIANGLE OF TRIANGLES AS THE CORNER OF AN OBLIQUELY ROTATED CUBE POKING THROUGH THE PICTURE PLANE.

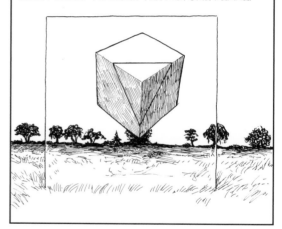

NEXT, DRAW A CIRCLE AROUND THE ENDS OF THE TOP LINE USING A COMPASS AND MARK WHERE IT INTERSECTS THE VERTICAL LINE. LINES DRAWN FROM THAT POINT TO THE UPPER TWO CORNERS MEET AT EXACTLY 90°.

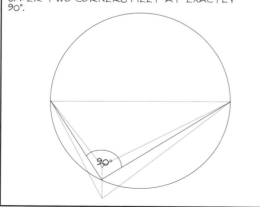

LINE A UP A PROTRACTOR WITH THOSE LINES AT 0° AND 90° AND PLACE A RULER AT 45° TO FIND A POINT ON THE TOP LINE.

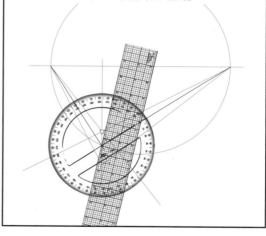

THERE IT IS!

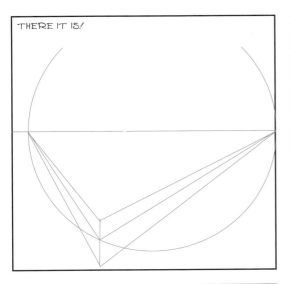

NOW WE DRAW A LINE PERPENDICULAR TO THE LEFT EDGE OF THE TRIANGLE EXTENDING TO THE RIGHT UPPER CORNER.

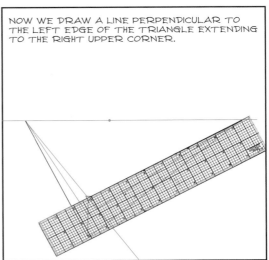

ANOTHER CIRCLE DRAWN AROUND THE LEFT EDGE INTERSECTING THAT PERPENDICULAR LINE WILL GIVE YOU ANOTHER 90° CORNER.

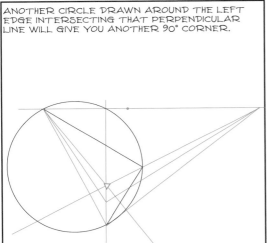

REPEAT THE PROCEDURE WITH THE PROTRACTOR AND RULER TO MAKE ANOTHER 45° MARK ON THE LEFT EDGE.

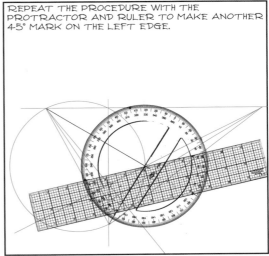

HERE IT IS!

YOU HAVE TWO MARKS ALREADY BUT YOU NEED TO FIND ONE MORE. HERE'S A QUICK WAY TO DO IT — DRAW LINES FROM THOSE MARKS TO OPPOSITE CORNERS —

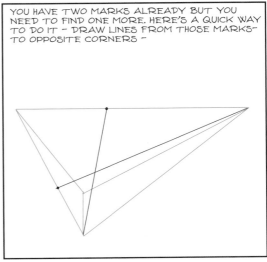

DRAW ANOTHER LINE FROM THE REMAINING CORNER THROUGH THE POINT WHERE THOSE LINES CROSS TO THE RIGHT EDGE AND YOU HAVE YOUR THIRD MARK!

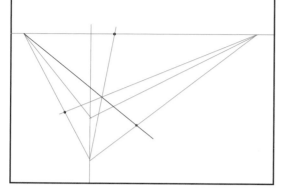

AND NOW YOU REALLY HAVE EVERYTHING YOU NEED FOR A FINISHED PARALINE DRAWING — THE DIRECTION FOR ALL THREE MAJOR AXES AND YOUR DIAGONALS.

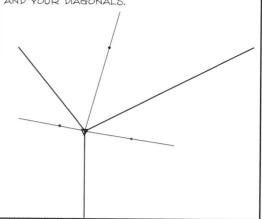

START ADDING LINES AND YOU'RE IN BUSINESS! USING DIAGONALS TO CREATE SUBDIVISIONS WILL GIVE YOU ACCURATE AND CONSISTENT MEASUREMENTS ANYWHERE IN THE DRAWING...

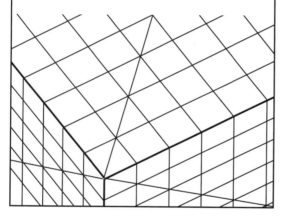

...WHICH YOU CAN CARRY OVER INTO ANY OBJECT YOU WISH TO DRAW.

ONCE YOU HAVE ONE CUBE DRAWN YOU CAN GENERATE MORE BY TILTING IT UP OR DOWN, KEEPING THE WIDTH THE SAME BUT CHANGING THE ANGLE OF RECEDING LINES, USING THE PROTRACTOR METHOD TO FIND DIAGONALS. MEASUREMENTS ON THIS NEW CUBE WILL BE CONSISTENT WITH THE FIRST.

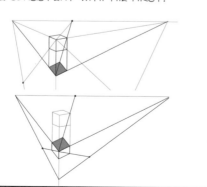

THE SAME METHOD WILL WORK TO CREATE NEW CUBES IN OTHER DIRECTIONS, NOT JUST VERTICALLY. DO THIS ENOUGH TIMES AND YOU CAN DRAW EVERY POSSIBLE ANGLE OF DIMETRIC AND TRIMETRIC CUBE.

EXTEND THE LINES OVER SO THAT THE CORNERS FORM A RIGHT ANGLE AND YOU HAVE AN UNFORSHORTENED SQUARE WHOSE SIDES ARE TRUE LENGTHS. THIS WILL COME IN HANDY WITH THE NEXT THING WE'RE GOING TO DO, NAMELY....

PROJECTION! WE TOUCHED ON THIS IN THE FIRST BOOK. START BY DRAWING FRONTAL AND PROFILE VIEWS OF YOUR OBJECT, PUT THEM INTO PERSPECTIVE AS IMAGES ON THE WALL, THEN DRAW LINES FORWARD FROM THE VANISHING POINTS TO MAKE INTERSECTIONS THAT DEFINE YOUR FIGURE. UNFORTUNATELY, THIS PROCEDURE IS SO TIME-CONSUMING YOU'LL PROBABLY QUIT BEFORE YOU'RE DONE!

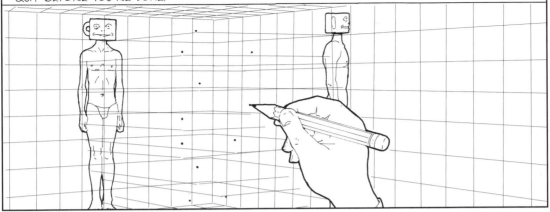

FORTUNATELY, IN PARALINE YOU CAN SKIP THAT MIDDLE STAGE AND PROJECT DIRECTLY FROM TWO VIEWS.

FOR A HORIZONTAL OBLIQUE, SET AN OVERHEAD VIEW UP TOP, ROTATED, WITH A FRONT OR PROFILE VIEW OFF TO THE SIDE.

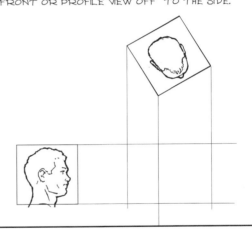

CROSSED LINES FROM CORRESPONDING POINTS GIVE YOU THE SHAPE OF YOUR OBJECT IN A VIEW SOMEWHERE BETWEEN FRONT AND PROFILE.

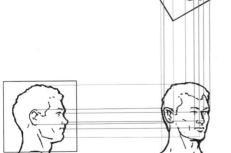

A FRONT VIEW AND PROFILE CAN COMBINE TO GIVE YOU A VERTICAL OBLIQUE VIEW WITH THE FIGURE TIPPED FORWARD OR BACK.

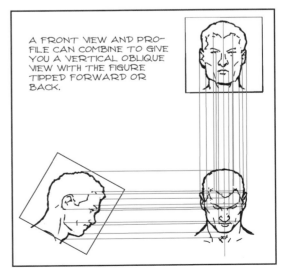

HERE'S HOW IT'S DONE FOR AN ISOMETRIC, DIMETRIC OR TRIMETRIC. YOU PROBABLY WON'T NEED A TOP VIEW – A FRONT AND PROFILE SHOULD GIVE YOU ALL THE INFORMATION YOU NEED.

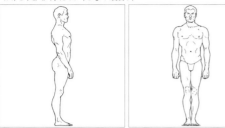

IT MAY SEEM TO WASTE SPACE, BUT WHAT-EVER THE SHAPE OF YOUR OBJECT, IT'S BEST TO MAKE THE DRAWING SQUARE.

NOW CONSTRUCT A CUBE, MAKING SURE TO START WITH A SQUARE THE SAME SIZE AS YOUR DRAWINGS, THEN DRAW LINES EXTEND-ING FROM THE CORNERS LIKE SO...

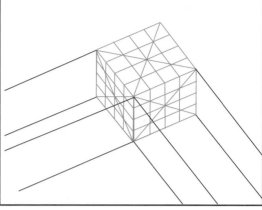

SET YOUR DRAWINGS ALONGSIDE THE CUBE, TILTED SO THEIR CORNERS LINE UP WITH THE LINES EXTENDING FROM THE CUBE'S COR-NERS.

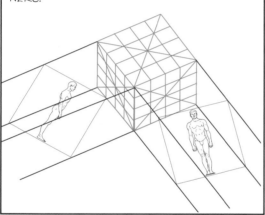

LINES EXTENDING FROM LIKE FEATURES ON THE TWO DRAWINGS MEET AND CRISSCROSS. MARK ENOUGH INTERSECTIONS, AND YOU HAVE YOUR DRAWING!

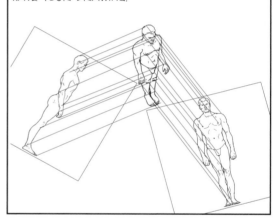

IT'S NOT JUST HUMAN FIGURES THAT YOU CAN DRAW THIS WAY. TRY IT OUT ON A COMPLEXLY CURVED OBJECT LIKE A CAR!

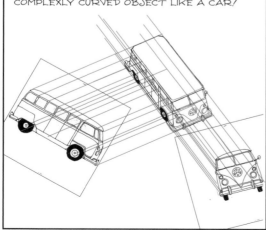

PARALINE CAN SAVE YOU TIME WHEN YOU'RE WORKING IN PERSPECTIVE. DID I REALLY NEED TO DRAW THOSE DICE THE HARD WAY?

CHAPTER 9
Reflections

The perspective of reflections is simple in concept, but in practice a world of hurt awaits. You can count on at least double the perspective labor on any drawing you add a mirror to, because you must precisely calculate the relative positions of the object, the mirror, and the reflection in order to insure that you show what you need to. I will let you in on a little secret—most of the time when I need to show reflections in an illustration, I find it simpler to either take photographs or set up the scene in CGI than to work out all the perspective on the drawing board, so take what follows with a grain of salt.

IN MOST CASES THE PERSPECTIVE OF REFLECTIONS IS NOT COMPLICATED. WHEN THE MIRROR IS DIRECTLY AGAINST THE WALL, REFLECTIONS HAVE THE SAME VANISHING POINTS AS THE OBJECTS THEY REFLECT, AND THEIR POSITIONS ARE EASILY DETERMINED BY GRIDDING UP THE FLOOR

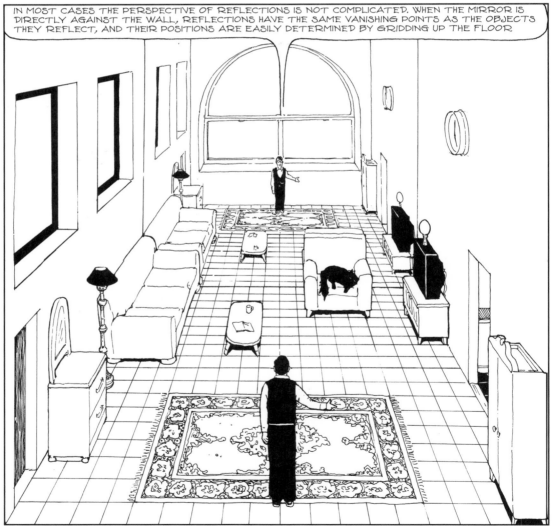

A MIRROR ON THE WALL WILL ACT LIKE A WINDOW INTO AN EXACTLY REVERSED ROOM.

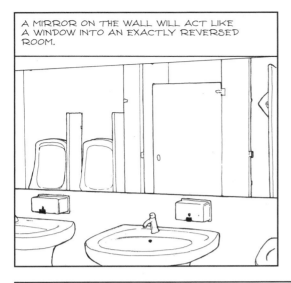

THINGS GET MORE COMPLICATED WHEN A MIRROR IS TURNED AT AN ANGLE.

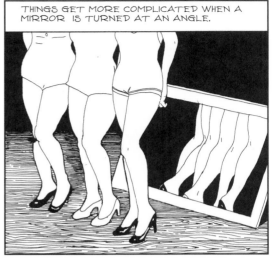

THEN YOU GET ALL THE COMPLICATIONS INVOLVED IN WORKING OUT THE PERSPECTIVE OF MULTIPLE VANISHING POINTS.

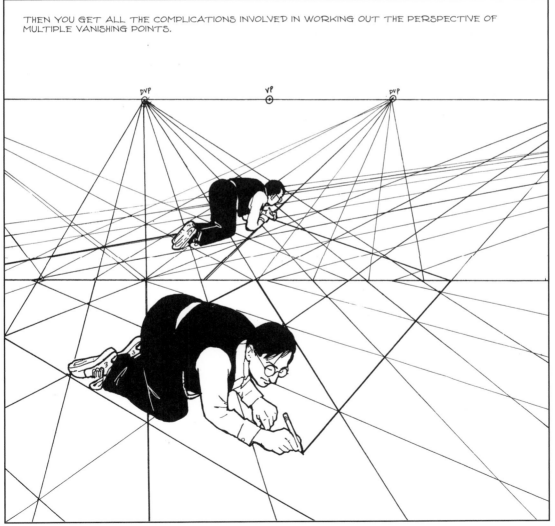

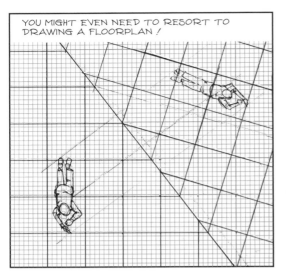

YOU MIGHT EVEN NEED TO RESORT TO DRAWING A FLOORPLAN!

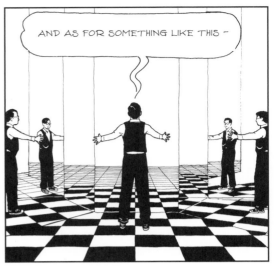

AND AS FOR SOMETHING LIKE THIS —

AGAIN, THE BASIC CONCEPT IS NOTHING WE HAVEN'T ENCOUNTERED BEFORE, BUT WORKING OUT ALL THE DETAILS OF IT IS DEVILISHLY TIME — CONSUMING!

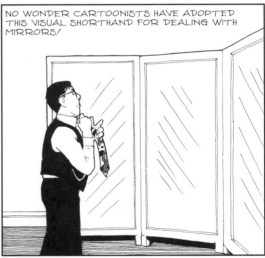

NO WONDER CARTOONISTS HAVE ADOPTED THIS VISUAL SHORTHAND FOR DEALING WITH MIRRORS!

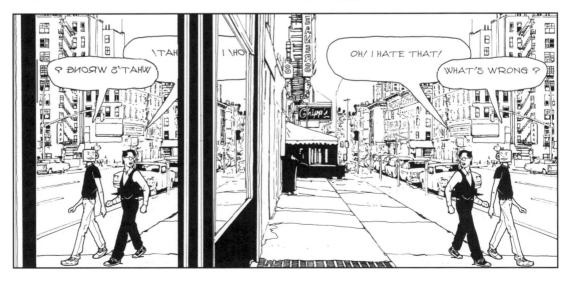

WHAT'S WRONG?

OH! I HATE THAT!

WHAT'S WRONG?

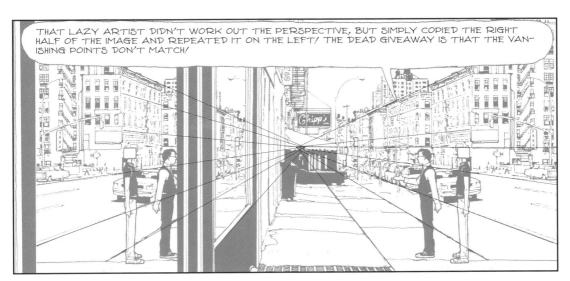

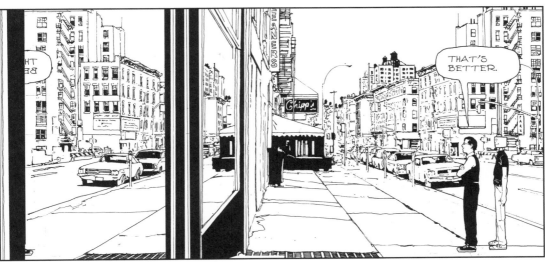

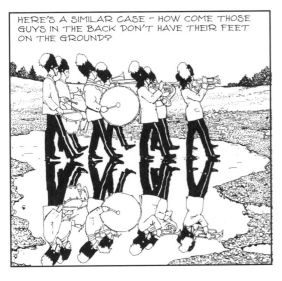

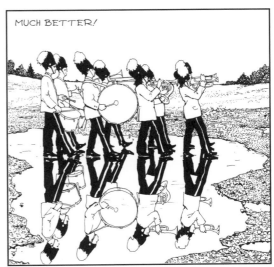

BOTTOM LINE — A MIRROR SCENE WILL ONLY BE EXACTLY REVERSED IF YOUR EYES HAPPEN TO BE EXACTLY AT THE LEVEL OF THE MIRROR.

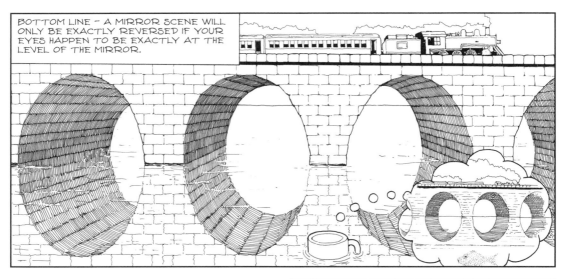

NOW, LET'S LOOK AT ANOTHER KIND OF MIRROR.

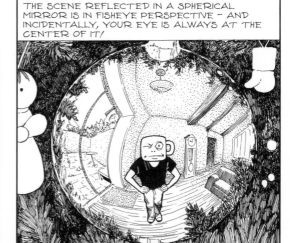

THE SCENE REFLECTED IN A SPHERICAL MIRROR IS IN FISHEYE PERSPECTIVE — AND INCIDENTALLY, YOUR EYE IS ALWAYS AT THE CENTER OF IT!

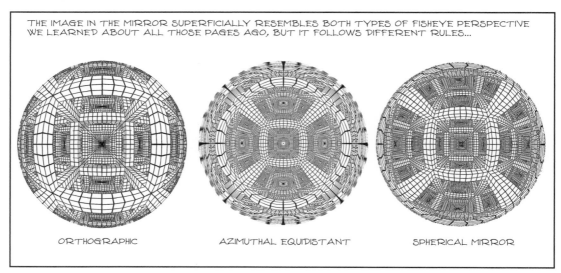

THE IMAGE IN THE MIRROR SUPERFICIALLY RESEMBLES BOTH TYPES OF FISHEYE PERSPECTIVE WE LEARNED ABOUT ALL THOSE PAGES AGO, BUT IT FOLLOWS DIFFERENT RULES...

ORTHOGRAPHIC AZIMUTHAL EQUIDISTANT SPHERICAL MIRROR

FIRST, WHAT YOU SEE IN A MIRROR DEPENDS ON THE ANGLE IT'S TURNED. IF IT'S FACING YOU YOU SEE YOURSELF.

TURN IT SOME AND YOU'LL SEE SOMETHING ELSE — OBVIOUS ENOUGH, RIGHT?

WHAT MAY NOT BE OBVIOUS IS THAT WHAT YOU SEE IS AT DOUBLE THE ANGLE BETWEEN YOUR LINE OF SIGHT AND THE MIRROR — IF YOU'RE LOOKING AT A MIRROR THAT'S TURNED 45°, WHAT YOU'LL SEE IS SOMETHING AT 90°.

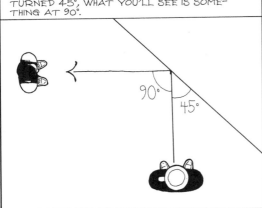

ON A SPHERICAL MIRROR THE CURVATURE OF THE SURFACE MEANS THAT EVERY POINT ON IT HAS A DIFFERENT ANGLE.

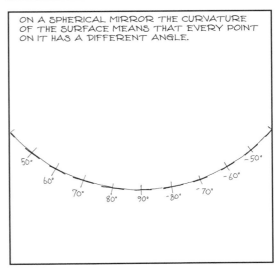

THE INTERACTIONS BETWEEN YOUR ANGLE OF SIGHT AND THE CURVED SURFACE OF THE MIRROR ARE COMPLICATED, AND WHAT'S WORSE, THEY CHANGE AS YOU GET CLOSER OR FARTHER AWAY.

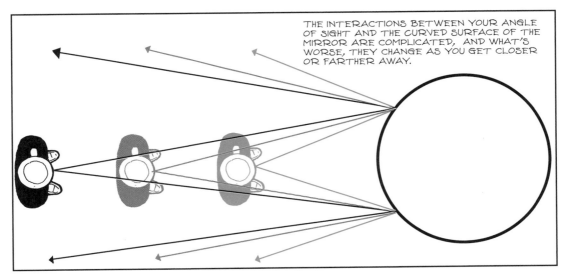

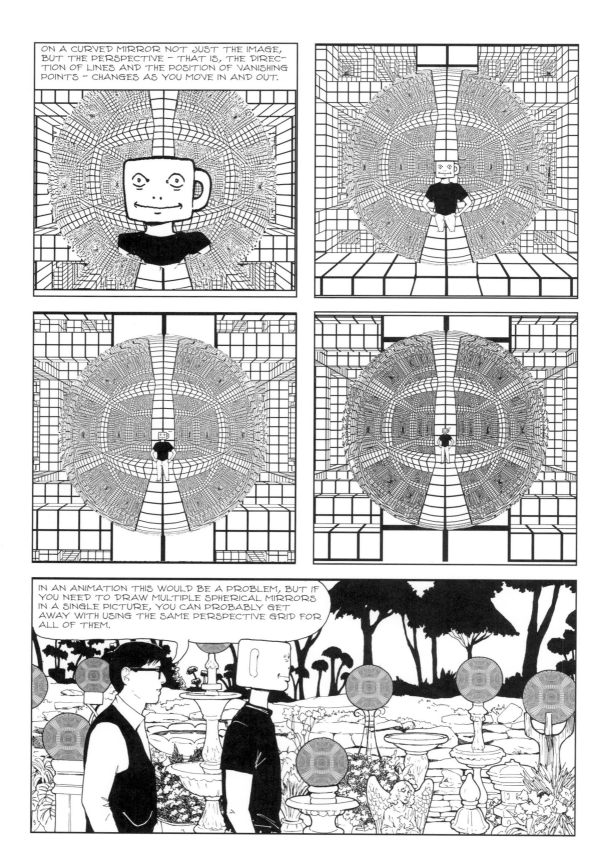

ON A CURVED MIRROR NOT JUST THE IMAGE, BUT THE PERSPECTIVE – THAT IS, THE DIRECTION OF LINES AND THE POSITION OF VANISHING POINTS – CHANGES AS YOU MOVE IN AND OUT.

IN AN ANIMATION THIS WOULD BE A PROBLEM, BUT IF YOU NEED TO DRAW MULTIPLE SPHERICAL MIRRORS IN A SINGLE PICTURE, YOU CAN PROBABLY GET AWAY WITH USING THE SAME PERSPECTIVE GRID FOR ALL OF THEM.

AND RATHER THAN WORKING IT ALL OUT, YOU COULD JUST USE AN ORTHOGRAPHIC OR AN AZIMUTHAL EQUIDISTANT GRID – PARTICULARLY IF THE MIRROR IS ONLY A PARTIAL SPHERE, THE DIFFERENCES ARE SLIGHT AND NOT LIKELY TO BE NOTICED.

IF YOU'RE LOOKING AT A PARTIAL SPHERICAL MIRROR AT AN ANGLE – LIKE THIS ONE – KEEP IN MIND THAT YOUR REFLECTION IS AT THE CENTER OF WHAT WOULD BE THE FULL SPHERE.

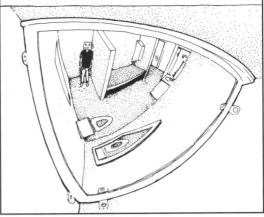

CYLINDRICAL MIRRORS – SUCH AS YOU MIGHT SEE ON A COLUMN IN A HOTEL LOBBY – OPERATE BY SIMILAR RULES.

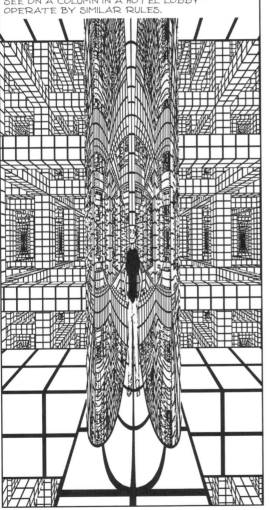

YOU CAN WORK OUT THE PERSPECTIVE HONESTLY, BUT IF YOU SUBSTITUTE A CENTRAL CYLINDRICAL OR EQUIRECTANGULAR GRID NO ONE IS LIKELY TO MIND.

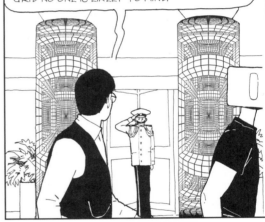

AND WHILE WE'RE ON REFLECTIONS IN CYLINDRICAL MIRRORS HERE'S A KIND OF WEIRDLY DISTORTED ANAMORPHIC DRAWING THAT WAS POPULAR IN THE RENAISSANCE –

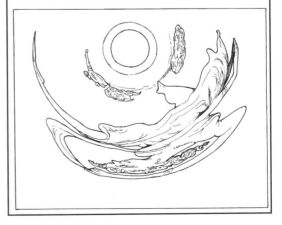

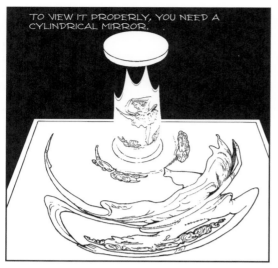

TO VIEW IT PROPERLY, YOU NEED A CYLINDRICAL MIRROR.

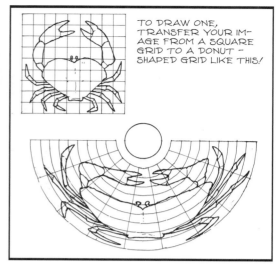

TO DRAW ONE, TRANSFER YOUR IMAGE FROM A SQUARE GRID TO A DONUT-SHAPED GRID LIKE THIS!

LOOKS NICE, DOESN'T IT?

ANY APPLICATION TO COMICS?

OH, NONE AT ALL, BUT I CAN'T LEAVE OUT SOMETHING THAT TOUCHES ON REFLECTIONS, ANAMORPHOSIS, AND CURVILINEAR PERSPECTIVE! THAT'S A TRIFECTA!

SO WHAT'S OUR NEXT MOVE, DAVID?

COME, WALK WITH ME, MUGG.

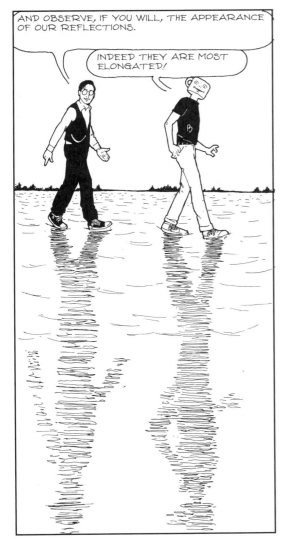

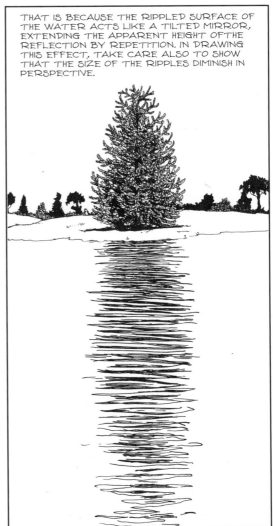

CHAPTER 10
Perspective on the Computer

I still do most of my perspective work on paper, not on the computer, but the computer has made a big transformation in the way I draw comics. Here are a few words on my working method.

I begin with notes for each chapter scribbled on my palm pilot. Working from those, I then open InDesign, which is Adobe's application for layout, and create a basic page of empty frames—usually six on a page. Then I start on the dialogue, writing in little text boxes within each frame, using the Mac's handwriting software because I am allergic to typing. (People are sometimes surprised to learn that I write in all the dialogue for each scene before I begin with the art, but I already know in my head what I will be drawing.) Once I have completed a page of dialogue, I print the page out onto a sheet of vellum graph paper, and draw pencil thumbnails in the little windows, turning the translucent paper over several times in order to refine the drawing, erasing prior versions as I go. When I am reasonably happy with the drawing, I scan it and then print out a pale magenta or cyan version on a sheet of Bristol board. That's what I draw my final inks over. Then I scan the art and import the individual frames back into the square panels of my original layout. I know many artists have made the switch to working entirely on computer, but I still find it easier and more satisfying to work mostly on paper. In the continuum between fish and lizard, I am barely a lungfish.

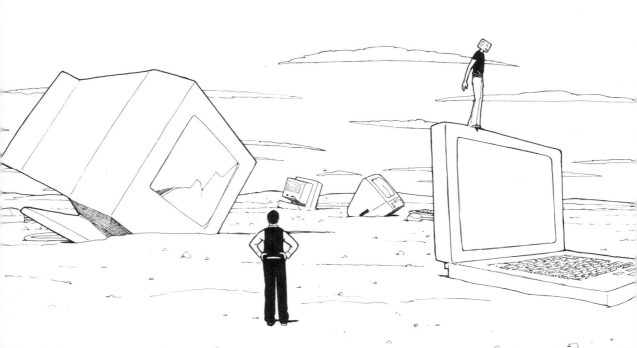

SO, MUGG, WE HAVE COME TO THE LAST CHAPTER.

YEAH.. THE ONE I'VE BEEN WAITING FOR – PERSPECTIVE ON THE COMPUTER!

NOW, HOLD ON, I DON'T WANT YOU TO EXPECT TOO MUCH. A CHAPTER LIKE THIS CAN ONLY SCRATCH THE SURFACE. FOR ONE THING, THE SOFTWARE CHANGES SO FAST THAT ANYTHING I WRITE IN HERE TODAY IS BOUND TO BE OBSOLETE BY THE TIME IT APPEARS IN PRINT.

ISN'T TODAY YOUR ANNIVERSARY?

AUGUST

OH! THAT'S RIGHT! I'D BETTER GET MY WIFE SOME FLOWERS!

LET'S FINISH THIS CHAPTER FIRST.

RIGHT. SO WHAT'S CURRENT NOW WON'T BE CURRENT WHEN THIS COMES OUT, LET ALONE YEARS FROM NOW WHEN SOMEONE CHECKS THE FOURTH PRINTING OUT OF THE LIBRARY. AND WHAT I HAVE ON MY COMPUTER RIGHT NOW ISN'T EVEN CURRENT.

YEAH, I NOTICE YOU'RE STILL WORKING IN PHOTOSHOP 7.0.

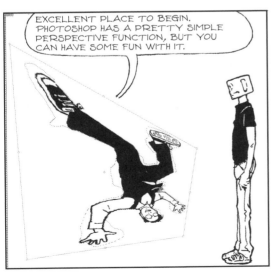

EXCELLENT PLACE TO BEGIN. PHOTOSHOP HAS A PRETTY SIMPLE PERSPECTIVE FUNCTION, BUT YOU CAN HAVE SOME FUN WITH IT.

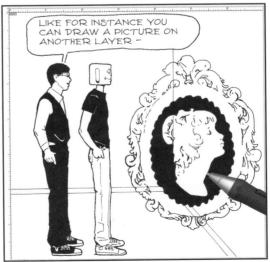

LIKE FOR INSTANCE YOU CAN DRAW A PICTURE ON ANOTHER LAYER –

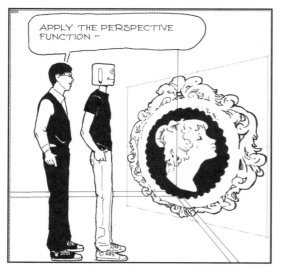

YOU CAN ALSO USE IT TO DRAW SOME PRETTY CONVINCING SHADOWS.

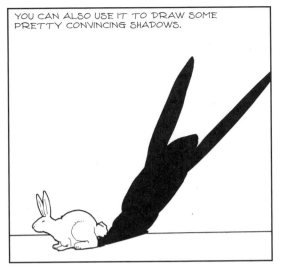

FIRST, DRAW A SILHOUETTE AS IT MIGHT BE SEEN FROM THE POINT OF VIEW OF THE LIGHT SOURCE.

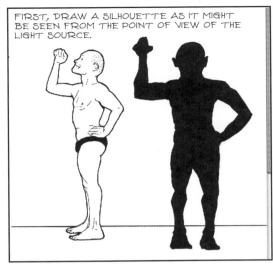

THEN TWEAK IT INTO A DISTORTED FORM WITH THE PERSPECTIVE FUNCTION.

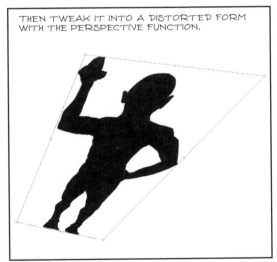

AND APPLY TO THE FIGURE.

THE PERSPECTIVE FUNCTION REALLY COMES IN HANDY IN SETTING UP ANAMORPHOSIS. FIRST TAKE A FRONTAL SHOT OF THE WALL YOU WANT TO PAINT ON, WITH THE AREA YOU INTEND TO DRAW IN OUTLINED.

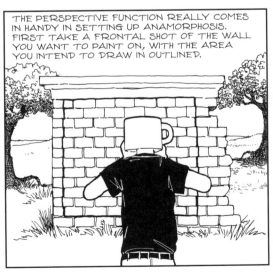

NOW TAKE A PICTURE OF THE WALL FROM THE SPOT YOU INTEND TO VIEW THE ANAMORPHIC IMAGE FROM.

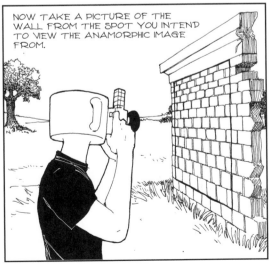

LOAD ALL YOUR PICTURES INTO THE COMPUTER.

SCAN THE PICTURE YOU WANT TO BE THE ANAMORPHIC IMAGE.

NOW OPEN THE PICTURE YOU TOOK FROM THE STATION POINT.

AND PASTE THE SCAN OF YOUR ANAMORPHIC IMAGE IN EXACTLY WHERE YOU WANT IT TO APPEAR. YOU MAY NEED TO RESIZE IT SOMEWHAT TO FIT.

(ALTERNATE METHOD: DRAW THE IMAGE DIRECTLY USING A TABLET AND STYLUS.)

NEXT, FLATTEN LAYERS.

CROP USING THE FOUR CORNERS OF THE YOUR PICTURE AREA IN PERSPECTIVE MODE.

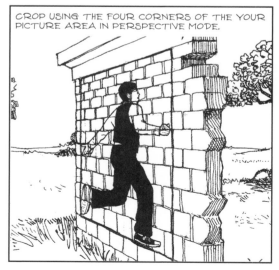

NOW OPEN THE FRONTAL SHOT.

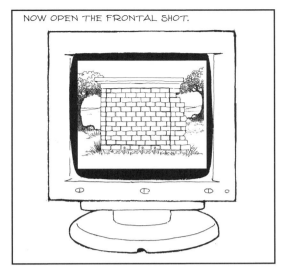

PASTE THE CROPPED IMAGE ON THE FRONTAL SHOT.

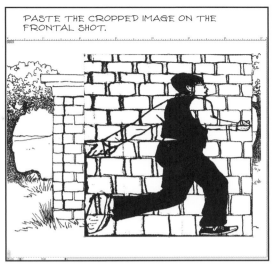

IN PERSPECTIVE MODE, ADJUST THE CORNERS SO THEY LINE UP EXACTLY.

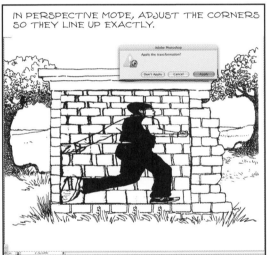

FLATTEN LAYERS AND SAVE.

NOW YOU CAN PRINT OUT YOUR PICTURE AND USE IT AS A GUIDE FOR PAINTING YOUR MURAL!

ANOTHER APPLICATION I USE A LOT IS ILLUSTRATOR.

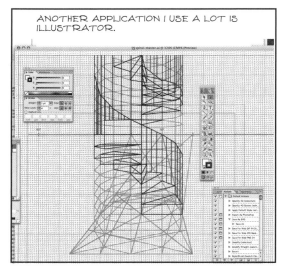

IT'S VECTOR-BASED INSTEAD OF PIXEL-BASED, SO THE FILES ARE A LOT SMALLER THAN IN PHOTOSHOP.

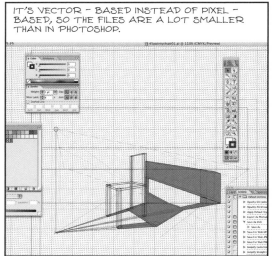

YOUR IMAGE AREA IS VIRTUALLY UNLIMITED, SO DRAWING A THREE-POINT PERSPECTIVE WITH EXTREMELY DISTANT VANISHING POINTS IS A SNAP!

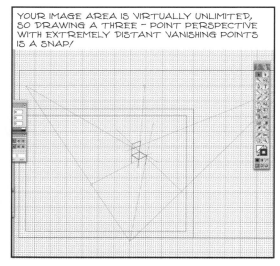

YOU CAN ZOOM IN ON A TINY AREA AND WORK IN DETAIL - LINES GOING BACK TO THE VANISHING POINTS WILL PIVOT AROUND AND CAN BE USED AS RULERS TO KEEP THE OTHER LINES IN YOUR OBJECT IN TRUE PERSPECTIVE.

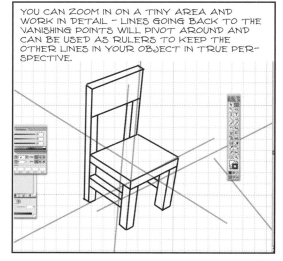

ONCE YOU HAVE THE DIAGRAM COMPLETE YOU CAN PRINT IT OUT AND WORK OVER IT.

ME, I LIKE WORKING DIRECTLY ON COMPUTER!

OK, I'M BORED. WHAT DO WE DO NOW?

LET'S GO ONLINE!

PHOTO SHARING SITES LIKE FLICKR HAVE AN INTERESTING FEATURE - IMMERSIVE PANORAMAS!

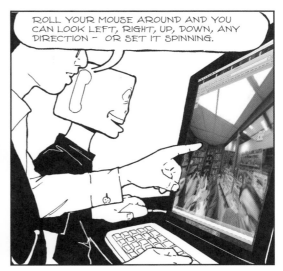

ROLL YOUR MOUSE AROUND AND YOU CAN LOOK LEFT, RIGHT, UP, DOWN, ANY DIRECTION - OR SET IT SPINNING.

THAT LOOKS LIKE A PHOTOGRAPH, DAVID.

IT IS.

A PHOTOGRAPHER TAKES A NUMBER OF SHOTS IN ALL DIRECTIONS FROM ONE POINT IN SPACE -

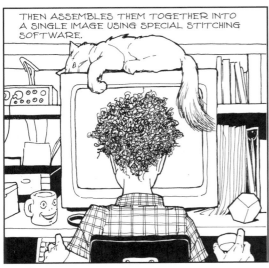

THEN ASSEMBLES THEM TOGETHER INTO A SINGLE IMAGE USING SPECIAL STITCHING SOFTWARE.

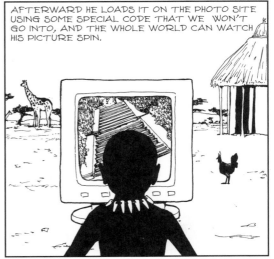

AFTERWARD HE LOADS IT ON THE PHOTO SITE USING SOME SPECIAL CODE THAT WE WON'T GO INTO, AND THE WHOLE WORLD CAN WATCH HIS PICTURE SPIN.

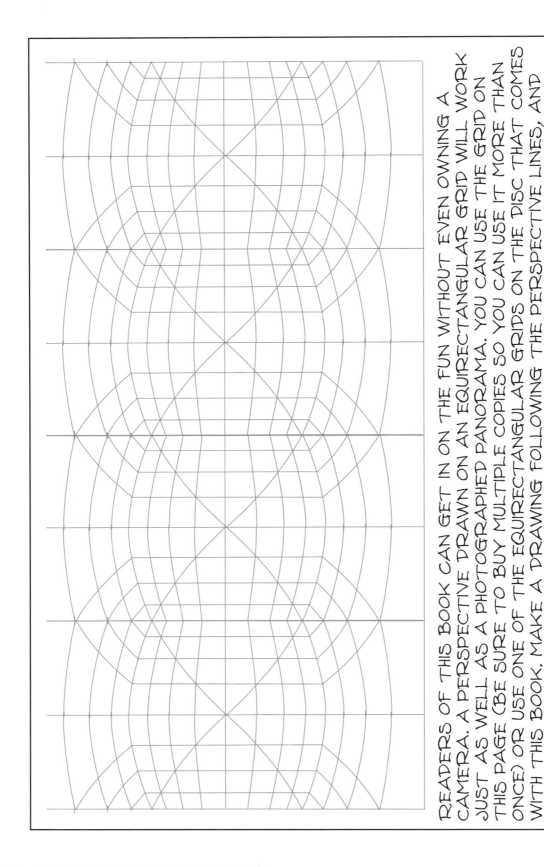

READERS OF THIS BOOK CAN GET IN ON THE FUN WITHOUT EVEN OWNING A CAMERA. A PERSPECTIVE DRAWN ON AN EQUIRECTANGULAR GRID WILL WORK JUST AS WELL AS A PHOTOGRAPHED PANORAMA. YOU CAN USE THE GRID ON THIS PAGE (BE SURE TO BUY MULTIPLE COPIES SO YOU CAN USE IT MORE THAN ONCE) OR USE ONE OF THE EQUIRECTANGULAR GRIDS ON THE DISC THAT COMES WITH THIS BOOK. MAKE A DRAWING FOLLOWING THE PERSPECTIVE LINES, AND THEN POST THE RESULTS TO FLICKR AND WATCH YOUR DRAWING SPIN!

OK, THAT'S ENOUGH. I'M DIZZY. ARE WE GOING TO DO CGI NOW?

UH - WE'RE NOT COVERING CGI IN THIS BOOK, MUGG.

GEE, WHY THE HECK NOT? YOU USED IT ENOUGH PUTTING THE BOOK TOGETHER!

SHHH!

COMPUTER GENERATED 3 - D IMAGERY IS A MARVELOUS TECHNOLOGY WHICH WILL GIVE YOU CORRECT PERSPECTIVE RESULTS EVERY TIME, BUT IT'S OUTSIDE THE SCOPE OF THIS BOOK PARTLY BECAUSE YOU DON'T NEED TO KNOW ANYTHING ABOUT PERSPECTIVE TO WORK IN IT BUT MAINLY BECAUSE MAKING THE MODELS IS SO MUCH WORK!

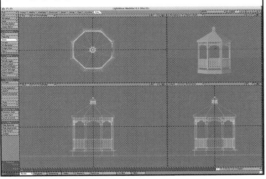

I'M OUTTA HERE.

HOWEVER, WE CAN SORT OF KIND OF GET INTO IT A LITTLE BIT -

THERE ARE LOTS OF ALREADY MADE CGI MODELS FLOATING AROUND THE INTERNET, AND IT'S PRETTY EASY TO USE THEM IN YOUR ART.

WHERE DO WE START?

WELL I'VE ALREADY GOT GOOGLE SKETCHUP INSTALLED.

LET'S LOOK FOR AN OBJECT TO DOWNLOAD FROM GOOGLE'S 3D WAREHOUSE.

I LIKE THE LOOK OF THIS STAIRCASE.

NOW THAT I'VE DOWNLOADED THE OBJECT, I OPEN IT IN SKETCHUP

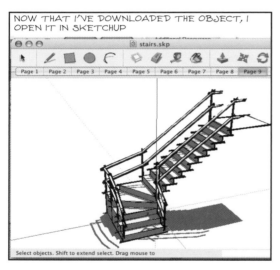

I CAN MOVE THE OBJECT AROUND AND ROTATE IT JUST LIKE I COULD IN MAYA OR LIGHTWAVE. I DON'T WANT TO DEAL WITH SHADOWS, SO I'VE TAKEN THE LIGHTS OUT OF THE SCENE.

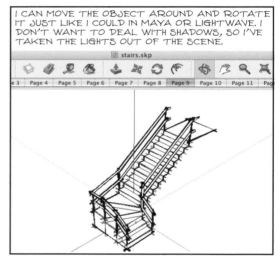

ONCE I'VE SETTLED ON AN ANGLE I LIKE, I MAKE A RENDERING IN SKETCHUP, THEN EXPORT IT.

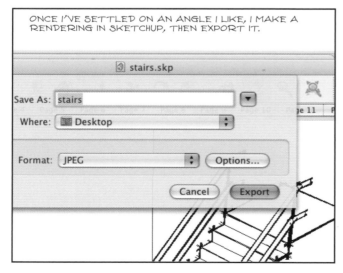

THEN I OPEN THE RENDERING IN ANOTHER APPLICATION, IN THIS CASE ILLUSTRATOR.

WITHIN THE VAST SPACE OF AN ILLUSTRATOR DOCUMENT, I EXTEND LINES FROM THE STAIRCASE BACK TO ALL THREE VANISHING POINTS.

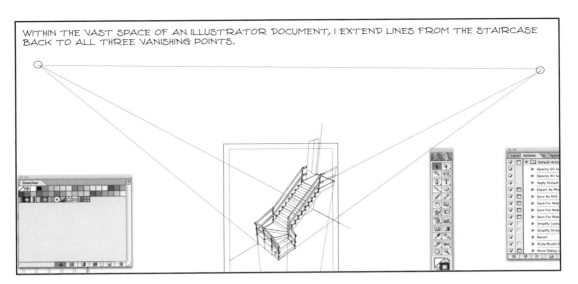

NOW I CAN ADD MORE LINES TO THE SCENE. MOVING AROUND A LONG LINE TETHERED TO A VANISHING POINT ESTABLISHES THE DIRECTION FOR ALL THE SHORT LINES.

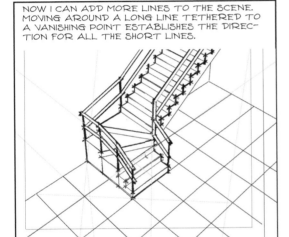

IN A VERY SHORT TIME I HAVE BUILT A PLAUSIBLE SCENE AROUND THE STAIRCASE.

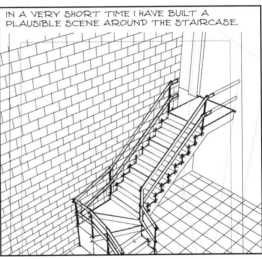

I MIGHT PRINT MY ILLUSTRATOR FILE OUT AT THIS POINT AND START DRAWING ON IT, BUT SINCE THIS IS THE CHAPTER ON COMPUTERS, INSTEAD I WILL OPEN IT IN PHOTOSHOP.

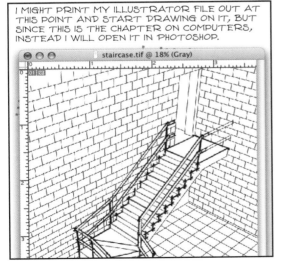

I START DRAWING FIGURES ON TOP OF MY STAIRCASE SCENE -

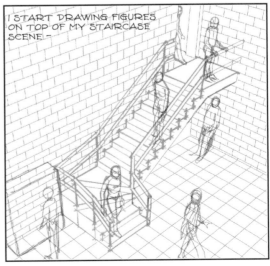

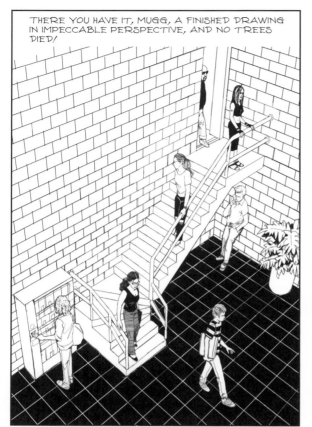

GLOSSARY

HORIZON: THE APPARENT LINE THAT SEPARATES EARTH FROM SKY. IN CONVENTIONAL ONE AND TWO - POINT PERSPECTIVE, ALL VANISHING POINTS WILL BE ON THE HORIZON.

DIMINUTION: IN PERSPECTIVE, THE EFFECT OF AN APPARENT DECREASE IN SIZE OVER DISTANCE.

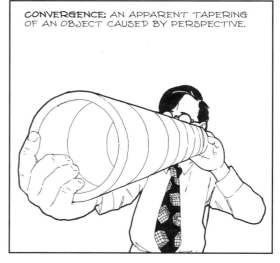

FORESHORTENING: THE VISUAL EFFECT OR OPTICAL ILLUSION THAT AN OBJECT OR DISTANCE APPEARS SHORTER THAN IT ACTUALLY IS BECAUSE IT IS ANGLED TOWARD THE VIEWER.

CONVERGENCE: AN APPARENT TAPERING OF AN OBJECT CAUSED BY PERSPECTIVE.

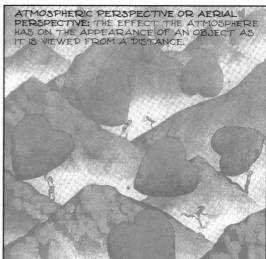

OVERLAP: IN PERSPECTIVE, THE EFFECT BY WHICH NEARER OBJECTS PARTIALLY HIDE FARTHER ONES.

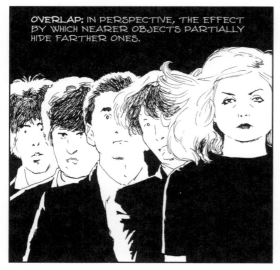

ATMOSPHERIC PERSPECTIVE OR AERIAL PERSPECTIVE: THE EFFECT THE ATMOSPHERE HAS ON THE APPEARANCE OF AN OBJECT AS IT IS VIEWED FROM A DISTANCE.

STATION POINT: A LOCATION OR VANTAGE POINT FROM WHICH A SCENE IN PERSPECTIVE WILL APPEAR CORRECT TO AN OBSERVER.

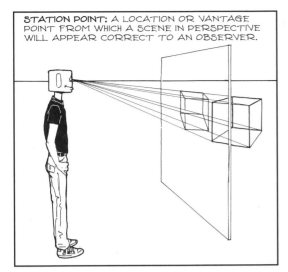

PICTURE PLANE: THE IMAGINARY FLAT SURFACE WHICH IS USUALLY LOCATED BETWEEN THE STATION POINT AND THE OBJECT BEING VIEWED.

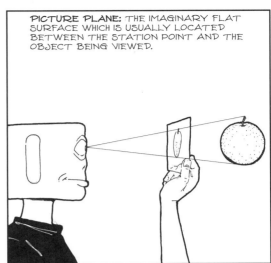

VANISHING POINT: THE POINT IN A PERSPECTIVE DRAWING TO WHICH PARALLEL LINES OF OBJECTS APPEAR TO CONVERGE.

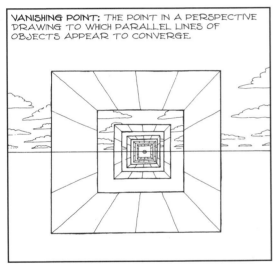

DIAGONAL VANISHING POINT: A POINT TOWARD WHICH LINES DRAWN THROUGH THE DIAGONALS OF A RECTANGULAR OBJECT APPEAR TO CONVERGE.

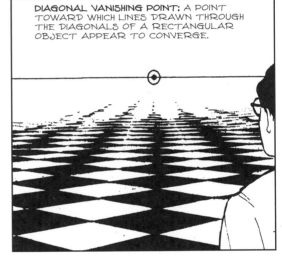

ZENITH: IN PERSPECTIVE, A VANISHING POINT DIRECTLY ABOVE THE OBSERVER TOWARDS WHICH VERTICAL LINES APPEAR TO CONVERGE.

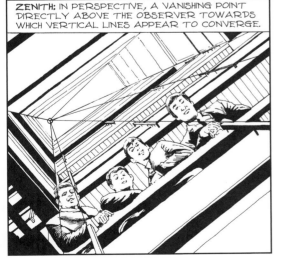

NADIR: IN PERSPECTIVE, A VANISHING POINT DIRECTLY BELOW THE OBSERVER TOWARDS WHICH VERTICAL LINES APPEAR TO CONVERGE.

TRANSVERSE HORIZON: IN PERSPECTIVE, A LINE CROSSING THE HORIZON AT RIGHT ANGLES. IN VIEWS WHERE THE HORIZON IS TIPPED, IT LINKS VANISHING POINTS ON THE HORIZON WITH THE ZENITH OR NADIR.

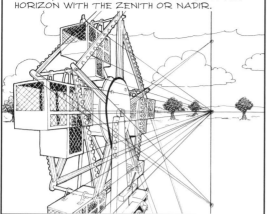

CENTER OF VISION: THE POINT ON THE PICTURE PLANE NEAREST THE OBSERVER. IN ONE-POINT PERSPECTIVE THAT POINT WILL COINCIDE WITH THE CENTRAL VANISHING POINT.

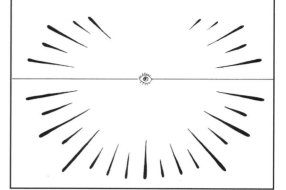

CONE OF VISION: A CONE WHOSE BASE IS A CIRCLE AROUND THE CENTER OF VISION ON THE PICTURE PLANE AND WHOSE APEX IS THE EYE OF THE OBSERVER. THE WIDER THE CONE OF VISION, THE MORE OF THE PERIPHERY IS SEEN, AND THE MORE EXTREME THE PERSPECTIVE DISTORTION AT THE EDGES BECOMES.

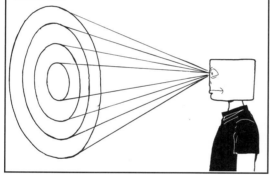

ONE-POINT PERSPECTIVE: A SCENE IN WHICH THE PICTURE PLANE IS PARALLEL TO TWO AXES OF A RECTILINEAR SCENE. ALL ELEMENTS THAT ARE PARALLEL TO THE PICTURE PLANE ARE DRAWN AS PARALLEL LINES. ALL ELEMENTS THAT ARE PERPENDICULAR TO PICTURE PLANE CONVERGE AT A SINGLE POINT (A VANISHING POINT) ON THE HORIZON.

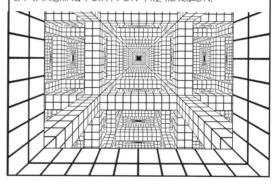

TWO-POINT PERSPECTIVE: A SCENE IN WHICH THE PICTURE PLANE IS PARALLEL TO ONE AXIS OF A RECTILINEAR SCENE BUT NOT TO THE OTHER TWO AXES. TWO-POINT PERSPECTIVE HAS ONE SET OF LINES PARALLEL TO THE PICTURE PLANE AND TWO SETS AT ANGLES TO IT. PARALLEL LINES OBLIQUE TO THE PICTURE PLANE CONVERGE TO A VANISHING POINT, WHICH MEANS THAT TWO VANISHING POINTS ARE NEEDED.

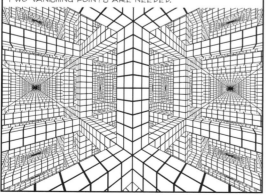

THREE-POINT PERSPECTIVE: A VIEW OF A RECTILINEAR SCENE WHERE THE PICTURE PLANE IS NOT PARALLEL TO ANY OF THE SCENE'S THREE AXES. EACH OF THE THREE VANISHING POINTS CORRESPONDS WITH ONE OF THE THREE AXES OF THE SCENE.

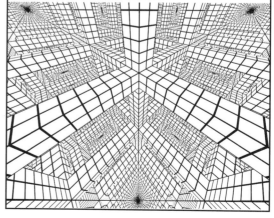

GRAVITY LINE: IN THREE - POINT PERSPECTIVE, A LINE PERPENDICULAR TO THE HORIZON WHICH LEADS TO THE NADIR OR ZENITH AND IS ALWAYS A TRUE VERTICAL.

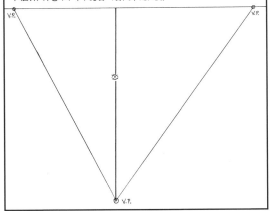

X METHOD: A WAY OF FINDING THE CENTER OF ANY RECTANGLE IN PERSPECTIVE BY DRAWING CROSSED DIAGONAL LINES FROM OPPOSITE CORNERS.

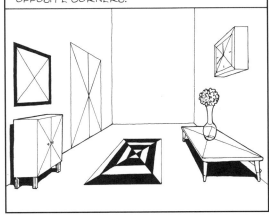

PROTRACTOR: A CIRCULAR OR SEMICIRCULAR TOOL FOR MEASURING AN ANGLE OR A CIRCLE. THE UNITS OF MEASUREMENT UTILIZED ARE USUALLY DEGREES.

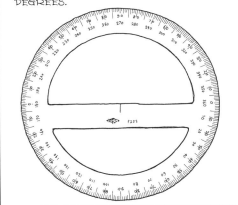

GREAT CIRCLE: A CIRCLE THAT RUNS ALONG THE SURFACE OF A SPHERE SO AS TO CUT IT INTO TWO EQUAL HALVES. ON A GLOBE, THE EQUATOR AND ALL LONGITUDES ARE GREAT CIRCLES. WHEN A PERSPECTIVE SCENE IS TRACED ON A SPHERICAL SURFACE, ALL STRAIGHT LINES ARE DRAWN AS GREAT CIRCLES.

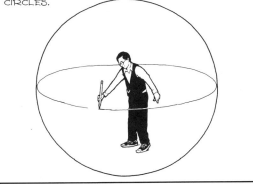

SMALL CIRCLE: THE CIRCLE CONSTRUCTED BY A PLANE CROSSING THE SPHERE NOT IN ITS CENTER. SMALL CIRCLES ALWAYS HAVE SMALLER DIAMETERS THAN THE SPHERE ITSELF. LATITUDE LINES ON A GLOBE ARE SMALL CIRCLES, AND WHEN A PERSPECTIVE SCENE IS TRACED ON A SPHERICAL SURFACE, SPHERES WILL BE DRAWN AS SMALL CIRCLES.

CONIC SECTION: A CURVE OBTAINED BY INTERSECTING A CONE (MORE PRECISELY, A RIGHT CIRCULAR CONICAL SURFACE) WITH A PLANE. DEPENDING ON ITS SIZE AND THE ANGLE OF VIEW, A CIRCLE IN PERSPECTIVE WILL HAVE THE SHAPE OF ONE OR ANOTHER OF THE CONIC SECTIONS.

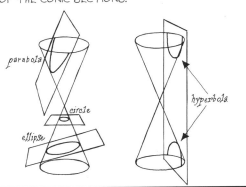

PARALINE: A NONPERSPECTIVE DRAWING METHOD IN WHICH ALL LINES IN A GIVEN DIRECTION ARE PARALLEL AND DO NOT MEET AT A VANISHING POINT. TYPES OF PARALINE DRAWING INCLUDE ISOMETRIC, DIMETRIC AND TRIMETRIC, HORIZONTAL AND VERTICAL OBLIQUE,

ANAMORPHOSIS: A DISTORTED PROJECTION OR PERSPECTIVE REQUIRING THE VIEWER TO USE SPECIAL DEVICES OR OCCUPY A SPECIFIC VANTAGE POINT TO RECONSTITUTE THE IMAGE.

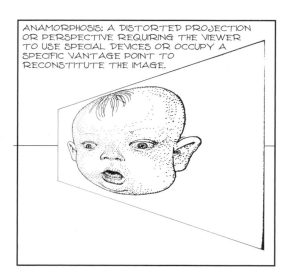

CYLINDRICAL PERSPECTIVE: A FORM OF CURVILINEAR PERSPECTIVE IN WHICH A SCENE IS DRAWN ON AN IMAGINARY CYLINDRICAL WINDOW WHICH IS THEN FLATTENED INTO A RECTANGULAR PICTURE. ALL STRAIGHT LINES ARE DRAWN AS CURVED EXCEPT THOSE THAT RUN PARALLEL TO THE SIDES OF THE CYLINDER.

SPHERICAL PERSPECTIVE: A SCENE COVERING A 360° VIEW IN ALL DIRECTIONS, DRAWN ON EITHER THE INSIDE OR OUTSIDE OF A SPHERE.

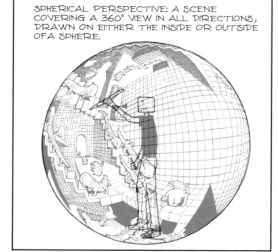

FISHEYE PERSPECTIVE: A FORM OF CURVILINEAR PERSPECTIVE IN WHICH THE IMAGE IS CIRCULAR AND ALL STRAIGHT LINES ARE DRAWN AS CURVED EXCEPT THOSE PASSING THROUGH A CENTRAL POINT.

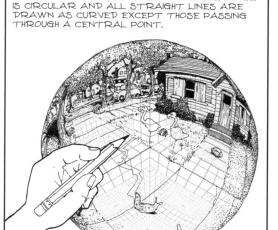

INDEX